"I HAVE A TASK FOR THEE, WELL SUITED TO THY SKILLS. Dost know a knight's manor," she said, "just within the wood's edge?"

The brigand nodded, cleared phlegm from his throat. "Hartwick Manor? Aye, Lady, that I do."

"Then take thy band thither tonight. Slay every soul within its walls, from the lowliest spit-boy to the knight and his infant son. In fee, take the knight's plate and his linen and his coffered gold, and sport with his maid-servants as ye must, but see thou that no man of thy band touch or molest his lady."

Puzzled by this capricious mercy, the brigand scratched his verminous head. "Why spare even one might tell tales after? Slit one, slit all, I always says, and leave t' place nice and quiet." Evilly he grinned at her, baring scraggled, brownish teeth. Margaret stared at him from moonstone eyes until his grin drooped and he began to tremble.

"You will do the lady no harm," she repeated. "You will not slay her, you will not cut or bruise her, you will not so much as touch the least thread of her hair. Go now, and return here to me when all are dead."

"A very satisfying medieval dish of good and evil, romance, death, and magic."

—Patricia A. McKillip

Through A Brazen Mirror

DELIA SHERMAN

ACE BOOKS, NEW YORK

This book is an Ace original edition,
and has never been previously published.

THROUGH A BRAZEN MIRROR

An Ace Book / published by arrangement with
the author

PRINTING HISTORY
Ace edition / January 1989

ISBN: 0-441-89687-1

Ace Books are published by The Berkley Publishing Group,
200 Madison Avenue, New York, New York 10016.
The name ''ACE'' and the ''A'' logo are trademarks
belonging to Charter Communications, Inc.

PRINTED IN THE UNITED STATES OF AMERICA

10 9 8 7 6 5 4 3 2 1

To Jo Ann, who helped her to Design this labyrinth, and also to Greer, who most patientlie helped her to Hoe, Weed, and Water the same, the Author rendereth up her most hearty Love and Thanks.

Acknowledgment

I would like to thank Martin Carthy for permission to quote from his expanded version of "The Famous Flower of Serving Men," which appears on SHEARWATER (Mooncrest Records, 1972).

Winter

Chapter One

THE THIRD OF November was a day so black that no man could tell by the light whether the abbey bells rang for terce or for vespers. The flambeaux were lit by midday and smoked sullenly in the heavy air. Rain fell in a dismal rattle—a cold, small rain that had been falling steadily for three days. There had been a great storm on All Hallow's Eve, a regular sorcerer's sabbath, with hail and lightning and thunder like the drums of war. By dawn it had slacked, but it had not ceased. Old men said there had not been such a rain since their grandsires' days.

Out of the kitchen entry and into the puddled courtyard staggered an under-scullion on his way to the midden with a bucket of slops. The bucket being heavy and the scullion but a scrawnling and weary besides, he stumbled over the stoop and dropped it. Potato parings and offal flew broadcast.

"Devil take the poxy steps!" cried Ned and stamped his foot.

A thump and a heavy sigh sounded from the shadows behind him. Forgetting the slops, Ned whirled and peered. What with the rain and the gloom and the uncertain torch-light, it took him a moment to make out the figure of a man, cloakless and shivering, crouched in the mud by the castle wall. Ned moved closer; the man lifted his head. "I have come to serve the King," he said.

Three-day rains and flambeaux at midday and ragged strangers at the King's kitchen door were tales for a winter's night, and clear outside Ned's ken. Terrified, the boy gaped at the man's hollow and filthy countenance and spun away to flee. But the stranger caught his jerkin and held him fast.

3

"Help me to my feet, lad."

His voice was light and sweet, no outlaw's growl; Ned took courage and studied him closer. The stranger was beardless, and under the dirt, his skin was pale and marred with bloody scratches.

Here was wretchedness indeed. Giving the young man both his hands, Ned hauled him up with such hearty good will that he nearly had them both down in the mud. For a nightmare moment, they grappled and slipped in the mucky yard before Ned could steady himself against the wall and thrust an arm under the young man's drooping shoulder. Panting, he supported him into the kitchen and stood with him at the edge of the scurry and shout that attended the preparation of the King's dinner. Now what would he do?

"Take me to the King's Cook, lad," the young man said. "I would speak with him."

"Indeed, sir, ye much better not," said Ned. "Master Hardy'll be all of a grumble until the last dish be carried up, and I dasn't go nigh him."

"Where is he, then? I will go to him myself." The young man pushed away from Ned's shoulder and looked curiously at the scene before him. Undercooks and serving-men swarmed and jostled around the long trestle tables; scullions darted hither and thither, laden with pottery jars and wooden bowls. The room seethed like a boiling pot, with the shrilling voices and the rasp of turning spits all mixed with the clash of iron pots and ladles in a fine, chaotic stew of noise. As the young man stepped forward, an angry bellow lifted itself above the teem.

"Mindless child of a cross-eyed sow! Hast greased thy fingers? Hast made a study of stupidity? Go, study the spit and grease thy wit, thou gizzard!"

The young man cocked his chin towards the noise. "Master Hardy?"

"Aye."

Before Ned could offer arm or aid, the young man had set off into the living maze. His goal was a tall subtlety, a spun-sugar roe buck at bay against a rock of black-glazed cake. At its feet, with arms akimbo and his face all red from the heat of his anger, stood a tall corpulent man. Bowing, the young man addressed him: "Master Hardy, I . . ."

"And who in the name of St. Mendicus and all the little cherubins may you be, sirrah, to make so free with my name?'' Master Hardy looked the young man up and down, from his matted locks to his mired boots. "We give our sops to the poor in the morning, fellow.''

The young man drew himself up proudly. "I ask no charity here,'' he said. "I am well able to work for my bread.'' A fine speech, indeed, for one so white and thin as he; but he spoiled it somewhat when first he reeled, then turned up his eyes, and finally tumbled down onto the flagstones in a faint.

Master Hardy snorted and toed the stranger in the ribs, gently, to see if he would stir. Ned ran to fetch a basin of water and a rag. In a trice he returned and wiped the young man's face, then unloosed his cotehardie and his fine cambric shirt to reveal an ugly gash under the point of his jaw and a filthy bandage wrapped tight around his chest.

"Holy Mother of God.'' Ned drew a breath whistling through his teeth. Around him, turnspits and kitchen knaves appeared as from nowhere.

"He's taken a right drubbing,'' said Jack Priddy, hugging his own ribs in sympathetic memory.

"Aye.'' Ned swabbed industriously at the young man's throat and chest. "T'were no dry-beating, neither. Were yon scratch deeper, the man'd be sped. Oh.'' The soft cloth caught and pulled on some roughness under the top of the bandage. A glint of gold, a slender chain. "Oh. Here's sommat in his bosom.''

Master Hardy, who had up to now attended to this pother with half an ear, pushed Jack aside and hunkered down in his place. Hooking a meaty finger into the loop of chain, he drew forth a miniature portrait set with pearls and backed with an entwined "E'' and "W'' picked out in rubies. It was the likeness of an ugly, spade-faced man with yellow locks, dressed like a lord, with a wide collar at his throat. Threaded on the same chain was a plain gold ring, a little scratched and bent with wear. Master Hardy turned bauble and ring over and back in his broad hand, then tucked them under the bandage and heaved himself to his feet.

"Well, scullion, since thou'dst liefer meddle with a stranger than keel the pots, bring him to himself before he is trodden on. Then give him bread and meat, and we'll see if he be as

quick to proffer his service fed as starving." Ned scurried off
obediently, and Master Hardy became aware that most of his
underlings were not cooking at all, but crowding around the
stranger and staring like sheep at a salt-lick.

"What!" he roared. "Will His Majesty go hungry that one
nameless lubbard might be fed? By St. Coqua and her iron
ladle, he will not!" Hands on broad hips, he glared left and
right, and knaves and undercooks, sauciers and bakers scat-
tered before his wrath fairly bleating with terror.

Warm with virtue and freedom from the spit, Ned sprinkled
the stranger's face with cold water from the pump until he
awoke, then drew him over to the settle and gave him bread,
meat, and a pint of brown ale drawn from Master Hardy's
special butt. He looked lonely, Ned thought, and by way of
making him feel welcome, sat himself down on the warm
hearthstone and gawped. The young man seemed to take this
scrutiny in good part, for he smiled pleasantly between bites
and gave Ned a sip of his ale.

While the stranger sat toasting his feet and drinking Wat
Brewer's strong October, the bustle in the King's kitchen
swelled to a frenzy. Undercooks carefully dressed great plat-
ters with food and garlands and gave them to the marshals,
who carried them to the surveying board above, whence
pages and men-at-arms would bear them through the great
hall in a proud processional. Dish by dish, the roasts and
entremets, the subtleties and puddings, the pies and sallets
and *farcis* mounted the stairs; dish by dish, the remains
descended by the same route. Now the cooks and the
undercooks had leisure to untie their reeking aprons and sit
down to their own meat, but the scullions simply exchanged
their paring knives, pestles, and spit handles for a row of
wooden washing-tubs and towers of greasy pots and salvers.
They'd eat while they washed, or when all was done.

By the time the second course had come down from the
hall, the young man had eaten the last crumb of his bread and
drained the last drop of ale from the tankard. He sleeved his
mouth, sighed, and fell into an abstraction with his eyes
unfocussed upon the flames and the tankard dangling loose
from his hand. His face had borrowed some color from fire
and food, but still it was drawn and strained, as with sorrow
or long hunger. Ned reached to take the tankard before he

should drop it and the stranger recoiled from the touch, terror stretching his eyes and mouth. Almost at once he turned the movement into a stretch and a yawn, but Ned had seen what he had seen.

The young man smiled, kind and sad as the figure of St. John Martyr in the abbey window. "I thank you, lad, for your good offices. I feel more like a living man than I did." He tousled Ned's rough hair and rose, his tankard in his hand.

Master Hardy was sitting down to a trencher of his own excellent *henne doree* when he caught sight of the stranger making for the washing-tubs with Ned trailing behind him.

"By St. Limus' muddy fingernails, boy," he shouted across the room. "You're no use to me half-dead and reeking like a midden in June! Thou, scullion, this stray is thy affair. Get him clean linen from Mistress Rudyard and show him the wash-house. You, boy, can sleep in the stable until we find you a pallet—tell Master Hayward I said so." The young man bowed slightly and turned to follow Ned. "A moment, boy. What are we to call you?"

"I am called William Flower, and I thank you for your kindness, Master Hardy."

The King's Cook laughed sourly. "Time enough to speak of kindness when you've turned the spit for a sennight." Then, remembering the bandage, "What's that swaddling about your breast?" he asked.

William Flower's face grew very still, and his hands went to his throat to pull his shirt-strings tighter. "I was set upon by thieves, sir, and received of them two broken ribs. A Grey Friar found me and wrapped my ribs thus, and told me not to unbrace for a month or so. That is only three days past."

"Thieves, you say? In good sooth, that's sorry hearing." Master Hardy's voice was kind, but he eyed the young man shrewdly. Where were the thieves who would beat a man so thoroughly that they would break his ribs and yet leave him possessed of a jewel worth the price of a good warhorse? Master Hardy shrugged. It was no shame to feed the hungry and clothe the naked, even if the hungry proved to be a knave or the naked a plausible rogue. He could always turn him out of doors in the morning.

Chapter Two

A STONE TOWER stood in the heart of Hartwick Forest: the remnant, perhaps, of an ancient border fortress. Though the western marches had long been peaceful, the tower was a fortress still, for it reared its massy walls against the forest itself. It stood in a wide clearing, and the trees that ringed it were gnarled and stunted and choked with blackthorn and brambles. Not so much as a blade of grass or a tuft of moss marred the barren soil between forest's edge and tower's foot, but to the tower's stones a dark ivy clung, shrouding its arched door and its slitted windows.

This tower was hard to find, and not only because it was built deep within Hartwick, which is the vastest wood in Albia. Stone and mortar though it was, it was curiously elusive, and the path that had led to it once might not pass near it a second time. Few men were foolhardy enough to search for it, but fewer yet could come to it, and so men said of that tower that it could move at will, or hide itself, or even that it was the ghost of a tower, not really there at all.

From time to time, by chance or fate, a man did push through those gnarled trees, cross that uncanny clearing, and put aside that musty ivy. When such a man entered the tower, he still might think it a ghostly abode, for the ground floor was a ruin of hacked furniture and charred hangings, crusty dark stains and tumbled bones. Spiders had festooned the walls with swags of webbing, and a family of foxes nested in the hearth. Surely, no human could have dwelt here since before the days of John the Mage, a hundred years gone.

However, when that man mounted the crumbling stone

steps to the first floor, he would find a room, painfully clean and bare, which was clearly in present service as both bed-chamber and kitchen. Above that, mystery: a chamber tightly shuttered and empty but for certain odd drafts and whispering voices murmuring of grief and torment beyond human under-standing. Fleeing upwards from these sibilant horrors, he would reach an airy solar, the tower's topmost chamber.

If the man then looked about him—panting maybe, and wiping cold sweat from his eyes—he would see a scholar's cell, lined with books and scrolls, furnished with two long tables set with crucibles, alembics, globes, and vials, and lecterns bearing heavy, secretive books. By the hearth he would see hanging a brazen horn, twisted and shining as a snake; above the hearth, a tapestry depicting a unicorn torn by leering demons. Under his feet would be a stone floor, inno-cent of rushes and polished to a steely sheen. In the center of the chamber would stand a tall carved chair like a throne, with a thing like a tapestry frame set by it, child-high and veiled in iridescent silk. Winter or summer, the air would smell of snow.

Such a man came to the clearing on the last day of Octo-ber, All Hallow's Eve, led by a singing breeze. Drawn on by curiosity and enchantment, he brushed aside the clinging ivy, cursed at the foxes and the spiders, stumbled on the uneven edges of the stairs, passed through the monkish bedchamber, slunk nervously through the whispers of the empty room. He was a wolf's-head, the chief of a band of brigands. He had robbed, murdered, and raped at will, laughing at damnation and the hangman's noose. Yet as the outlaw stood on the polished flags of the topmost chamber and gazed on the woman who had sent her invisible minions to bring him hither, he sweated with fear.

Margaret, Sorceress of the Stone Tower, sat at her ease in the high carved chair. A vixen fox, flame-haired and onyx-eyed, lay on a green velvet cushion by her feet. The brigand licked dry lips and stared. By all accounts he knew, this same sorceress had filled the tower with haunted winds ever since the death of her master, nigh on thirty years ago. Now, Magister Lentus had been a bogey of the outlaw's childhood, and by that reckoning, the Sorceress Margaret must be forty years old, or even fifty, an old woman indeed. The woman in

the chair looked no older than five-and-twenty: her face was finely drawn and pointed at the chin; her skin was unwrinkled and white as new cream against the red-gold glory of her unbound hair. She sat straight and still, her arms laid along the arms of her chair, and only by the slow rise and fall of her bosom could the outlaw be sure that she was indeed a living woman and not a marble counterfeit.

Unblinking she stared until the brigand began to wonder whether he should step forward uninvited or turn while he could and flee.

"Approach." The sudden command made him start and totter back a step. A stiff breeze sprang up, forced him forward. As he drew near the chair, the vixen unwound herself from the cushion and sniffed disdainfully at his miry boots.

The Sorceress' lips thinned with disgust. "Stand further back; thy garments stink of carrion." Gratefully, he retreated. She eyed him measuringly while he sweated and wondered what she wanted of him. "I have a task for thee, well suited to thy skills," she said at length. "Dost know a knight's manor, north and east of here, just within the wood's edge?"

The brigand nodded, cleared phlegm from his throat. "Hartwick Manor? Aye, Lady, that I do."

"I would have thee take thy band thither at night—not tomorrow nor three nights hence, but this night, All Hallow's Eve. Your task is to slay every soul within its walls, from the lowliest spit-boy to the knight and his infant son. In fee, take the knight's plate and his linen and his coffered gold. Sport with his maid-servants as ye must, but mark thou well that no man of thy band harm his lady wife."

The brigand scratched his verminous head, puzzled by this capricious mercy. "Why spare even one might tell tales after? Slit one, slit all, I always says, and leave t' place nice and quiet." Evilly he grinned at her, baring scraggled, brownish teeth, but Margaret only stared at him from eyes hard as moonstone until his grin drooped and he began to tremble.

"You will do the lady no harm," she repeated coldly. "You will not slay her, you will not cut or bruise her, you will not so much as touch the least thread of her hair. Go now, and return here to me when every man in Hartwick Manor is dead."

Then Margaret turned her face from the outlaw as if she could no longer bear to look upon him, and, attended by the sourceless breeze, he slunk down the tower steps and disappeared into the dusky wood to gather and instruct his pack.

That afternoon and evening, Margaret busied herself with books and crucibles, concocting a sleepy spell. A little after sunset, she released it upon a wet and thundery wind. Demon after demon she called from the chamber of whispers and sent winging from the tower windows, and soon an enchanted tempest howled through the clearing, bringing rain to patter on the ivy.

For two hours and more, Margaret stood and watched as her joyous demon winds flayed the heavens. It had been long since she had last unleashed a storm as wild as this. She had grown too inward of late, she thought, too occupied with potions and scryings and crabbed spells.

Lightning spat fire across the trees of Hartwick and Margaret laughed for joy. This was power, to summon the devils of Hell and, driving them in the harness of her will, hold chaos in her hands. She had planned the storm as a display and a mask, a cover for the brigands' entry and a show of her strength. Now she saw that it served her in other, more privy ways as well. Its wildness, she thought, was an emblem of her magic, her sorcery that had the power to free her from the chains of fear. She had made a storm when her enemy first troubled her; now she made another. Rage at the beginning and triumph at the end: two tempests like windy hands cupped around an insect, and her enemy caught between them, as industrious, as ignorant, as poisonous as a bee.

By midnight, Margaret judged the outlaws had arrived at the manor. She closed the shutters, lit a branch of candles, and placed it where the light would fall full upon the veiled form that stood close by her chair. The vixen leapt up, put her black forepaws on the carved arm, and nosed at the iridescent veil.

Margaret laughed and stroked her. "Softly, softly, little one," she said. "Thou shalt see the play unfold as soon as I." Lifting the vixen in her arms, she sat and cast aside the veil.

Water-silk folds pooled at the foot of a long oval mirror that blazed like fire in the dark room. Margaret leaned close,

but the mirror's polished surface returned nothing to her scrutiny—neither candles nor vixen nor her own sharp, fair countenance—but seemed to open onto a glimmering void. Then Margaret passed her hand over it, and from its depths the mirror cast up visions, clear and silent and gorgeously tinted, like illuminations in a Book of Hours.

The first image was a nocturne: a small stone manor set in a forest, its oaken doors shuddering under the blows of a crude ram.

A blink, a golden glimmer, and the scene shifted to the manor's great hall. A pack of wolvish men stood just within the gaping, splintered doors and pointed to the firepit where a dozen men-at-arms sprawled unmoving.

The outlaws hewed the men-at-arms as they slept, then padded through the manor in search of other prey. In obedience to Margaret's will, the mirror flickered from hall to kitchen to stables to solar, sketching rape, robbery, and murder. The vixen whined as they watched the carnage, and Margaret primmed her lips. Fiends of Hell though they were, her winds were not as crude as these human weapons. But, like a villein who fights with harrow-blade or hoe because a sword is denied him, Margaret could not well complain if her armament were crude and unhandy.

Finally, the mirror turned its brazen eye upon the knight's bedchamber. The shutters being closed and barred upon the storm, the room was dark as a tomb. But Margaret's sorcerous sight could count the stitches in the bed-curtains and the slow breaths of the knight and his lady and their little son cuddled between them in the great bed. A maid-servant, curled on a pallet by the hearth, twitched like a dog in her dreams.

The door flew open and the darkness broke into shards of light and shadow. Six thieves, flushed with wine and bloodshed, entered the chamber, their faces demonic in the torches' glare. They made quick work of the maid-servant, then turned their attention to the three upon the bed. Laughing, they cut the knight's throat. His blood poured over his lady's yellow hair and dabbled the face of his little son. The child awoke, and his rosy mouth gaped in a terrified howl. Margaret smiled.

Roused from her enchanted sleep by her son's screaming, the lady blindly gathered him into her arms and sought to

comfort him against her breast. When he would not be soothed, she opened her eyes, and then did her gaze fall upon the blood that dyed her white bed-linen crimson. Eyes stretched as though to equal the horror of what they witnessed, she stared from the second mouth gaping in her husband's throat to the ring of wolvish men. Margaret saw her gasp—a small, sudden swelling of her ribs—and then the lady tightened her arms around her child and glared defiance at her husband's murderers.

One of them, their leader, flicked the shining fall of her hair away from the boy with the tip of his sword. Then he bared his teeth in a grimace of resolution or distaste and pierced the child's body through.

The lady flinched and stared wild-eyed at the outlaw and the sword, flinched again when he withdrew it. Swiftly, she laid her son across her knees and looked unbelieving on the wound in his back. She pressed her hands against it to staunch the flow of blood, but it welled out between her fingers, thick and red and very bright.

Her movements bared her breasts, and the eyes of the outlaws narrowed with lust. One reached out to fondle her arm; another ran a strand of her golden hair through his rough fingers. The chief himself laid the point of his sword under her jaw and forced her to raise her head. He put his hand to her breast, smiled, tightened his fingers in her flesh. Margaret, watching, dug her nails into her palms and drew back her lips in a soundless snarl.

How dared this animal disobey her, who held his very soul at her mercy? Margaret whistled—a complex, minor phrase. A cold draught coiled around her ankles, up the mirror's stand, and into the image reflected there. The chief shivered, removed his hand, wiped it down his leather tunic, dropped his sword; wild-eyed, the thieves broke their eager circle and scrambled from the chamber. In his panic, their chief abandoned his sword where it lay. Margaret released her breath on a long and trembling sigh. It was done.

The last scene of all was richly painted in tints of scarlet, gold, and white, as still and formal as a missal page. Alone in her desecrated bower, the knight's lady bent over her marriage bed. Her white body was half-clothed in blood and her long pale hair was netted with it. On the bed lay her

husband—an ugly, spade-faced man of middle age—and her son. Both were yellow-haired; both were dead.

The scene held for a moment. Then, abruptly, the mirror darkened. Her heart racing, Margaret leaned forward and passed her hand over its blind surface. She murmured spells and stared into the golden void until her eyes ached, but for all her efforts the mirror remained stubbornly blank.

Early next morning the outlaw returned with a black-browed lieutenant slinking at his heels. Together they stood before Margaret's carved chair, snuffling and twisting their hoods in their hands. The chief made his report with his eyes fixed firmly on his boots.

When he was done, Margaret asked him, "And you made sure the whole household was dead?"

"Aye," said he. "We slit every throat we found, milady, just as you commanded."

"The knight's, too, and the infant's?"

The outlaw grimaced. "Aye," he muttered. "The babby's dead enough, never fret."

"And you did no scathe to the lady?"

"Nay, milady. We didna touch so much as a lock of her hair." He raised his eyes to Margaret's and held her cold gaze steadily. "Not one hair," he repeated; but his feet shifted uneasily on the stone floor.

The vixen pricked her ears and coughed. Margaret stroked her, humming a phrase of music. The outlaw smiled, his belly unknotting. A small breeze stirred his greasy hair, coiled itself around his neck, tightened invisible coils. He gasped and scrabbled at his throat.

"That," said Margaret, low as a growl, "is for lusting after the lady when I had forbidden thee naught else." The breeze freshened; the outlaw's eyes began to bulge. "Fool! Didst think I could not see thee at thy play?"

Twitching, the outlaw slumped to the ground and his fellow dropped to his knees beside him and cowered. Margaret nursed her rage, held it warm and luxurious in her belly, feeding it upon the outlaws' fear. It blazed for a space, then, suddenly as a smothered flame, it died. An empty chill filled her; she looked with distaste upon the unclean vermin groveling on her polished floor.

"He is not quite dead," she said to the quivering lieutenant. "If you aid him, he will live to lead you still. Or you may slay him. In either case, remove yourself and him: the sight of the pair of you is an offense to my eyes."

Scrambling and sweating, the second thief lugged his captain to the door by his feet and bumped him ungently down the stone steps. A scented breeze swept neatly about the room, cleansing the stink of fear from the air. In the ruined chamber below, the vixen's kits chased the lieutenant from the tower with shrill barks, then returned to squabble noisily over the feast he had left them.

Margaret cast aside the mirror's veil and passed her hand over its burnished surface. The mirror shimmered, then filled itself to its very edges with the likeness of the knight's yellow-haired lady, dressed in inky mourning, with her hair hidden under a wimple and veil. Beside her stood a tall man. Flaxen hair curled below the hood covering his face from brow to chin, and in his hands he held a struggling, snarling vixen. A fire blossomed at the feet of the pair, and as the woman bowed her head, the man cast the vixen into the sun-bright flames.

With numb and trembling fingers, Margaret pulled the veil back over the mirror's face. After storm and spell and carnage, nothing had changed. Margaret began to pace across her polished floor, back and forth like an animal caged, gnawing at her nether lip and twisting her hands. How could every detail of the prophecy remain as she had first seen it, twenty years ago and more? She had been as sure as reason and magic could make her that the man in the black mask must be either the knight or his son. But their deaths had not struck out the image of her doom.

Why? All the provisions of magecraft and prophecy had been met: she herself had had no direct hand in the murder; the lady's blood had not been shed. Margaret halted. Ah, but it had been shed, a crimson trickle following the tip of the outlaw chief's sword as he forced the lady's eyes to his.

"May succubi shrivel their manhood, and their lecherous souls burn in torment forever." The vixen, which had been trotting back and forth behind her as she paced, barked in agreement. For a moment Margaret pondered a fit punishment, then strode to the hearth, took the brazen horn from its

hook, and sounded upon it three clear notes. A light wind
whisked up the steps from the chamber below and wound
around her like a cat, purring a little as it stirred her hair and
skirts.

"Go thou," she whispered to it. "Take hold of their
weapons and turn the edges against their own throats. When
all are slain, leave their noxious bodies for the vermin to feast
upon. Their souls thou mayst sport withal." Then she re-
leased it, and with a joyful whistle, the wind swept out
through a lancet and was gone.

For the rest of that day and well into the next, Margaret
methodically pulled books and scrolls from the high shelves,
carried each to a lectern and read what it had to say concern-
ing prophecies—their making, their breaking, their casting,
their reading. She read Brevius on the secrets revealed by the
pancreas of a virgin ewe, and Lapsarius on the curious rite by
which Voltar sought to avoid the death foretold for him, that
he would be killed by an unborn child. As she came to the
end of each book and scroll, she clasped it up or rolled it
neatly and put it back in its proper place so that no sign of
desperation might disturb the order of her rite.

Like calling a demon, laying a prophecy is a matter of
ritual, a series of actions planned out and followed in their
right and proper sequence. Or so Margaret reasoned. A nov-
ice is able to study various oft-tried rites by which a demon
may be called and mastered. But there are no accepted texts,
no tested rubrics for the breaking of prophecies. Thus Marga-
ret had developed her own ritual of study and experimenta-
tion, hoping by patience and logic to succeed where Brevius
and Voltar had failed.

When Margaret had once again taken careful note of all the
scryings and foretellings known to the hieromants, stichomants,
lithomants, catoptromants, and pyromants represented in her
library, one by one she tried them. She chose passages at
random from an alchemical text she had read but once before.
"Stynche is a vapour," she read, "a resolued fumosite/ Of
thingis which of eville complexion be." And, "Dedd clay is
callide such a thynge/ As had soeffrede grete Roostynge."

She tossed a handful of polished stones across a small ring
of chalk inscribed on the floor and read the riddling message

spelled by the pebbles within the circle. Chalcedony and bloodstone, sapphire and onyx: spiritual blindness, passion and storm, power over spirits, fearful dreams, death. She turned over a deck of irredeemably greasy cards; Death and the Falling Tower leered up at her from the center of the sort. At the last, she had her winds bring her a virgin ewe which she butchered in the ruined chamber, frowning fastidiously as she ripped the pancreas free of the still-twitching body. The prophetic organ turned from pink to grey in her hands, and the pattern of the veins across its spongy surface was like leaping flame.

Margaret sighed and pushed the ewe's carcass closer to the hearth for the kits. Well, if the signs were no better than they had been before All Hallow's Eve, then they were no worse, and she could take some comfort from that. Margaret sighed again, a deep breath like the beginning of a sob, and the vixen left her children to sit by her mistress and nose her blood-slimed arm.

"Yes, I reek of blood, little one," said Margaret. "And of sweat and fear and anger." Rising, she went to the tower door, pushed aside the ivy and looked out over her domain. The rain, which she had called up three days before and had forgotten to dismiss, fell steadily, and the barren clearing was now a sea of gelatinous mud that heaved as if some demon slept uneasily beneath.

"Some of this great excess of rain will yield me water to bathe in. I will call in the storm, cleanse myself, then sleep." She frowned and rubbed her sand-heavy eyes. "Perhaps onei-romancy will tell me what the other scryings would not."

When at last she had called her windy demons home from their three-day play and scrubbed the blood from her skin and garments, Margaret's first sleep of exhaustion was too deep for dreaming. But just before dawn, she woke sweating and trembling from a dream of a golden forest glade with a Hart at the center of it, white as milk against the gold. He tossed his branching antlers and caught between them a ruby sun that swelled and flared and burned her eyes.

Chapter Three

IN THE GREY November dawn, Master Hardy heaved aside his coverlet as if it were woven of stone and crawled reluctantly from his bed. His eyes were heavy, and as he tied the points of his hose, he gaped sleepily. The mystery of the kitchen-boy's jewel had kept him wakeful and wondering late into the night.

Then there was the problem of how to employ him. His broken ribs would keep him from turning the spit or stoking the fire, and something within Master Hardy balked at the picture of William plucking fowl or drawing piglets. There was an easy solution to both mystery and quandary, and that was to send the knave packing without further ado. However, when Master Hardy came yawning into the kitchen at cock-crow, he found William there before him, deftly crimping the top of a pie before an admiring audience of scullions. Amused, Master Hardy held his tongue and let the young man find his own work.

By day's end, when William had shown himself to be a most excellent cook, neat-handed and wise in the ways of spices and alayers, Master Hardy had decided to mind his own business. If some pretty lordling wanted to be-grease his white hands in the King's kitchen, said Master Hardy to himself, he was welcome to his game, as long as he worked hard at playing it. Next day, when he took the accounts to Sir Andrew Melton, the King's Steward, Master Hardy asked that the name ''William Flower'' be added to the household register as undercook.

Sir Andrew peered at the Master Cook through wine-bleared

eyes. "Enough undercooks," he said crossly. "More cooks
than nobles at court nowadays." Nonetheless, he scrawled
"Wm. Flr.—uncoke" on the edge of the day's inventory of
wheat and barley flour where the King's Chamberlain, Lord
Roylance, saw it next morning.

"Some crochet of Master Hardy's," Sir Andrew told him.
"Says the man's a wonder with pastry. Made him undercook
without a by-your-leave."

Lord Roylance, who'd been Chamberlain for upwards of
two score years, muttered toothlessly over the expense, rooted
through the hummocks of parchment on his desk, unearthed
the Household Register, and made an entry in his crabbed,
spidery hand: "Wm. Floure, ūder-cooke: xl s *p.a.*" And so
William Flower became a cook in the King's kitchen.

The staff of the royal kitchen was as motley a crew as one
could hope to find under one roof this side of Judgment Day.
At one extreme was the scullion Ned, who was the fatherless
offspring of Mistress Rudyard, the King's Laundress. At the
other was Master Peter Rawlings, the Saucier, who was the
youngest legitimate son of Alfred Rawlings, the Earl of
Brackton. Between these were ranged freemen, noble bas-
tards, younger sons, adventurers, and city riff-raff, all stuffed
higgledy-piggledy in the kitchen like eels in a pie.

Besides a healthy fear of the Master Cook's temper, the
one thing shared by these assorted knaves and gentlemen was
a thorough knowledge of one another's personal histories.
Long hours in sweaty contiguity, laboring at the same tasks,
heated by the same fires, made brothers of gentle and simple
as the Archbishop's most eloquent sermons could not.

This brotherhood, however, was founded not on Christian
love, but on a contemptuous familiarity. All the world knew
that Richard Talbot would not return to his native village for
fear of his shrewish wife, and that the old King's seneschal
was thought to have begot Hal Clemin upon Hugh Clemin's
wife. They could tell the names of Peter Rawlings' by-blows
and whether their mothers lived in the hall or in Cyngesbury
town. But even after the new undercook had been amongst
them six weeks or more, no man or boy could say that he
knew so much as the county that had seen the birth of
William Flower, much less the name of his father or the
quality of his estate.

"A fine, mysterious gentleman, indeed," complained Peter Rawlings to whomever would listen. "Bah! Mark my words, he'll run off within the fortnight, and take the plate with him. That, or he's a weaselly, grasping knave who'll be wanting to teach Master Hardy a better way to make almond milk before the year's half spent."

Master Rawlings proved to be a poor prophet. Unlike the other prentice cooks, who gossiped and disported themselves in season and out, Master Flower was a quiet man who stirred his own pot and was not minded to put his spoon into his neighbor's. When questioned about his origins, he smiled and shook his head; when offered a bowl of ale or a place at a game of dice, he politely declined. His personal habits were as shamefast as a monk's, and he never spent a farthing-piece of his wages in the taverns or brothels of Cyngesbury.

But although William Flower was both cleanly and well living, he was not well liked. Dick Talbot called him a Jack-down-at-mouth, a kill-joy who took pleasure in dampening other men's spirits. Hugh Tusser, the Baker, dismissed him as being proud and cold, a regular king-pike who fancied himself more suited to the company in the hall than to the company in the kitchen. Hal Clemin thought him a hole-and-corner losel who affected mystery.

Throughout that winter, Ned was William's only supporter. He wheedled a second blanket from his mother, Mistress Rudyard, and a length of clean linen to make a new bandage for his ribs. He brought William whatever spices, meats, flour, or fats he might require. He defended him against every charge of coldness, and knocked over any boy who laughed at his modesty. In fine, Ned appointed himself William's champion and personal scullion, and in return, William began to initiate him into the finer mysteries of cookery.

This was a reward that had its pains as well as its pleasures. When Master Hardy caught Ned at some task unsuited to a kitchen knave—straining a syllabub, perhaps, or mixing an alayer—he would box his ears and boot him off to scrape vegetables or pluck a fowl. These blows Ned bore lightly: it was natural for the Master Cook to beat him from time to time, if only to shake the dust from his jerkin. Far harder to bear were the jeers of his erstwhile comrades. "Lickspittle," they called him, envying the knowledge Master Flower taught

him, and "Ganymede," and "flower-boy," which made Ned
flush and swear and bloody their noses. For "Ganymede"
and "flower-boy" were the names given the pretty boy whores
kept by Master Giles Ling at the sign of the 'Country Lad.'

"He be gentle and fine," Ned shouted at the turnspit who
had begun the jape. "He do speak me fair, like I were a
gentleman born, and he learneth me cookery. If that maketh
him a Sodderite, then I'll sell meself to the 'Country Lad,'
and bide there happier than ever I were here, Jack Priddy."

Despite, or perhaps because of, Ned's most heroic efforts,
the scullions and turnspits continued to giggle and whisper in
corners, and soon all the cooks, undercooks, and prentices
came to share their opinion. Master Hardy heard this gossip,
just as he heard the squeaking of rats fighting in the larder,
but he paid it as little heed. He himself did not like William,
but he had no reason to think ill of him: for all that he was
thin as a rake, the man was a good cook, and much can be
forgiven one who can turn his hand to sauces as well as fancy
pastes. Not until February, near the Feast of St. Matthias, did
Master Hardy accept a truth his kitchen had looked upon as
self-evident since December.

It was past nones, the lax hour between the noon and the
evening meal. The kitchen was quiet. A sucking pig turned
idly on one spit and four prentices were gathered around the
hob, tending the sauces. Master Hardy, who was keeping his
eye on the baking of a delicate *pyke en doucette*, sat by the
smallest of the ovens. At a long table, William constructed a
wonderful *entremets* for the night's feast—a griffin made by
sewing a large cockerel to a lamb's body. The beast was
already stuffed and cooked, and now he was refeathering the
cockerel. Ned stood by to hand him the feathers, one by one.

To this scene of masculine tranquillity entered Bess, the
fairest of the laundry-maids. She stood in the arched door and
announced in her high, clear voice that Mistress Rudyard had
run short of dried lavender for the royal sheets: could Master
Hardy open the store-room and give her a bunch? The King's
Cook quite forgot his pastry and the prentices let the sauces
scorch, for Bess—eighteen, black-eyed, and plump as a doe
rabbit—was a sight to rouse any proper man's blood. The
heat of the laundry had crisped her dark hair to frame her face
with damp black curls. The strings of her smock were untied

to reveal her round white throat and her sleeves were rolled high above her dimpled elbows. When she was satisfied that every eye was fixed on her, Bess tripped across the kitchen to Master Hardy's side.

One pair of eyes, the handsomest there, had not done her homage. As Bess passed William, she halted and sent him a berry-sweet glance across the narrow wooden table. "God gi'ye good-day, Sir," she said.

William, engrossed in sticking a feather to his griffin with warm fat, returned neither glance nor greeting. Bess frowned, then flounced around the table to examine his handiwork. When she reached William's side, she stumbled artfully so that William was forced to catch her lest she bring his griffin, feathers and all, down onto the flagstones with her. The prentices sighed enviously.

"Your pardon, Master Flower," she said breathlessly, leaning her soft breast into his arm. "I know not how I come to be so clumsy."

William looked down into her rosy face, and then at his *entremets*, which had been knocked awry. "Do not disturb yourself, Mistress," he said, his light voice clipping the courtesy icily. "The flags are damp and slippery underfoot." He pushed her upright, beckoned to Ned, and returned to his griffin, as insensible to Bess's heaving breasts and kindling cheeks as a tonsured monk.

Observing this by-play, Master Hardy was troubled. " 'T'ain't natural," said he to himself. Here was a lad who was palpably of gentle birth, cast out and begging for employment even though he could cook near as well as Master Hardy himself; a young, pretty lad, who wore about his neck a lover's ring and the jeweled image of an older gentleman; a lad who repulsed the advances of the most bed-worthy wench in the royal laundry. It would seem that the kitchen rats had been squeaking to some purpose.

His reverie was broken by Bess, her voice quivering on the edge of tears. "The lavender, Master Hardy. If it please ye."

The King's Cook shut his mouth that had been ajar with speculations, rose, and led her to the storeroom. As they walked, he smiled down at her warmly and squeezed her plump arm, but her face remained so clouded that Master Hardy was moved to give her a kiss or two with her lavender.

But truth to tell, even as he kissed away her pouts, Master Hardy's mind ran more on William's cold blood than on Bess's warm mouth.

Master Hardy released the wench, patted her absently upon her fundament, followed her into the hall, locked the storeroom. Noble bastards, he thought, frequently found their way into a lord's kitchen—look at Hal Clemin and Wat FitzHugh. If such a bastard were quick and clever, he might rise through the ranks of the household to carve fowl or to serve meat at his lord's table, where, if he were pretty enough, he might catch the eye of some noble gentleman, who might give him such a jewel and such a ring. Under certain circumstances.

Being a God-fearing man, Master Hardy's first impulse was to take young Flower, thrash him soundly, and thrust him out of doors, as his former master had undoubtedly done. Then Master Hardy remembered the excellence of William's stuffing for roast swan and the way William could dress a leg of salt mutton so that the keenest palate might not tell it from venison.

As he entered the kitchen, Master Hardy reminded himself that the lad bore himself modestly enough, although a man might wonder at his interest in that scrubby scullion—Ned, was it? Well, he was not one to condemn a man for past sins, and it ill became a Christian man to be lacking in charity to a repentant sinner. For charity's sake, Master Hardy concluded, he would keep the boy. But he must tell him that he had winkled out his secret.

Accordingly, late one evening when the cook-fires were banked and the scullions curled snoring under the tables, Master Hardy drew William Flower into the stillery and sat him down upon a three-legged stool. Twice he opened his mouth to embark upon his prepared speech, and twice, overcome with embarrassment, he shut it again and paced to and fro, his head brushing the herbs that hung from the rafters. At length, William asking him courteously what he wanted of him, Master Hardy took heart of grace.

"I feel obliged to say that I know thy secret," he began, and was pleased to observe William start and turn pale. "Look ye, I'm no priest to judge of a man's sins, so I will not betray thee, however little I may understand thy . . . unnatural desires."

Here William stared, then slowly flushed deep scarlet, distress and shame so evident in his beardless face that Master Hardy fairly pitied him. Yet for his soul's sake, the thing must be said, and strongly, lest the lad mistake charity for complicity. "But I will not stand for any unholy goings-on in my kitchen. Thou mayst stay and welcome—thou'rt a good enough cook, and I'd be sorry to lose thy *galentine*. But let me hear no complaints from the pages or the scullions. And see thou keep young Ned more at arm's length."

During the latter part of this speech, William bowed his head humbly and trembled as though he struggled with tears. Encouraged, Master Hardy went on to express the pious hope that William would come, in time, to a more Godly way of life. In a strangled voice, William assured him that he would think well on it, and swore by his hope of salvation that he would give his master no cause to regret his kindness.

"You need have no fear that Ned will take harm of me, sir," he said unsteadily. "I look on him as on a young brother who shapes well to be a cook. I thought but to encourage his natural leaning towards the art."

"Well, keep him as thy prentice, then, lad, but 'ware how he comes to dote on thee. Thou knowest how tongues clack in the kitchen."

William smiled ruefully and nodded. Relieved that the interview had concluded so painlessly, Master Hardy smiled upon him in return, clapped him on the shoulder, and dismissed him, well pleased with himself and with his evening's work.

Chapter Four

AS WINTER DREW in, withered ivy tapped pleadingly at the shutters of Margaret's high tower while sentinel winds whined and sighed at the corners. She ate but little, and like her vixen, slept for days on end, wrapped in a deep winter's sleep. During her waking hours, she read, but more often she communed with the mirror. It served her as teacher and companion and tool and window on a wider world. It allowed her to spy on the rituals of foreign sorcerers and necromants to learn secrets they would never willingly have taught her. It helped her harrow the pits of Hell and pry after the hidden names of demons and study the measures of the celestial dance.

Such scryings and readings made up a round of study and sleep that had taken on the force of ritual. For nigh on thirty years she had thus renewed her strength and refined her knowledge, and had therefore come to love this chill and quiet season as the heart of the year. How great then was her distress when the mirror would not show Margaret what she most wished to see: where the knight's lady had gone after All Hallow's Eve.

Whenever Margaret sought her enemy, the mirror flared bright with the prophecy, and by no exercise of will or spellcraft was she able to banish the image from its surface. At such times, she could only replace the veil, wait for the vision to fade of itself, and resolve to banish the lady and her fate from her mind. But time and again curiosity compelled Margaret to seek her out, and time and again fascination compelled her to watch the image of her own fiery death.

At length there came a time when she could no longer even be sure of the mirror's partial obedience. Sometimes it remained stubbornly blank, barring the pits of Hell to her or the studies of her unconscious tutors. Sometimes it traded one image for another, giving her a fleering demon in place of the winter stars. More and more erratic grew the visions until, by Christmastide, the mirror was answering Margaret's commands only with scenes of its own choosing, scenes of a great castle and an herb garden, scenes she did not understand.

One snowy night, Margaret sat before the mirror and pondered. Perhaps she had been straining her magic. If the shedding of her enemy's blood had wounded it, weakened it, perhaps it needed time to heal and regain its strength again. Very well, she'd return to simple things, the simplest she could think of, and by little and little, work up to the greater again. Fingering the shimmering stuff of the mirror's veil, Margaret cast her mind back to her apprenticeship and her first tottering steps into the mirror's world.

She remembered a farmstead, a prosperous freehold, which was the first clear vision the mirror had given her. The farmwife had been a comely woman, round-faced and rosy, her hair sloe-black and her eyes as grey as glass. She moved from kitchen to garden to dairy to stillery, filling her days with orderly toil and her shelves with cheeses and dried herbs and flagons filled with the essence of flower, leaf, and root. There was a brisk and friendly air about her, and her smile was like sun on still water. Margaret had practiced small afflictions on her of lumpy butter and smoking chimneys and maids who dozed over the churning, but had nonetheless felt for her a kind of envious affection. She had entrusted her with—No. She would not think on that. If the mirror would obey no other command, Margaret thought, surely it would obey this, if only of old habit.

She unveiled the mirror, passed her hand firmly over its surface. For a time it shimmered blankly, then the brazen mist resolved into the sullen flicker of a fire in a round stone hearth. Ah.

The hearth was unswept and cluttered with clay pots fouled with old porridge. Margaret knitted her brows—this was not the farm she thought she remembered. Her farmwife was a

tidy soul, who would never let pots sit on the fire uncleaned or suffer old coals and ashes to smutch the hearth. Could so much have changed? Curiously, Margaret watched as the scene broadened. A small, faded woman crouched on a three-legged stool by the fireside, mending a torn smock with coarse thread. She was at once delicate and gross, with hollow, bony shoulders hunched over a belly swollen with pregnancy. A tangle of dogs and smudge-faced children tumbled and snapped at her feet.

Crying out in anger, Margaret covered her face. Of all the scenes of horror or omen the mirror might show her, it had chosen what she could least bear to witness. Little able to pity or understand her mother's eternal weariness when she was a girl, Margaret found she was less able now. She reached for the veil, began to cast it over her mother's face, then lowered it slowly and watched her mother setting great, uneven stitches in the dirty smock.

Why, she wondered, could the woman not have bestirred herself a little? Poverty may force a woman to feed her family on a handful of dried pease and bran, but it does not of itself cause the porridge to burn or the bread to bake unevenly. A blacksmith's wife is not a tinker's drab or a beggar woman, with never a dollop of soap to cleanse her smock nor a handful of sand to scour her hearthstone. Yet day after day, Margaret's mother had crouched by her reeking fire and bewailed her fate.

Margaret could almost hear the thin whine in which her mother recounted the querulous tale of her thick-crowding woes. Her husband ill-used her, her children would not mind her, the smithy was set on the poorest land in the parish, and how was she to tend the cow and the chickens and the garden and cot with six children marring all she mended, and her only daughter a willful quean who scorned to dirty her hands?

Two score years and death divided them; but her mother's shadow looked up from her sewing as though she sensed her daughter's presence. Her eyes met Margaret's and she shrank back, smiling pitifully. She reached out her hand, then started and looked fearfully towards the smithy door. The dogs and the children slunk away into the corners. A wide, sooty hand appeared around the ill-tanned hide and began to pull it aside.

In a convulsive haste, Margaret cast the veil over the

mirror to blind it. No misplaced sentiment, no lingering
sympathy could entice her to look willingly on her father's
face. He had been filthy of body and soul, a sink of foul
lusts, over-handy with fists and stick: she would not sully her
eyes with the sight of him.

Weeks passed before Margaret could bring herself to look
in the mirror again. She read and slept and needlessly dusted
the long rows of books in her upper room until finally bore-
dom drove her to light the branch of candles and once again
draw aside the watery veil. No gradual healing, she thought;
the wound must be forced shut. She was a sorceress, and the
mirror her tool. She would use it to enter the cell of a sorcerer
who dwelt in the mountains on the northern border of Irridia,
far across the sea. He bound his demons into the shape of
flames; his familiar was a salamander.

The golden haze shivered and cleared, and for a moment,
Margaret, triumphant, glimpsed the fire-master's sharp nose
and badger-bearded cheeks. Then, like oil spreading as it
pools, a second countenance overspread the first: Magister
Lentus, the Sorcerer of the Tower, the great master of shad-
ows who had promised to teach Margaret the art of sorcery.

Lovingly, the mirror painted Lentus' maggoty fingers and
grub-white nose, his cheeks round, pocked and rubicund, his
eyes glazy and flat as a dead fish's. The scene broadened, and
she saw Lentus standing before her father's smithy, coolly
fronting the lusty, red-headed smith. Her father's face was
distorted, his mouth working as he cursed. He overtopped the
little Sorcerer by a head, but Lentus clearly set no more store
by his ranting than by a cur's barking, for his image smiled,
showing small, even teeth like a row of bleached peas. Beyond
the mirror, Margaret shrank back as though the Sorcerer,
nine-and-twenty years dead, could reach through time to take
her hand and pull her back to that dooryard where her father
shook his fists and raved.

The mirror's silence spared Margaret her father's curses,
but they echoed still in her mind. Unnatural daughter, he had
called her: serpent, vixen, whore. If she went away with this
demon-master, who would cook for him and her brothers?
Now that her mother was dead, the family would starve
without her.

At that Magister Lentus had laughed, a rich mellifluous

laugh like honey, and led her from the yard. He had fondled her arm as they walked and told her that he dwelt in the stone tower in Hartwick Wood. His shadows had reported to him her beauty, her quickness of mind and hand, her fine, masterful spirit that was in danger of being heedlessly broken by churls. He would make her a sorceress, a mistress of demons, and she need never again gather wool for her spinning from the common pasture or coax the last drop of milk from a half-starved cow. His shadows would obey her least wish, and she would soon learn to call her own servants up from Hell as winds, or flames, or whatever shape pleased her best.

Full well did Margaret recall weighing her disgust with his person against her desire for what he offered her; full well did she recall laying her hand in his and swearing to serve him truly. In the mirror, the image of Lentus nodded briskly, then caressed a scarlet crystal that nestled among his many chins. A sourceless shadow fell upon the bright meadow, and Lentus stepped through it into a stone chamber lined with books and parchment scrolls, the chamber in which Margaret now sat with her vixen asleep at her feet. The mirror went dark.

She swore she would not look again, but two days later she did look, and the next day and the next, although what she saw gave her no joy. The mirror, spinning out her history day by day, caught her in a web of memory as sticky-strong as the more tangible webs spun by the fat, white spiders that had been Lentus' familiars.

The web's first strand was the vision of her mother; the second was a vision of the ritual that had made her a sorceress, dried her tears, and bound her to Hell forever. Dwarfish within the mirror's frame, the image of Lentus scuttled busily from reflected table to chest to hearth, preparing a crucible with copper and tin and drops of Margaret's blood. She watched once more while he kindled a sorcerous blaze with hell-fire and fed it upon coiled locks of her fire-gold hair. Melted over this fire, the mixture bubbled, fused into an alloy that, being impure, was yet stronger far than ordinary bronze. He cast the alloy into a twisted horn and an oval mirror, and cooled them in a vat of water and Margaret's urine. He kneaded the fat of a hanged man with Margaret's sweat and instructed her to burnish both horn and mirror with this mixture until they shone again. While she rubbed, Lentus had

stroked his apprentice's flaming hair and swore by the foul
fiend Mahu to help her discover the secrets of both horn and
mirror, once she had sufficient knowledge to use them.

In the months that followed, Margaret had come to realize
that Lentus would see to it that her knowledge was never
sufficient. Day after winter's day, Margaret sat in her chair
that once was Lentus' chair in her tower that once was his
tower, and watched the reflection of her own long hands
compounding elixirs to her master's instructions and assisting
him at necromantic or sorcerous rituals. Once the mirror
displayed the simple grimoire from which she had learned to
read, and from which she had stolen some orts and fragments
of alchemy and wizardry to piece out the little sorcery Lentus
was willing to teach her. She recognized a charm for banish-
ing lice, which was the first she had tried unaided; also a
cantrip for making the toenails grow inward with which she
had often galled her master. And in another book, bound in
unclean leather and clasped with iron, she saw the warding
spell she had cast to keep her body safe from the worst
violence of Lentus' magic.

That spell had kept Lentus' demons from taking her body,
had protected her from the poisons and sulfurous fumes pro-
duced by his sorcerous fires, but it had had no power against
Lentus himself. Each night, and as the rituals might require
it, Lentus had lain down with his apprentice and used her as
his whore. Margaret covered her eyes against the sight of his
fat, white body splayed like a bloated spider across the mir-
ror's surface; her memory could not so easily be blinded.
That night, lying sleepless on her cot, Margaret thought she
felt the ghost of Lentus' weight once more upon her, thrusting
painfully towards his pleasure.

Had her mother not neglected her herb lore as she ne-
glected her housewifery, then Margaret might have warded
herself with a posset and a simple charm. As it was, her
womb quickened and swelled, and in the summer of her
seventeenth year, Margaret bore her master a child—a daugh-
ter like a golden rose.

In the mirror, Margaret watched Magister Lentus, aston-
ished by fatherhood, sit by the child's cradle and stare at the
beautiful thing he had begotten. His likeness curled its full
lips into fish-mouths to coo at the babe, and Margaret felt her

gorge rise. How could he dote on such a thing—a squalling atomy that stank of piss and stale milk? It had swelled her and torn her, bound and fettered her in chains of need. She would have liked to kill it. But the strongest prohibition of magic's higher arts is that its disciples may not harm their own issue. No mage, wizard, sorcerer, alchemist, necromant, or thaumaturge may cast the smallest spell to kill or maim or curse one of his own blood but it rebounds on him.

Unable to kill the child and unable to bear the sight of her, Margaret added her hatred for her daughter to the hatred she already bore her daughter's father. Lentus had promised her much and given her little: the mirror was no more use to her than a toy, a magic window through which she saw scenes she did not understand; the horn bound nothing she could see. He had used her body and imprisoned her, and that differed not one whit from what her hateful father had done. Some knowledge she had stolen of working and warding and some little sympathetic power over the demons Lentus had imprisoned as shadows. These might be enough to serve. There was no magical prohibition against slaying another sorcerer.

Margaret was not surprised when the mirror balked at showing her the death of Lentus, for she perceived it now as her torturer. Her curse upon the outlaws—that their own swords might turn against them and slay them—seemed to have fallen back upon her. But she held that night in her memory and told it over to her vixen like a spell against despair.

An evening in late August, heavy with the threat of thunder. The child was two months old, fat and lusty, obstinate to live and thrive. In the tower's upper chamber, Margaret, Lentus, and the babe were gathered in a parody of domestic tranquillity. Margaret had been trying to sew a tiny smock by candlelight; the Sorcerer rocked the cradle with his foot. It began to rain heavily, waking the babe, who began to howl, insistent as her sire and loud as her grandsire. Lentus stooped to quiet her.

Suddenly within Margaret a black rage kindled and flared like a sorcerous flame, consuming the last of her hesitations. With its roaring in her ears, Margaret rose, caught up a heavy pestle, and struck Lentus across the back of his balding head.

Shadows swirled around her as his demons, somewhat belatedly, sought to protect their master from her violence.

"I may touch the crystal," Margaret told them calmly. "Give him to me and I will free you. I swear by Fliberdigibbet, by Hoberdidance, and by Smolkin. I swear by my horn and my mirror. I swear by my damned soul." The shadows left Lentus and enfolded his apprentice in agitated waves of darkness.

Bright and unwavering among the flickering shades, Margaret endured while their insubstantial fingers probed her soul to prove her boast. Their intrusion was an agony more intimate than rape, but the pain annealed her purpose. When they were satisfied, the demons drew away from her. At her feet, Lentus lay half on top of the screaming baby, his scalp bleeding and his breath stertorous. Like a hawk, Margaret stooped and tore the scarlet crystal from his fat white throat. Gently, his demons bore their master down to his bed, where they half-smothered him under their smoky bodies to keep him from waking before Margaret dissolved the bond that held them.

In the tower room, Margaret felt an exaltation of rage that cast out all doubt, all fear from her mind. Alchemical books and instruments flew into her hands; all her choices and spells were true, precise. Deaf to the baby's wailing, she heated acid, blood, and mercury in a crucible—the very crucible that had cradled her horn and her mirror. When the mixture smoked and steamed, she dropped in the crystal, spoke the appropriate spells. Slowly, the scarlet jewel dulled and paled, then crumbled into a small heap of colorless dust that dissolved into the solution, leaving not the slightest tinge or precipitate behind.

A crescendo of screams from the ground floor told Margaret that Lentus had become aware of his talisman's unmaking. Their abrupt cessation told her that his demons had unmade him.

Once again, shadows boiled at Margaret's feet and around the cradle, dimming the candles to a sickly glow. She thought she saw shapes of horns and claws and spiky wings, and among them a writhing white slug—Lentus' soul, perhaps. Then the candles burned clear again, and the only shadows

left in the tower were inanimate and without substance, mere absence of light.

Leaving the child screaming, Margaret descended to the lower chamber and considered what to do with Lentus' bloodless corse. She must burn it, of course: it would walk if she did not. She had not the strength to drag it from the tower, so she cast a spell of fire on the bed, and another to contain it there. She did not want the tower and its precious books to burn with their master.

When nothing was left of Lentus or the bed but charred wood, ashes, and a reek of burned feathers and meat, Margaret ascended to the upper room and seated herself in her master's chair. She felt exultant and powerful, a sorceress *in potentia* if not *de facto*.

The baby went on crying, an angry, miserable, interminable drone.

Margaret lifted her hands and called aloud upon the wind and rain. Rage crackled around her like lightning until she was drunk and laughing with the power of her anger. Outside the tower, rain turned to hail and the wind lifted and battered at the shuttered windows. As the storm grew wilder, Margaret's passion stilled. Kill the child? No need. There was a safer way to cheat Fortune and win for herself freedom from all the burdens Lentus had put upon her. Swiftly she carried the baby to her mirror, called up the farmstead and put her through, all with no more thought than a cuckoo laying its egg in the nest of a dove.

Chapter Five

IN THE YEARS when King Geoffrey and his fair consort Queen Constance reigned in Cyngesbury, all was well with Albia and those who lived within her pale. Not since the days of John the Holy had the country been so fat and prosperous. Even the most nervous of the earls and barons came not near the court, but sat contentedly within their desmesnes. Geoffrey was doing well enough without their help, they said. Let younger sons and court butterflies flutter in the halls of Cyngesbury Castle and hope for advancement—a landed man might tend to his business without fear of the country's going awry. And where the lords were happy, tenant-farmers prospered, serfs lived easy, and a freeholder was able to sow his corn and graze his kine in full confidence that his lands and living would not be overrun by war or overburdened by taxes. Such at least was the opinion of Thomas Martindale of Nagshead Farm, and all the world agreed that Thomas Martindale was a wise and knowing man.

Certainly Tom Martindale was a prosperous man, with five plows of land near the northeastern skirt of the great forest of Hartwick to call his own. He counted his prosperity in a snug farmhouse, stone-built and enduring, a water-mill, four maid-servants to milk his cows and make cheese, and five laboring-men. Bet Martindale, his wife, counted her prosperity in the herb lore that had earned her the name of witchwife and healer to the market town of Seave and its outlying farms. It was a grief to them both that there was no child to stand heir to Thomas' fields or Bet's stillery, but in the main, they were well content.

There were some in the village who said that ill luck dwelt under Hartwick's dark trees, that there were outlaws and worse than outlaws living in its mazy depths; but Bet did not credit their whispered tales of sorcerers and stone towers. How could there be a sorcerer living in the wood? All the world knew that a hundred years ago and more, John the Mage had cast a spell over Albia—a spell of warding. And its power was such that no sorcerer, necromant, alchemist, or warlock could bear to breathe Albia's clean air.

Even so, Tom swore that he had once met a hooded figure drifting under the eaves of the wood, attended by shadows, and if that weren't like a sorcerer, he didn't know what were. And one May, Bet herself began to have an uneasy sense of being watched in her daily round. She'd be making or mending, picking or grinding, and all at once her nape would bristle and she'd feel eyes upon her, curious and jealous. Finally she mentioned it to her husband.

"It be like a boggle come to live under the hearth," she said. "My thumbs're aprick with hot needles, and the kitchen fire do smoke so, I thought a martin had built a nest in't, but 'twere no such thing. And to cap all, the butter haven't turned this fortnight, let Molly churn never so long and hard."

Tom shrugged. He was a stubborn man, of whom it was said that he would not credit a report of a wolf's being vicious until it bit him. "If thou want'st the chimney cleaned, hast only to say," he said. "There be no call to natter of boggles and hants. And yon Molly's a gormless wench that'd nod over the dash and swear herself stone blind that she'd been churning from dawn to dusk."

"But I tell thee, Tom, I feel eyes upon me, watching whether I wake or sleep, until I'm fair mazed."

Tom glanced up from his porridge, his brows cocked between hope and derision. "Wife, wife. Art breeding?"

Twenty years of marriage had taught Bet that Tom warded his deepest yearnings with mockery, but still his words cut deep. She was forty years old, and no Sarah to bear healthy children in old age when she could not in youth. Childless they were and childless they would continue; Tom must learn to accept that truth. "Nay, Tom," she said angrily. " 'Tis not kind in thee to throw my barrenness in my face."

Tom flushed scarlet. " 'Tis not kind in thee to take offense when none were meant, wife. Nay, there's no pleasing thee."

Bet did not speak of her hauntings again, but they continued nonetheless, through summer and into harvest. It was a slow summer for growing, being colder and wetter than common, and not until late August did the barley stand golden in the fields, ready for Tom and his men to cut it and bind it into sheaves against the autumn rains.

It lacked three days to the Feast of St. Giles, and a blustery wind had been blowing damp for days. Then came a lull, heavy and obstinate, where the sky lay like a flagstone over the reapers' heads. Tom, smelling a thunderstorm, called his wife's women from the dairy, and maids, master, and men worked feverishly at binding and stacking until, just before sunset, the clouds burst. First the rain sluiced down the sky, and then hardened into hailstones that rattled around the laborers' ears and drove them all into the barn, where they spent the night watching hail pummel the straw into a sodden mat.

When the storm broke, Bet stood long at the stillery door, debating with herself whether she should comfort the reapers with meat and ale. But as full dark fell, the hailstones grew big as a baby's fist, the wind howled and gibbered madly to itself, and wild lightning crackled along the very rooftree: it were madness to venture abroad.

Bet thought she might soothe her conscience by compounding a syrup to physick the reapers against the ague. It was a simple decoction of daisy flowers and rampion, but distilling and skimming took longer by rushlight; when at length she crept into bed, Bet thought that weariness alone would let her sleep through thunder, wind, and pelting hail. Instead, weariness kept her wakeful, and wakefulness allowed the tumult to batter at her like an old sorrow. Bet tossed and sighed, and when she heard a great clatter in the kitchen below, she pulled the pillow over her head. If the rats were seeking shelter, on such a night as this she would not begrudge it them.

Then Bet Martindale heard a sound she had not thought ever to hear in this house: the thin, angry squall of a hungry infant.

She leaped out of the bed and, pausing only to pull a smock over her nakedness, tumbled down the steps barefoot. The copper of washing she had set to soak by the pantry door was overturned, but Bet waded through the aprons and shirts aswim on the puddled floor without noting them.

The banked fire cast a faint glow over the hearth-stone. A naked infant lay upon it, a girl-child who kicked her fat legs and screamed in an ecstasy of fury. In pity and wonder, Bet knelt beside her, and, trembling, smoothed the pale fuzz covering her round head. The babe quieted for a moment and opened wide slatey eyes. For a sucking child, her gaze was oddly steady, and it seemed to Bet that she looked directly into Bet's eyes and knew her. In a trice the moment was gone, and the babe had folded her face again and commenced to howl.

"O ba, my lamby-sweet," crooned Bet lovingly. "To be sure, thou'rt hungered and cold and wet as a frog. Hush, love. Thee mother'll tend thee." Laughing with a joy she had thought dead within her, Bet scooped the baby from the hearth, wrapped her in a soft woollen shawl, and quieted her with goat's milk and barley water.

When Tom came home at dawn, he walked into a kitchen awash with water and sodden linen. His wife, oblivious to the muddle, was sitting on the settle clad in nothing but her smock, cooing over a bundle in her lap, a bundle that squirmed and cooed again.

"What's yon?" asked Tom, and frowned unbelieving when Bet held the child out to him. "I'll have no church-porch foundling in my house," he shouted. "How cam'st thee by the brat?"

"Hush, Tom. Thou'lt affright her. Look. Is't not a pretty babe?"

Tom harrumphed. "Here's the kitchen at high tide and the fire near out, and thee gone daft over some drab's bastard. I be frozen, woman, and clemmed nigh to death. Is a chance-found brat more to thee than thee husband?"

So happy was Bet that she could find no anger in her. "Here, love," she said cheerfully. "Hold her whilst I mend the fire." And she dumped the little bundle into Tom's shrinking arms.

Harder men than Tom Martindale might have been wooed

and won by that foundling baby. She showed no fear of his scowling face, but chuckled up at him and clutched at his beard with her fat fists. By the time Bet had dished up a pottage of bread and warm milk, there was no question but that they would keep the babe and raise her as their own. Within the week, her birth was registered in the church at Seave. Father Mark balked a little at the implicit lie, but seeing Bet's glowing countenance, he let it stand, and in the name of Father, Son, and Holy Spirit, christened the found-ling Elinor Martindale. When the holy water touched her brow, small Elinor squalled as though she had been scalded, which her mother took for a good omen.

Not knowing exactly when she had been born, Bet chose the feast of St. Bartholomew as Elinor's saint's day, and Tom gave her a little wooden dog he had carved to mark the occasion. Three years later, he gave her a real pup from his bitch Sheba's last litter. The year that Elinor turned five, a quartan fever killed both Tom's sister and her husband. Tom and Bet took in their two little sons, Jack and Hal, who between them soon transformed Nagshead Farm into a house echoing with childish voices and cluttered with childish messes.

Elinor herself was a tidy child, and her dog Trey an *exemplum* of canine propriety. Sometimes Bet would come across the two of them in the garden, squatting behind a cabbage or a bush of sage, solemnly watching the progress of a lady-bird over a leaf. The two faces, one black and white, the other pink and red, would hover over the mite, breathing as gently as may be, while Elinor put one finger in the lady-bird's path, holding it perfectly still while the creature tickled over it. If she saw Bet watching her, however, she would flick the lady-bird onto the ground and run away laughing. She never liked her plays overlooked or questioned, and after she had bitten him once or twice, her cousin Jack learned not to follow her when she went out alone into the dooryard or the garden.

At six, Elinor knew the names of all the herbs in her mother's garden, and could be sent out to gather a handful of summer savory without fear of her returning with rosemary. More than most children, her nature was light and dark mingled. Send her into the garden to weed or set her to watch little Hal so that he might not eat nightshade or monkshood as

he played among the herbs, and Elinor could be steady as a girl twice her age. But only ask her spin a distaff of wool or sew a plain seam, and she would be sure to break the thread or pucker the stuff or prick her finger to the bone and throw the botched work from her with angry tears.

But many little maids cry at the sight of a spindle—an even thread comes hard to small fingers. More inexplicable was Elinor's love for Hartwick. She would creep off into the deeps of the wood, sometimes with Trey, more often alone, and hide for hours while Bet called for her in the fields. Tom always harrumphed and said the lass'd come to no harm, but Bet, thinking of outlaws and wolves, worried just the same. On one occasion, just in her eighth year, Elinor trailed home long after sunset filthy and scratched, with not a berry in her basket to show for her long absence. Tom shook her and demanded where she'd been stravaging off to, and what she'd meant by worriting her mother half-witless. Elinor said nothing, but set her lips.

"Wilt stand and smirk when thee father do ask thee fair where thou'st been?" Tom shouted.

Elinor only looked at him solemnly, her grey eyes shadowed with secrets, her bare, grubby feet folded one on top of the other. In a helpless fury, he beat her with a willow-switch until Bet stayed his hand in pity of her youth.

"She's sorry, Tom," cried Bet, cradling the child to her bosom. "She'll not fright us so again. Do give over."

But never a cry did Elinor utter while he was beating her, and Tom knew, if Bet did not, that she defied him still.

By the time Elinor was nine, she was helping Bet in the stillery, patiently grinding herbs into thick paste in a mortar. In vain would Hal, by then a sturdy boy of six, beg her to come into the barn and slide down the hay with him. In vain would Jack, who was eleven, challenge her to a game of toss. Elinor would not answer them, but only shook her head until her wheat-gold plait wagged across her back like Trey's plumy tail.

"Go, child," Bet would urge her. "All work and no play maketh Jill a dull wench."

"The hay do prickle," Elinor would answer, or: "Jack

ever measures my tosses short. I'd liefer poultice Daisy's hoof.''

It was at such times, when the girl was most dear, most her own, that Bet feared most for her. ''Every blessing has its price'' was an adage as old as Adam, and when she felt blessed, Bet always wondered when payment would be required of her. Old tales spoke of babes molded by childless couples out of clay and snow or woven from corn, babes that had been ensouled by the parents' longing. Sometimes Bet half-feared Elinor to be such a child, born of thunder and ice, who would lighten Bet's heart for a space and then depart as she had come.

Knowing that Tom would make a jest of it, Bet said nothing to him, but she did tell him that she thought of Elinor as a wondrous gift for which payment might yet be exacted.

''Seemeth us did pay full measure for 'un,'' said Tom sourly. ''Not two bushels of grain did I save from the hail, and the good barley straw all beaten to nowt. Nay, the wench be paid for, wife; we did buy 'un with thin beer and a lean winter.''

Since the night he had beaten her, Tom had been wary of his foster daughter. The wench was not his blood, as Jack and Hal were, and she was fey and strange and over-bold. When other men's daughters were content to keep to their dooryards and busy themselves in spinning and milking, Elinor was always darting hither and yon. One moment she'd be chasing the goat from among the cabbages, the next disappearing into the wood on the pretext of gathering acorns for Bet's old sow. As she grew older, Tom found himself thinking of Elinor as Bet's foundling who had cost him a barley crop, and not as his daughter at all.

If Elinor knew her father half-disliked her, she gave no outward sign. All her world was Trey and Bet, the fragrant stillery and the glades of Hartwick. With Bet she was quiet and obedient—except in the matters of sewing and spinning. But with Trey in the wood, she became a hoyden. She climbed trees to peep in nests, tore her gown on brambles, and muddied herself to the skin squatting by a stream to catch the little darting fish in her bare hands.

So Elinor grew from day to day and from year to year until,

in October of her fourteenth year, she came into Eve's inheritance and the possibility of witchly power.

As every man in Albia is born with the ability to plough or to tan leather, to sing and dance or to shape a spoon of wood, so every woman in Albia is born with the ability to gather the herbs of the field and, by drying, crushing, or decocting them, create potions and unguents powerful to heal or to harm. Some men are artists or fine craftsmen; some women are witches.

Once, it is said, the great wizards and mages were men and women both, and high-born ladies minded their herbals and spellbooks as now they mind their embroidery frames and their lutes. But little by little, magic became the province of a few learned men, and witchery dwindled into a thing of the country, the province of farmwives. Few mothers in this time of Albia's prosperity bothered to make for their daughters a proper ceremony of Measuring when womanhood came upon them; few mothers taught the lore to their daughters to use as their power allowed them. Thus it was that Bet, whose mother had kept to the old ways, was witchwife to a parish even though her healing lay more in her sharp eye and her good sense than in her magic. In her great grandam's day, any girl who had reached woman's estate could have done as much as Bet; some might have done much more, curing ills of the heart and working spells against darkness. But such spells had increasingly fallen into disuse since the fearsome days before John the Mage had banished dark magic from Albia's shores.

Bet, old-fashioned as her mother, observed Elinor's passage into womanhood with due and solemn ritual. At the rise of the first full moon, she gathered the few fresh herbs necessary to an autumn Measuring, and at moonset she set them to steep in rainwater for a day and a night. Before dawn of the next day, she tipped the whole into a wide earthen pot, which she heated over a fire of rowan-wood and alder.

As the sky paled towards sunrise, Bet took the pot from the fire and called Elinor into the stillery. Old Goodwife Gittings attended her with the dairy-maids Doll and Kitty and Janet. Doll and Kitty were wide-eyed and awed, unsure of what they were to witness or what part they were to play. Janet had been Measured the year before; she and the Goodwife and Bet each stirred the pot until the bits of herbs and flowers swirled

again. Then Elinor put her hand into the whirlpool and held it still while the shimmering water settled around her fingers and the herbs drifted slowly to the bottom.

Solemnly, Bet studied the pattern. Goodwife Gittings, who had read the herbs at Bet's Measuring, mumbled her toothless gums and hemmed. ''Yon's a Tree,'' she said at last. ''I had th' lore of it from me grannie, said her seen it as a little wench. Thee had a Leaf, Bet, like as most lasses. I had a Branch, a Rowan Branch 'twas, and few enough of them seen since King John's day. But to see a Tree!'' The wonder of it silenced her.

The Tree. Old wives said that the Leaf, Branch, and Tree reflected a girl's inborn power, her ability to strengthen the natural virtues of the herbs she gathered. At the bottom of Bet's Measuring pot had lain a Leaf, small but unmistakable, a pointed oval like a willow leaf. A weak magic and a sad life, Goodwife Gittings had told her, and so in the main it had been, although Elinor and the boys had brought her joy. Janet's Measuring had yielded an alder Leaf; Nan the miller's daughter over to Seave had merited a good-sized rowan Leaf, and was said to be over-proud of the sign.

But a Tree! As Bet looked at her foster daughter, she was aware of her strangeness. This was not, could never be, a child of hers, so tall and pale, her golden hair all loose down her back like sun through clouds, her grey eyes blank and unreflecting.

Goodwife Gittings found her tongue at last. ''Th' Tree's a yew, a strong tree. It bringeth death and strife and long struggle, so it be no comfortable life thou'lt have with thee power, my lass.'' She lifted the pot and swirled it so that the pattern broke, then dumped the whole over the fire, which hissed sullenly and went out.

''Thou'rt a woman now, Elinor Martindale; see thou bear theesel' according.'' There was a dark, breathless moment, then the Goodwife's cracked voice: ''Open th' door, Bet, won't 'ee? It be black as a priest's pinny, and I dasn't move.''

Janet let in the morning light, Doll and Kitty began to chatter and giggle behind their aprons, and the stillery returned to its normal homelike aspect. The Goodwife hobbled

out on her stick towards her well-merited drop of ale, and the dairy-maids went with her, leaving Bet and Elinor alone.

Through the Measuring, Elinor had not said a word. Bet had always found her daughter's silence peaceful and a welcome change from the boys' constant noise, but now it seemed uncanny, unnatural. The lass was only fourteen years old. How could she not wonder, or laugh, or exclaim aloud? Bet remembered vividly her own Measuring, her hope that the herbs would form a Branch, her cruel disappointment when they did not. She had wept a little, quietly, not to bring Goodwife Gittings' scorn upon her head. But after the ceremony she had laughed aloud at the joy of being at last a woman grown.

For a moment, Bet and Elinor stared coldly at one another across the smouldering ashes. Then the girl was shivering and sobbing in her mother's arms, huddled against her even though she must stoop to hide her eyes in Bet's shoulder. Sadly, Bet stroked her daughter's silky hair, murmuring, "Hush thee, baby-sweet. Hush, lambkin. Thy mother's by. Hush thee," as though the tall girl were a child again, troubled by evil dreams.

Spring

Chapter One

As THE DAYS lengthened, bringing tender greens and new-born lambs to the King's table, William began to unbend. The spring sun seemed to thaw him as it thawed the frozen ground, allowing a small seed of fellowship to sprout within.

"You might even think the man was human," Dick Talbot told Hal Clemin one day. "Why, only yesternight he laughed on hearing my tale of the jolly monk and the young maid, you recall, the monk begs to lie with her, and she says: Oh, no, I fear Hell-fire, and he says: No fear, sweeting, for surely I could whistle you out of Hell, and she says . . ."

"I know the tale," said Hal shortly, "and 'tis nothing so droll as ye think it. If William Flower laughed thereat, I doubt he's as over-fine in his tastes as rumor has made him." He picked up a hair-sieve and began to press fruit pulp through it into a basin. "As for me, I've always liked him well enough, and have told Hugh Tusser more than once I thought the lad more grief-struck than proud."

"So say I," agreed Dick Talbot mendaciously. "And so I've always said."

A large household is like a flock of sheep at graze. First one meadow, one idea or opinion, is all the flock's delight, and it will shun all other pasturage until the subject is cropped close and bare. Then an old tup or an adventurous wether will wander onto new ground, find sweet grass and herbage, and soon the whole flock will drift after, by ones and by twos. Once Dick Talbot and Hal Clemin had taken William's part, it was not long before Hugh Tusser, then Wat Fitzhugh, and

finally even Peter Rawlings began to forget they had ever found the undercook's ways secretive or sinister.

Among this hirsel of kitchen sheep, Jack Priddy was something of a goat. He was fourteen or fifteen, almost a man, with not so much delicacy of feeling as a common billy. He had a nose for the smell of lust, and no amorous secret could for long be kept from his curious snuffling. Ned no longer interested him, but Jack knew that a man like William, beautiful and aloof, attracts desire as the rose attracts the bee. There'd be other hopeless lovers to torment: he had only to wait and watch.

One day, Jack's patience was rewarded by a glimpse of Bess, lurking in the pantry with a hamper of linens. The pantry not being the nearest way between backstairs and laundry, Jack folded his lanky person behind a kist of flour and awaited revelations.

Bess halted at the pantry door, looked about her fearfully, peered into the Kitchen, blushed and sighed, and crept out of the pantry again, looking melancholy. When she was gone, Jack unfolded himself, and, peering out likewise, saw Master Flower's profile close by, bent above a basket of eels. His smile, gap-toothed and wet, boded ill for the laundry-maid.

Thereafter, Jack dogged Bess's footsteps faithfully. Hardly could she come near pantry or scullery without the turn-spit popping up to taunt her on Master Flower's manly beauty and Master Flower's monkish ways. This was better sport than Ned, and much to Jack's taste; for where Ned had come after his tormentor with bony fists flailing, Bess blushed scarlet and heaved her bosom in a most stimulating way. The sight was well worth the boxed ears and scratched hands it eventually cost him.

Soon the only person who did not see that Bess the proud laundry-maid had lost her heart to the new undercook was William himself. She would stand openly by the hearth or the pantry door with her smock gaping at the neck and hunger in her eyes, like a gaze-hound bitch leashed back from a grazing hare. Kitchen opinion favored the hare over the bitch—more especially as he treated her with a courtly courtesy that amused its beholders as much as it bemused its object.

It was this same habit of courtesy, unfailing and catholic as the blessing at the end of Mass, which finally enticed the

kitchen flock to enter William's fold. First, Peter Rawlings noticed that Master Flower could always find a willing knave to chop and fetch for him, and thought he might refrain from cuffing his assistants to hurry them. Then Wat Fitzhugh and Dick Talbot began likewise to hold their hands and lower their voices. As more cooks followed their courteous lead, the beleaguered brotherhood of the washtub and spit began to drop fewer pots, scorch fewer sauces, singe fewer roasts, and hop more featly to their tasks. And as William's influence spread through pantry and kitchen like a spring rain, Master Hardy felt his authority begin to soften and slide beneath his feet.

Being a fair man in his way, Master Hardy was willing to give an underling credit for what he had done. Freely the Master Cook acknowledged that William Flower had a genius for order, for giving commands without seeming to, for getting a lazy knave to work without beating him. He did not wish him gone, no indeed. So Master Hardy took counsel with himself and reasoned thus. It was only good policy to set a man to do the thing he did best. There were cooks enough in the King's kitchen, and as good as it was, William's *galentine* was not altogether without peer. What Cyngesbury Castle sorely lacked was someone to direct the dressing and the serving of the royal meals—an under-steward or Surveyor. Why, the pages and marshals had steadily been growing more slovenly since the day the last Surveyor had died, was it eight years ago? Yes. William should be made Surveyor, and bring order to the hall. So thinking, off marched Master Hardy to the Steward's closet.

Long ago, Master Hardy had learned to determine, before broaching any subject to him, whether Lord Steward Sir Andrew Melton was mad or only maudlin-drunk that day. If the Steward swore or hurled an inkpot when he made his greeting, then would Master Hardy retreat. But if Sir Andrew only sighed, muttered that he was well enough, thank'ee, and blinked as though wondering whether he should know this man, then would the Master Cook step forward boldly.

Preparing to duck or flee, Master Hardy pushed wide the oaken door, bowed, and, "God keep you, my lord," he said cautiously. There was silence, then a smell of sour wine as the Steward belched.

"And God keep you, good Cook," he replied, "and preserve you from such a griping of the guts as I suffer this day. Four hundred souls in the castle, and only one to see to their feeding and comfort. And that one grows old, good Cook. He grows old." Sir Andrew fetched a great sigh and rubbed the tonsure age had worn in his sand-grey hair. "If you are come to tell me there are no fish to be had in Cyngesbury town, I do not wish to hear it."

Master Hardy gripped his hands tight behind his back and forced himself to speak soft and small. "Your lordship will remember the new undercook, William Flower, taken into the household on St. Leonard's Day? He is a good cook, my lord. But we have cooks enough . . ."

Sir Andrew wagged a wine-stained forefinger. "Said so at the time, Cook. Said so at the time. I'll dismiss him at once. In the morning."

"No, my lord." In his alarm, Master Hardy's voice rose to its accustomed bellow; Sir Andrew clutched at his ears and glared. "My lord," Master Hardy murmured hastily, "pray you forgive my lack of moderation. But by St. Bibax, it galls me to see you thus overwrought and suffering. One such as William Flower could easily peer into pots and chivvy servingmen, saving your lordship's strength for weightier matters."

"Under-steward, eh?" Sir Andrew reached blindly for his goblet and swallowed a thoughtful draft. "Surveyor or Pantler?"

"Surveyor, my lord. No underling should have governance of the King's wines, my lord, but only you yourself."

Sir Andrew nodded, pondered, then frowned, his small red-rimmed eyes fierce as a boar's under his lowering brows. "I will have no low-born rascal set over our noble pages and squires. Is the man of gentle birth?"

"He seems so, my lord," said Master Hardy cautiously.

Sir Andrew's raddled countenance cleared. "I'll speak to Lord Roylance come morning," said he, and belched again most stertorously. "Now, good Master Cook, send up a page with a flagon of rheinish. This malmsey hath made me bilious."

When Sir Andrew approached him with this proposal a day or so later, Lord Roylance humphed and hummed and spoke at length of unnecessary expense. But when Sir Andrew reminded him that there had been a Surveyor in old Queen Constance's day, Lord Roylance dipped his quill without

further argument and wrote by William's name: "*fecit metatore* ye firste Aprilte. x markes in monye *pa* & a sute of good clothynge." Below, the Chamberlain listed all the other appurtenances to the position—*viz.*, a dole of white bread, a gallon of beer, a hot meal from the Kitchen, a mess of roast daily, and a small chamber of his own to sleep in.

No sooner had Master Hardy told William of his advancement than Ned, who had been lurking nearby, told Jack Priddy, who hawked the news abroad. Hugh Tusser heard it from Peter Rawlings, and, coming upon Joan the laundry-maid in a back corridor, offered to sell her some interesting tidings for a pair of kisses. The trade being most pleasant to both buyer and seller, the two kisses might have become three or more, and the news they were to buy quite forgotten. But Hugh was an honest soul, and while he fondled her, he murmured into his sweetheart's neck that gossip had it that Master Flower was raised to Surveyor. No sooner had the words passed his teeth than Joan removed his hand from her bosom, and without even pausing to retie her smock strings, ran posthaste to the laundry.

The stone wash-house that was the domain of Mistress Rudyard reeked like a kind of damp inferno, with the stench of lye and rancid soap taking the place of sulphur and brimstone. Clouds of steam and smoke from the fires and wash-tubs billowed in the air, giving the laundry-maids employed therein the aspect of demons pounding and wringing the souls of the damned. In a great round washtub pranced Bess, fairest of fiends, noisily treading out sheets with her skirts tucked up to her plump thighs. Joan cocked her fists on her hips and shouted across the room.

"Master Will'm Flower be made Surveyor and set over all the kitchen saving only Master Hardy himself. If he were proud afore, he'll be prouder by and by. What price thy black hair and white teeth then, Mistress Bess?"

Two dozen curious eyes turned from Joan to Bess. Her scarlet cheeks blanched whiter than lime, and she gasped once or twice, then scrambled from the wash-tub and dashed barefoot past Joan, out the door and across the back court to the kitchen, where she cast about for Master Flower like a hound on the scent. After a moment she sniffed him out weighing out grain by the barley-kist.

"William Flower!" Clutching her sodden skirts in a bunch at her waist, Bess gave tongue and triumphantly brought her quarry to bay.

William looked with a puzzled air upon the dripping laundry-maid and bowed slightly. "Mistress Bess?"

"I love thee, William Flower. Be thou cook or surveyor or knight or prince disguised, I love thee true as any maiden born."

Mistress Rudyard, puffing up behind her errant maid, slapped the words from her mouth. "For shame, girl! Wilt beggar thy modesty by laying thy heart before a man will have none of thee?"

"T'ain't her heart she's laying," piped up Jack, who had observed Bess's attitude. " 'Tis her belly."

Dick eyed her legs, still bare to the knee. "Or her maiden-head, belike," he muttered, at which the undercooks leered and the scullions snickered.

William's mouth tightened. "Mistress Bess," he said. "This is too public a place. Pray you, Dame, accompany her, and we will talk privily." Then he snapped shut the kist and marched off toward the stillery, with Bess and Mistress Rudyard trailing behind.

The conference was not long and Bess emerged from it subdued, sullen, and crimson-eyed. Mistress Rudyard refused to relate what had passed, saying only that Bess was a great gaby and Master Flower a reasonable enough man, but high-nosed and cold as a hake. She wished the marshals and pages joy of him.

Master Flower slid into the Surveyorship as comfortably as a hand into a fitted glove. His post was by the surveying board, and his task was to carve the meat and decide which page would carry the lark pie and which usher the roast boar. The surveying board stood in the screens passage, where he could hear not only the bleating of the kitchen flock discussing the Cyngesbury whores and the price of white herring, but also the far, sweet murmur of the lords, knights, and barons clustered around the kingly throne, discussing policy.

Over the winter, the talk above the salt had been dull and barren: Lady Blanche was creeping from her husband's bed to lie in Sir Edmund Sewale's; Lord Molyneux, having struck

before the King at the last boar-hunt, languished in disgrace; the King himself was mopish and strange as a breeding woman. The pages, who carried news as well as dishes, declared they were bored of this monochrome winter landscape, and thanked heaven for the coming of spring, which always favored gossip. Lent was for them that year a time of rejoicing rather than penitence. For, on Ash Wednesday, word came to Cyngesbury that King Arnaud de Gallimand was sending a formal delegation to discuss an alliance between King Lionel of Albia and King Arnaud's only daughter, la Haulte Princesse Lissaude.

Now, King Lionel of Albia was a lusty youth, tall, yellow-haired and strongly built, who was fonder of the hunt and the lists than he was of the council-chamber or the confessional. His temperament was hasty, warm, choleric—an unchancy combination for the king of a small country. Upon taking the throne, his first act had been to gallop north to Brant with the young Earl of Toulworth by his side, intending to win that small mountain kingdom for Albia. But the war had gone disastrously against him, and within the six-month, King Lionel had come limping south again, leaving nigh half his army buried in the uplands of Brant. He had not left Toulworth there—though the Earl had fallen in the last, decisive battle—but brought his corpse home with all honor and interred it beside the altar of the Lady Chapel in Cyngesbury Abbey.

Since that day, King Lionel had kept to his castle at Cyngesbury, overseeing the building of a sepulchre of surpassing beauty and expense over the young Earl's grave. He had not taken the court to Harldon for Christmas, nor had he held a Twelfth Night Tournament. Concerned by their monarch's excessive mourning, nobles who had not been at court since his coronation abandoned their estates and descended upon Cyngesbury in a worried swarm, bringing their ladies and their retinues with them. With so many new mouths to feed, Lord Chamberlain Roylance had cause to complain of expense, and even better cause to spend ten marks and a suit of good clothing on a competent Surveyor.

All up and down the backstairs and inner corridors of Cyngesbury Castle scurried provincial serving-men and pages, gossiping as they went. It was high time the King was wed,

they said: two-and-twenty, he was, if he was a day. A goodly man, and freehanded, but not the king his father had been. Where was his sense of duty? they asked one another. Where was his wife? Where was his heir? Why, his father Geoffrey had first married when he was eighteen, and got his first son on his wedding night, if princesses carried their babes for nine months like common folk. Prince Arthur had been a wise and solemn child, thoughtful beyond his years. He would have made a fine king, they whispered, just and learned like his father before him. But Arthur had died at thirteen, slain by smallpox on the eve of his manhood. And his mother, gentle Maud, died soon after of her third miscarriage.

Even burdened by this double grief, Geoffrey had found the strength to behave in kingly wise. After a year of mourning, Geoffrey had looked about him for a second queen and chosen Constance of Capno, fair and subtle and learned in magic. 'Twas true at first she bore him only girls and still-born boys, but she had proved a good queen. And in time she had achieved a living son, Prince Lionel the Golden, who was now King.

If Queen Constance had lived, the servants agreed, things would be otherwise than they were now. She would have seen to her son's education and stood no romantic nonsense of a kind that better became knights-errant than heirs-apparent. But Queen Constance had died when Lionel was twelve, and King Geoffrey had indulged his only son. It was whispered that in coddling the boy, King Geoffrey—God rest him—had allowed the man to grow willful. Look at how he had insisted on warring with Brant, as if that rocky and barren land were worth troubling with. Look at the tomb he was building for his hey-go-mad friend with coin he should be saving to buy gewgaws for his bride.

So ran the talk on the backstairs. At the high table, the tune was the same, but the words were more discreet. Baron Carstey murmured to his ancient crony Sir Nicholas Webster that it was low water indeed with Albia's coffers; Sir Nicholas murmured back that Gallimand was a rich land. Lord Chief Justice Giles Higham remarked that the Principality of Rin seemed to be a little late with its tithe this year; the Earl of Brackton shrugged his shoulders and said that the King had mentioned that fact in council and spoke of higher taxes.

Then they all glanced sidelong up the table to where their young monarch sat with his golden chin propped upon one broad fist and his cerulean eyes overclouded with wine and gloom.

Chapter Two

DEEP IN THE heart of an April night, Margaret prepared herself to call up a demon. At sunset, she had washed herself in herb-strewn water, combed her fox-fire hair free of knots, and draped her white body in a heavy black gown sewn with crystal stars. Now, her vixen looking on, Margaret deftly traced a pentagram and set at its five points squat black candles, which she lit from the hell-fire burning unquenchable in an iron brazier. A spark of this hell-fire served to kindle the summoning blaze at the pentagram's center, and lent its sulfurous reek to the odors of myrrh and obscurer perfumes that she cast upon the pale flames, causing them to flare black and lightless.

When she was satisfied that all was set and ready, Margaret began the chant to summon her chosen demon from Hell. It troubled her not at all that she barked rather than sang the notes of the ritual, for the strength of a calling-spell does not depend upon its beauty. Magister Lentus had had a melodious voice, clear as a warbler's, and Magister Lentus had never dared to call up any spirit more puissant than a fiend. His sense of pitch had not been precise, so that the rich numbers that had fallen from his lips were often untuned, a quaver above or below the true note. Margaret's voice might grate like stone upon the ear, but it ground its charms true.

Through the beckoning, wordless melody Margaret wove the myriad tortured syllables of the demon's name, each in its proper place, each with its proper intonation. Over the years she had extracted it, note by note, letter by letter, from the mirror's cryptic images of Hell. It was a rare art and a

dangerous to translate sight into sound and puzzle out the grammar and pronunciation of flame, but Margaret found she had a gift for it, and now eighty sprites, imps, fiends, and minor devils whispered in her lower chamber, the slaves of eighty black fires, eighty rituals of calling. With this, the eighty-first, she called an arch-demon, a duke of Hell only a little less powerful than those princes whose names all men know: Asmodeus, Belial, Samael, Mephistopheles.

Time passed; the black candles burned low. As she chanted, Margaret struggled against small, chill premonitions of fear. Why did the demon not come? Her other slaves had begun to form at the second repetition of their names, growing more manifest throughout the third that wound up the charm. Already she had sung through the arch-demon's full name twice and made her way well into the third. Soon the charm would return, like Ouroboros, to its first word, its fourth repetition, and still there was no sign or shadow of genesis within that black fire. Might she have unaccountably missed some grace note of her calling-spell, some tiny syllable of the demon's name? Could she be summoning a strange demon whose strengths and properties she did not know? Would her charm, miscast, bind her in its coils, making her a slave to that power she had thought to enslave?

Margaret faltered in her chanting. As if in answer, a scarlet shadow appeared within the inky flames, swelling rapidly and ramifying as it prepared to take shape.

Between one breath and the next, Margaret recovered her wits. Grasping the serpentine horn, she set it to her lips and blew upon it five peremptory notes. The shadow whipped and sucked like a scarlet whirlpool within the flame, then drifted quietly, reft of its form and color.

"Demon," said Margaret, hoarse and triumphant. "I take from thee thy name by which I called thee hither, and give thee in its stead the notes by which I have bound thee. Thou shalt reign in Hell no longer, but dwell among the airs of this world, blowing where and when I will." She scratched a bronze stylus across a line of black powder, breaking the pentagram's integrity by a hair's breadth. The shadow howled towards the breach. But when Margaret sounded its signal notes, the gale fell abruptly into a sullen calm.

"Where and when I will, demon." A noxious odor breathed

poison in her nostrils; Margaret held the horn to her lips and the stench died in a bitter whiff of myrrh. One final act and the rite would be complete. She had snared her prey and mewed it up closely. Now she must humble the demon and teach this infernal tempest that it was beyond any doubt her slave and a lord of Hell no more.

"Thy rudeness has knotted my hair," she remarked, lady to careless tiring-woman. "Make it seemly again."

There was a breathless pause, then a gentle air lifted and smoothed the red-gold strands about her shoulders until not a tangle remained in all its gleaming fall. Margaret flicked one finger at the door. "Get thee to thy fellows below."

The arch-demon trickled in a thin draft down the stone steps to the lower chamber.

Weary though she was, Margaret did not retire immediately to her bed, but straightaway began to remove every trace of her summoning from her chamber. She could not rest until she had performed this rite of unpreparing, this act with which she closed her conjurations and warmed the soul-deep coldness they left behind them. Act by act, she undid her preparations, tidied away horn, brazier, and powders, swept the pentagram from the floor, folded her starry robe into a chest.

The work soothed her; she smiled as she closed the chest. It had been unexpectedly easy to bind the demon once she had called him: she had felt no violent struggle against her will, no cooling of the flaming heart of her strength. Truly, this art of sorcery brought great content to its practicer. Eighty-and-one winds now blew at her whim, and one of them was a duke of Hell.

The night began to pale towards dawn. Her vixen stood at the top of the stairs, whining and swinging her fiery brush as if begging her mistress to descend and rest. But as she stretched, Margaret caught sight of a row of books leaning drunkenly over a fallen codex. Confusion! she thought, and went to remove the stragglers from their shelf and brush imagined dust from their edges before stacking them neatly back again.

A small, heavy volume fell upon her foot. Angrily, she kicked it from her, then, penitent, retrieved it and smoothed its scratched cover. *De Rerum Eternis*, she read. She remem-

bered holding it thus when first she came across it and rejoicing that it was hers to read and use at her leisure. Lentus was dead: she no longer had to steal or dissemble knowledge. In this library that he had all unwilling left her, Margaret had found the tools of dominion she had so long lusted after. Reading, thinking, experimenting cautiously, she had gathered unimagined powers, held and hoarded them like minted gold, gloated over them and counted them and frugally spent them only to achieve a greater wealth.

The first small coin in her store had been a hideous imp that squatted in the brazier and grinned impossibly through its drooling beak. She had transformed the monstrous thing into a perfumed breeze, little more than a puff of air, and had used it to dust Lentus' library and to cool her soup. In summoning that slow, weak, stupid minor devil, she had shown little wit and less art, but the fact remained that she had called it and it had come. Demons ever test a sorcerer's will, obeying only the most obstinate mind. Lentus had loved ease and pleasure as much as he loved sorcery. Margaret, loving only sorcery, was stronger far than he.

Tenderly, Margaret put *De Rerum* back on its shelf. Sunrise seeped pale gold through the cracks in the wooden shutters and touched the folds of the mirror's shroud with opal fire. Margaret shivered and drifted wearily to her chair where she sat, too spent to move. The vixen crept from behind a lectern and leapt like a living flame upon her lap.

Sighing, she fondled the vixen's soft ears. Her familiar might stay by her and her horn might still bind demons to her service, but there would be no new demons: the brazen mirror was no longer at her command. And for this, the botched, hireling work of All Hallow's Eve was responsible.

Like an ox bound to a millwheel, Margaret's weary mind plodded along the well-worn path. After All Hallow's Eve, what had become of the lady? Her husband and son slain, had her enemy gone mad with grief and with self and desperate hands taken off her life? No, Margaret thought, then the prophecy would have changed, for its original terms would be void. Might she have crept to her mother's house to lick her wounds and weep? Margaret's hands tightened on the vixen, so that she yipped and looked up reproachfully.

"No," said Margaret to her vixen. "No daughter of my

blood would slink meekly home to wear out her life in barren mourning.''

Then what had become of her, this nameless child who was born to be her mother's bane? The question sang in Margaret's weary mind like a spell of summoning, calling her inexorably to the mirror once again. Tumbling the vixen from her knees, Margaret snatched aside the iridescent veil, grasped the mirror's frame, and fiercely willed to see her daughter. Overmastered, the brazen mist shivered, then parted reluctantly to reveal a slender figure dressed in sad scarlet and motley hose, the habit of a superior serving-man.

After a moment of angry bewilderment, Margaret recognized her daughter. It was not only that her form was unfamiliar, the swell of breast and hip concealed by a padded pourpoint, her long legs set off by the hose. No, it was the reflection's youth that disguised her most. Although the woman was fully nine-and-twenty, as a boy she looked no older than nineteen. Her wheat-gold hair was cut short to her neck behind and in a fringe across her brow which subtly altered the shape of her face. She stood in a wide passage hung with fine tapestries and bustling with pages, ushers, and marshals. Now and then she stopped a page to examine what he held. Her face was peaceful and intent: she looked happy.

Margaret bared her teeth in rage. She had imagined her daughter begging, despairing, starving, retired to a convent or even a brothel, but never dressed in man's array, serving in a rich man's hall. She must know, Margaret thought. Somehow the slut knew all about her mother and what she had done, and this mumming was only the first act of a long and complex revenge.

Unlike the hare, whose only desire is to escape the dogs and hide, a fox will play the hounds that hunt her, showing herself when the scent is lost, teasing them with doubled tracks. But should the fox tire while the pack is still upon her trail, she will begin to dash wildly to and fro without plan or thought. She may chance to go to earth where the dogs cannot come at her. But more often she will find herself trapped in a spinney or against a rocky culvert, and in a frenzy of fear, snap at the hounds even as they rend her.

Until this moment, Margaret, like the fox, had coursed and teased her fears. But the sight of her daughter—safe, well,

contented—acted upon her like the rumor of horses and human sweat blowing rank upon the wind. A pack of doubts and night terrors was suddenly snapping and baying at her very heels. At panic speed, Margaret ran to her shelves and pulled down at random a dozen books of baneful spells. Parchment cracked and wrinkled as she fumbled through their pages with shaking hands. A burning plague caught her eye: deadly, swift, and contagious as a cry of "Fire!"

A plague—why had she not thought of this years ago? If men fell ill and passed their illness on, she thought, could her daughter's death then be set at her door? Dragon canker, rat spleen, flea tooth, murderer's dung—she had them all gathered in a trice. It was only the work of an hour or two to render them all down into a deadly essence of fever.

It was full daylight now, the sun high and bright in a clear spring sky, and Margaret drew heavy curtains across the windows to shield against even those few weak spears of light that might pass through the shutters. She fetched down her horn from its hook, and, with two short notes, summoned a small drafty devil. This draft she endowed with the fever-essence and instructed it to blow pestilence on all it met, saving only the woman in man's attire. Then, heavy with its deadly burden, the devil sank like mist into the reflected hall.

Chapter Three

THE MORNING OF Maundy Thursday, a page crumpled to the stone floor during Mass in the royal chapel. His friends ascribed his weakness to overzealous fasting and let him lie until the *benedicite* was pronounced. But he proved hard to rouse, and his face and hands burned hot as coals. By Good Friday he was dead, and all those who had knelt near him were complaining of aching bones and light heads.

Easter morning dawned without joy upon a scene of pain and death more fitting for a pest-house than a king's castle. The course of the disease was simple: first, an eruptive fever forced streams of rank sweat out of the sufferer's body. Shortly thereafter, he would be tortured by phantasms of demons stifling his breath or crawling over his skin like prick-footed beasts. After a time, he would fall into a heavy stupor, from which he might wake only to life eternal.

The corridors of Cyngesbury echoed with the moans of the afflicted. Febrifuges were called for, and a letting of the evil humors. Mistress Rudyard, who served as witchwife when occasion demanded, lumbered to and fro among the servants with decoctions of honey and dittany, while the Royal Physician wielded his lancets and his cupping glasses among the nobility.

In the kitchen, Master Hardy wavered between fear of contagion and fear of the court's going hungry. Alternately he begged the drooping cooks to hurry along with the joint and searched their faces for the fever's scarlet signs. His own fear and the ruination of his banquet Master Hardy endured with what patience he could muster. But his meager store of that

virtue had long been exhausted by the time the King's page Thomas Frith presented himself flushed and damp-browed to serve the King's supper.

"Dost wish to kill our king?" he bellowed. "Be off with thy red face and thy contagious sweats, and let me see no more of thee until art well or i' the churchyard. Now St. Lues preserve me," he cried, raising his hands to heaven. "Where is Sir Andrew? Why does he send me dying boys to serve the King's supper? Is there no soul here with the sense of a dead haddock? Where the devil is Master Flower?"

Knaves scattered through the domestic offices like rats in search of offal. Jack Priddy finally sniffed out the Steward in a back pantry, glassy-eyed, crimson-cheeked, and swaying from something graver than an excess of malmsey. Ned found William Flower in the herbary, where he had gone to gather sage and a moment of quiet.

"O Master Flower," Ned cried. "The King's page dies and the King starves and you be called for. O hasten, ere Master Hardy do burst his belly wi' spleen!"

William dropped the sage and raced across the yard to the kitchen with Ned trotting breathlessly behind. Within, the storm had fallen into an uneasy calm. Those cooks and scullions left on their feet—about one in four of their number lay ill—went about their tasks in grim silence. At the far end of the room, Master Hardy stood spraddle-legged at the foot of the hall staircase, watching Thomas Frith weakly support the even weaker Sir Andrew toward his apartments. Behind the vinegar-soaked cloth he held pressed over his nose and mouth, Master Hardy was swearing softly and steadily.

"Sir Andrew is taken with the plague, Master Flower, and Thomas Frith also." Smothered by the cloth, his voice was faint and toneless. "Soon we shall all be dead, and by St. Mortis, I for one will be glad of the peace. See you to the King's supper, lad, and order the kitchen as you will. I can no more." And turning his back on plague and cookery alike, Master Hardy descended to the cellars in search of strong ale.

King Lionel of Albia sat brooding by a small fire in his privy chamber, with his feet sprawled on the hearth and his golden chin drooped upon his velvet-clad chest. His face

wore a sulky frown ill-suited to its ruddy comeliness, and his smooth golden mane was twisted into elf-locks.

Dangling from one square hand was a much-crumpled parchment, decorated with a heavy row of scarlet seals—the official notice of Ambassador Tellemonde's visit. Since the moment when King Arnaud's envoy had put it in his hand on Ash Wednesday, King Lionel had read and re-read it. He had prayed that he might have misread its intent, but the message, both expressed and implied, remained stubbornly clear. King Arnaud of Gallimand sent his warmest greetings to his royal brother and requested him to look for his ambassador sometime near the first week in May. The time was ripe to discuss the matter of alliances between Gallimand and Albia.

The King picked up a second document from his knee and glared at it. It bore the imposing *lyon en face* that was the seal of the house of Frise and had been sent by Rosamond, Duchesse du Frise, sister to the late King Geoffrey's father: a lady of some seventy years, fully as shrewd as she was aged. King Geoffrey had always said that with her keen wit and taste for games of power, it was a pity that his aunt du Frise had been born a woman. King Geoffrey's son had always thought his great-aunt a high-handed and interfering old enchantress.

The Duchesse's letter was in her own vigorous and sprawling hand, as though she thought the contents too private to entrust to a clerk.

To our best-belov'd neveu, greeting. You will rejoyce with mee that I at laste have found you a Wyfe. Shee be prettie, not over-shrewde, meeke as an Ewe-lambe and of verrye good faith. Her Dowerie must swelle Albia her cofferes and her persson wyll please Albia her Kynge. Also, hyr familye doth engender Boyes, shee beyinge the onlye wench. I heare you have bene mopish, Nefeu, since that yr. frend Ld. Robert Wykehame was kilt in Brant, and that you have builte hym a Tombe magnify-cynte. Thys passeth my undertandynge. He beinge a grete Fule. Ye were as grete a fule if ye do notte take Lys-saude to wyf and rid yrself of Debts and mopes and evyl gossips all togedyrs. Arnaud sendeth Tellemonde as

*Ambassadeur. Entreate hym well and see you give him
the Answere he seeketh.*

R du F

*De la grande duchesse du Frise au Lionel Roi d'Albia.
Ecrit la 6 Mars, xxiii Arnaud. Que Dieu vous benisse.*

King Lionel threw down this blunt missive and cursed his ill
luck. Two years ago, his aunt would not have written him
such a letter. Two years ago, he was the new and well-
beloved monarch of a small but prosperous kingdom. In the
fire's leaping flames, the King conjured images of his corona-
tion: the bright pennants snapping over Cyngesbury Castle;
the bright crowds lining the streets of Cyngesbury town,
waving their caps and roaring out "God bless King Lionel!"
and "Long live the King!" until his ears had rung with the
noise. Later, the abbey had been cool and dim and hushed, and
his heart had stilled with awe as the Archbishop set the jeweled
crown of Albia upon his brow and sealed him to his heritage,
his destiny, his kingdom.

On his coronation day, King Lionel's heart had swelled
with love for Albia, all her woods and fields and bogs and
hills, and every human soul that lived therein, but most
especially for Robert Wickham, Lord Wickham and Earl of
Toulworth. After the ceremony, there was long feasting,
singing, masqueing, and dancing, but when these revels at
last were ended, the new-crowned King of Albia retired to his
privy chamber, cast aside his scarlet and his cloth of gold,
and sat talking with his friend until dawn. Though they both
had drunk deep at the feast, yet they felt no heaviness of head
or tongue. Ideas, philosophies, ambitions rang in the air
between them until Lionel hardly knew which were his and
which were Robin's.

"You will be remembered, sire. You will be such a king
as songs are written of, and leave tales behind you like Edgar
the Dragon." Waving his goblet, Robin began to sing, his
voice rough with wine and shouting. " 'He swung his sword,
the blood burned bright / Worm of Reddingale died that
night.' "

Lionel laughed and shook his crowned head. "There are no

more worms in Albia, Robin, nor gryphons nor wyverns nor any other fabulous beast. When John the Mage banished evil magic from Albia, he nigh banished errantry as well. Oh, there are still knights in black armor who challenge all comers to battle, but they are few and weak and old; there is no honor in vanquishing them. I must find some other way of leaving a legend behind me. Certes, my father has not done so. King Geoffrey the Just! King Geoffrey the Cautious were a better name.''

"He was a good lawgiver and a fair judge," said Robin thoughtfully. "And I seem to remember his being merry and quick when we were children."

"Then your memory serves you better than mine, or else looks back with a more charitable eye. I never recall the King my father as other than dour, pious, forever on his knees or in council, asking after my progress in astrology and ancient history. I fear me he had not the fire to accomplish great deeds, or if he did, it died with my mother."

Robin gazed deep into his cup. Silence fell. Then, "What news of the Brantish borders, sire?" he asked slowly. "Come the bare-kneed lords as boldly across the marches as ever they did? Your father made a jest of it."

"He said the nights nipped colder to the north than here, and the Brants must needs fight continually to keep the blood liquid in their veins." Recalling past quarrels, Lionel spoke with some bitterness. "He always said there was nothing to be gained by making a pother over some cows and a few scraggly sheep." Seeing Robin peer slyly up at him through his nut-brown hair, the King laughed. "Ah, Robin, thou knave. Would'st incite me to war on Brant? Shall thou and I take these curtal savages and teach them better manners at the sword's edge?"

"Shall you be King of Brant and Albia both?" returned Robin, and the King's laughter died. Albia ruled Rin and half of Capno by ancient conquest and marriage-right, and the revenues of those tributary states did much to plump the royal purse. If Brant were added to these, how much mightier and more prosperous might Albia become? King Lionel the Warrior, King Lionel the Conqueror—these were titles sweet to a young monarch's ear.

The future Terror of the Brants grinned broadly among the

golden down of his beard. "We'll ride on Brant together, Robin mine, and reap such a harvest of bare-kneed savages as will busy the minstrels with our exploits for years to come. They will sing of King Lionel the Conqueror and his loving friend Wickham, who like King Beaubrace and the knight Joyeau fought side by side, equal in honor upon the field of battle."

At this, Robin smiled and, gripping his king's hand, fell to his knees to swear once more his eternal love and fealty. So lightly began the expedition on Brant.

They were young: Lionel had just turned twenty and Robin was but a year older. The children of a long peace, they had never ridden in battle. But they had ridden in tourneys and jousts, had seen men die, had even killed one or two themselves. And they knew all the old tales of battle off by heart. War to them was pennants and horns and the bold shouts of challenge that rang through old songs. When Lionel determined to march on Brant, their bright and ghostly clamor had drowned out the cautious voices of old men warning him that war is a costly and a complex business.

Robin would have marched off next morning, unprovisioned, with only the royal guard to support him. But Lionel having pointed out that not even the reckless King Beaubrace ever began a war in November, Robin retired to polish his armor and chafe until spring. The King passed the time more pragmatically, in the study of strategy and the tales of old soldiers. He called upon his nobility to support their liege with troops, and in the spring the soldiers gathered—along with horses, grain, weapons, armor, salt meat, straw, tents, wine and beer in oaken tuns, candles and horse-shoe nails—into a great camp pitched in Wyrmford Field, west of Cyngesbury. Finally, on a May morning, King Lionel of Albia and the King's Champion, the Earl of Toulworth, had ridden off to war at the head of an army of three thousand horse and twice three thousand foot, all brightly accoutered and with their hearts hero-high.

The Brantish war had been hounded by ill luck from the moment the Albian army had set foot upon Brant's heathery uplands. Lionel had trusted in his Champion's judgment until it became clear that his armor might be resplendent and his ferocity unparalleled, but his knowledge of military tactics

was nil. After Robin had lost twenty horsemen in an heroic but unadvised charge, Lionel was forced to admit that his friend might be an apt and eager pupil of mayhem, but he was no leader of men. Robin saw war as a kind of joust with edged swords and no marshal to stay the combatants' hands when one had beat the other to the ground. He had no patience with masses of troops, supply lines, forced marches, the necessity for respite between battles, the need to pay farmers for some part of the wheat and cattle the army commandeered.

This was an old quarrel Lionel had with himself: whether he should have marched out of Brant when the first battle went against them or whether he had been right in pressing on. He had feared retreat would mark him before the world as a puffed-up braggart who might huff and threaten, but would collapse and slink away whining if his enemy showed fight. More, he had feared such cowardly prudence might cost him the trust of his army; certainly it would cost him Robin's love. So Lionel pressed on, leading charges when the Brants allowed him a formal battle, urging his dispirited men to defend themselves when the Brants leapt upon them as they camped or marched. The soldiers were weakened by hunger, which made them prey to flux and fevers. Many fell in battle or ambush. Some deserted. By September, Lionel had lost nigh half the bright army that had ridden forth in May, and was quarreling with his Champion over when they should ride back again.

On the feast day of St. Bertin, King Lionel of Albia and King Douglas of Brant met upon Colum Field. At dawn, the opposing armies charged, the Albians calling upon their saint and their king, the Brants screaming, "A death! A death!" like wild men. Past noon they fought, and the heart's blood of many a brave man watered the thirsty soil. Brantish bards made songs of the carnage, and if they gloated over the losses of their foes, who was to blame them?

Thus fraye bugan at *Colum* field
 Bytwene the nyght and the day;
Before that day was gone and past
 Kynge Lionel rade awaye.

> There was slayne upon th' *Albian* perte
> For soth as I yow saye,
> Of ful two thowsand *Albian* men
> Two hondert cam awaye.

This was a victor's bombast: but six hundred Albians did die that day, among them Robert Wickham the Earl of Toulworth, slain defending his king and his standard. Like many others, he was perforce left where he fell, for soon after, the remains of the Albian army was driven south over the River Col. Before sunset, King Lionel sent a herald to King Douglas requesting a parley. Two days passed away in the exchange of demands, recriminations, and ultimata, and the end of them was this: that Lionel should sign a treaty with Brant swearing to protect her from all foreign foes; that Lionel should hie him and his army posthaste out of Brant; that Lionel should pay King Douglas a sum of gold out of which he might comfort the widows and orphans of the brave Brantish men slain by Lionel's invading army. In addition, Lionel ransomed the dead body of Lord Wickham, paying for it a sum that would have been sufficient to redeem a baron alive.

More than a year later, Albia's wounds still festered unhealed. The treaty settlement, pensions for Lionel's soldiers, rewards and preferments for the knights who had fought by him, Robin's still unfinished sepulchre, these bled the exchequer sorely. The contiguous kingdoms of Estremark, Liscard, and the Principality of Rin began to sniff at Albia's borders like wolves around a dying sheep. Nobles who in Geoffrey's reign had kept decently to their demesnes were coming to his son's court with worried smiles and unwanted advice. The alliance with Gallimand, once perhaps a choice among many, was now a matter of stark necessity.

In the darkening room the fire burned low, for the King had not roused himself to call page or chamberer to make it up again. He could see no help or end to the woes he had called down upon himself, to which were now added this pestilent fever that felled the members of his court like a flight of arrows. It could only be a matter of time, the King thought glumly, until the plague spread from castle to town, and from Cyngesbury town to the surrounding countryside. Plague was

a grim death, though this fever was not so horrid as some he had read of. Nonetheless, for himself Lionel would prefer not to end his young reign upon a damp and noisome sickbed, but quick and clean upon a battlefield, with his foes ringed dead around him.

Unbidden then rose in his mind a memory of Robin's maimed body, returned to him mother-naked and lashed to a board. The tawny eyes had been open, sunken, staring. One arm had been hacked away; his breast had been hewn so that white ribs showed stark under a flap of livid skin. A battle-field death need not be either clean or quick.

Lionel shook off the vision and surged up from his chair. What could Thomas Frith be thinking of, to leave his sovereign so long unattended? No lord or serving man had come next or nigh him for hours, and, by God's bones, the King of Albia hungered! Preparing to roar his displeasure through the halls, Lionel threw open his chamber door.

A young man stood upon his threshold, one hand poised to knock. Before his mild gaze, the King fell back abashed.

"Your dinner, my Liege," said the young man briskly, and led two greasy kitchen knaves past their bemused monarch into the royal apartment. Low-voiced he directed them to lay their burdens on a chest and to draw a small table nearer the hearth. He spread the table with a fair linen cloth, set upon it a silver goblet and a trencher, dismissed his awed helpers, and turned to attend the King's pleasure.

The King stood planted by the chamber door, fists on hips. "Where is young Frith?" he demanded. "And who in the devil's name are you?"

"Thomas Frith is fallen ill of the plague, my liege, and I am William Flower, Surveyor of Your Majesty's kitchen."

"Where is Steward Melton?"

"Ill, my Liege."

"And little Edward Peel?"

"Dead, my Liege."

"God's bones," said King Lionel, and gloomily sat down to his meat.

At first the King's hunger claimed all the King's attention, and most of a lark pie and two thick slices of roast venison disappeared in short order. His stomach comforted, King Lionel began to take notice of his new man-servant, who was

both silent and deft, and sank to one knee when offering a dish or pouring out wine with remarkable grace. When at the meal's end Flower knelt to him with a bowl of scented water, the King dabbled his greasy fingers, then laid one dripping hand on the servant's shoulder and studied him. His face was cream and rose, firm-jawed and comely, lean at the cheek and round at the chin, like a boy's on the edge of manhood. Robin had looked so, before war had hardened him. "I know you not," said Lionel abruptly. "Whose son are you?"

The young man flushed. "My father's, Majesty," he said, and something in his tone sent the King's hand twitching to his jeweled dagger. No nameless kitchen-boy bespeaks his monarch so. But Lionel's sudden flare of anger died as suddenly into indulgent amusement. The boy was undoubtedly some noble's bastard; no peasant or knave could have sired that aquiline nose, that damask cheek, that touchy pride. Lionel released Flower's shoulder, but did not bid him rise.

Upon the table sat a bowl of peaches, the bounty of the Royal Gardener's glasshouses. Every year Tom Gatham himself brought the first peaches to King Lionel and presented them with a bow and a snaggled smile, just as he had brought early cherries to his father. Now Lionel drew the dagger he had been fingering, and taking up a peach, began to pare it, all the while studying the serving-man kneeling at his feet. "You are young to be an under-steward," he remarked.

There was a pause, as if the man must consider his answer. "I am . . . five-and-twenty, Your Majesty."

The King was disposed to be merry. "Why, your cheek is as smooth as a girl's; one would think your mother's milk still wet upon your lips. Five-and-twenty! Why, I myself am just two-and-twenty, and I've had hair to my chin for four years and more." He cut a slice from the peach and ate it, pausing to stroke a dribble of juice from his neat golden beard.

"Has Your Majesty found aught to complain of in the service of his feasts these three weeks past?" asked Flower stiffly.

The King shook a thoughtful head. "No. Indeed, I had thought that we owed the hot pies and unruffled peacocks to Lord Steward Melton's losing his taste for malmsey. That was your work?"

"Yes, my liege."

All at once King Lionel saw a remedy for at least one of the ills that beset him. He sat up briskly. "Master Flower," he said. "Your age be damned. Any man who can see to it that I am properly served, even if only a pair of scullions remains afoot to do it, is a man with his wits about him. Until Melton recovers, do you act as Steward. And seek out the Lord Chamberlain, if he is not fallen ill as well, and discuss with him the entertainment of the Gallimand delegation. They will be here by the end of the month."

Master Flower's smooth brow lifted, his eyes widened, and his mouth fell slackly ajar. Observing this mask of silent amaze, Lionel laughed aloud. "Never thank us, Master Flower," he said, "for it's a sore task we've set you, hard and bitter as this peach stone." Pleased with both conceit and decision, Lionel tossed the peach-stone to the man and settled back comfortably to finish his wine. "Rise now, Master Steward Flower, and go about our business."

Chapter Four

IN THE TWENTY-NINTH year of the reign of King Geoffrey, called the Just, his wife Queen Constance died. She drew her last breath on St. Thomas' morn, and word of her death blew from Cyngesbury Castle on a wind of grief so swift that before March was half-spent, all Albia was mourning her kind and well-loved queen.

Far from the capital, on the northern border of Hartwick, Tom Martindale heard the news from a Benedictine brother who had carried the sad tidings from his prior at Cyngesbury Abbey to the Prior of Barthon, just north and west of Seave. Now, this Brother Jerome was son to Tom's father's sister who had married a Cyngesbury farrier, and it was in the spirit of family fellowship that he broke his journey from Barthon to Cyngesbury to visit his cousin.

Brother Jerome rode into Nagshead Farm between sext and nones, a fat black figure astride a dumpy brown mule. The farmyard lay in after-dinner somnolence, empty but for the flock of chickens that flew up suddenly under his mule's feet in a dusty, squawking cloud. The mule, startled, commenced to bray. Brother Jerome, furious, lashed out with his hazel-switch and belabored both mule and chickens. The resulting hurly-burly brought Martindales running from byre, dairy, kitchen, and stillery until Brother Jerome beheld nearly all his cousins gathered before him: Tom and his wife Bet, their nephews Hal and Jack, Jack's wife Mary with their little daughter Anne astride her hip, and Tom's daughter Elinor, with a fat black-and-white dog wheezing at her heels.

Elinor shooed away the chickens while Hal stood to the

mule's head to calm it. Tom lingered frowning by the horse-trough. "What brings 'ee so far from Cyngesbury, cousin?" he called. "What seek ye here?"

Brother Jerome climbed down from his mule's back and shook out his dusty habit. "I seek you, Tom Martindale, to tell you and yours that the Queen is dead. Tomorrow I will seek out your parish priest that he may say a mass for her soul's repose." He looked about him at his cousins, who gawped at him blankly. "Is there no welcome for your fa-ther's kin, Tom?" he asked, and his voice was so plaintive that Bet was moved to come and kiss his greasy jowl.

Turning from the old woman, Brother Jerome chucked baby Anne under her plump chin and bussed pretty Mary heartily on the lips. "Kinsman's privilege, sweet Coz," he said, and winked broadly. "And thou"—holding out one fat hand to the tall girl hanging back from the press around him—"thou art my little Cousin Elinor. Come give thine nuncle a kiss, sweeting."

"Ye must be sore athirst, Brother," said Bet hastily, and took his arm to lead him indoors. "Come in and sit ye, while my lass Elinor fetch in a tankard to damp your throat. Queen Constance dead, ye say? And her such a young woman!"

Bet was near sixty now, hale but gnarled like an old apple tree that still bears well but creaks and splits in the winter winds. Her hands and knee-joints swelled and ached on rainy days, and she found it hard to knead bread or sweep the floor. As she drew Brother Jerome to the high-backed chair by the hearth, she smiled to hear herself describe the Queen—who must have been all of forty—as a young woman. A sure sign of age, she thought, when forty seems young.

When Brother Jerome was enthroned in Tom's own chair with ale and barley cakes set easy to his hand, the family disposed itself around him. He smiled, they smiled. Silence fell. Elinor and Mary began to speak at the same moment, then broke off, Elinor laughing and gesturing for Mary to begin, Mary shaking her head, a little sullen. Elinor looked to be twenty, Mary a little younger, and already ripening with a second child. Bet asked him about the Queen's last illness.

"Alas, Mistress Bet," Brother Jerome answered lightly, "I am not an herbwife or an infirmarian, but only an ignorant scribe who recks naught of rheums, agues, or palpitations.

God saw fit to call Her Majesty to His bosom the third week in Lent, and, like a dutiful daughter, she answered the summons. I know no more.''

''So the poor woman's been gone a fortnight, and us unknowing as so many babes. It be a quiet life we lead, as ye see, good Brother, with no news from Martinmas to the Lammas Fair. The burying must a' been a sight.''

Solemnly, Brother Jerome nodded. ''I myself walked behind the coffin among my brothers of Cyngesbury Abbey. Her Majesty having expressed a wish to be buried at Harldon, it was a long and dusty trek we had, all strung down the Harldon road like a band of strolling players following their wagon, that being the coffin, you know, loaded on a gilt chariot drawn by six horses in trappings, for all the world like a player's wagon, as I said, only black. Most of the mourners were walking, chanting prayers for the Queen—God rest her—and only Lord Foley and Lord Maybank riding, they being the Queen's close kin, and of course the King and Prince Lionel and the Prince's foster brother, all on black horses, though I hear that Lord Foley's horse was his grey mare Estelle rubbed with soot to take the shine from her, as the saying is. A mile without Harldon, the cortege was met by. . . .''

''A pest take thy cortege, Cousin,'' said Tom. ''By'r Lady, thee rattl'st on like to an old cart.''

Bet frowned at her husband and laid a soothing hand on the monk's black-clad arm. ''Brother,'' she said hastily, ''I'd hear of the King and young Prince Lionel. How looked they?''

Brother Jerome reminded himself of his vow of humility and took a deep pull of Bet's excellent ale. ''King Geoffrey rode to the chariot's left, ever and anon drawing up his horse and looking sorrowfully at the coffin within. There is no doubt he loved his lady, though she bore him more daughters than sons and was somewhat thick as to her waist and hips.'' Here he paused to cast a stern eye on young Hal, who was scarlet and nigh bursting with ill-suppressed laughter. His cousin Tom's family were an uncouth lot, he thought sadly, swine before whom he cast pearls unthanked. Yet they had asked to hear about the funeral, and he was duty-bound to tell them, be they never so ungrateful.

He continued. "Prince Lionel rode beside his father, more dazed than sorrowful, I think, for he is a lad of twelve or thereabouts and long out of his mother's governance. Lord Wickham rode just behind him, and a prettier pair you'd travel far to see: fair and dark like two sides of a stamped coin. David and Jonathan, King Geoffrey calls them. Wickham will be Earl of Toulworth some day, and that is a rich barony."

"Poor prince," said Bet. " 'Tis a sorrow for a little lad to lose his mother."

Encouraged, Brother Jerome went on to describe the entombment and the funeral offerings the King and Prince had made to the church on behalf of the dead Queen. He had just begun to list the gifts of the various nobles—the altar furnishings and hangings, the purses of money and bolts of fine linen—when little Anne began to fret and whine. Mary carried her into the yard to quiet her, closely followed by Hai, who could be heard without the kitchen door, braying with laughter. Tom and Jack loured resentfully, and Bet exchanged pained glances with Elinor. All four silently praised heaven when the distant clamor of a bell caused Brother Jerome to check and fall briefly silent.

"There's nones a-ringing and the meat uncooked!" exclaimed Bet hastily. "Good Brother Jerome, your tale hath bewitched us." Bet heaved herself to her feet and made purposefully towards the larder. "Elinor, fetch Mary in, and see thou if there be lettuce for a sallet, and I'll be wanting thyme and marjoram to put to the white herring and savory for the fowl."

With Brother Jerome, there were thirteen at the board that night. The dairy-maids and laboring-men could scarce chew their meat for listening to the tale of the Friar and the dying man with which Brother Jerome entertained them between copious mouthfuls of stewed fowl.

"So the esquire carving at the lord's board opened his mouth boldly and said that the sick man's bequest could be shared if a cartwheel were brought into the hall, a cartwheel with twelve spokes, and the friars should lay their noses to the spokes' ends, and Brother John should kneel under the midst of it, and the sick man should sit above him, bare-

arsed, and, having dined well on beans and other such flatu-
lent fare . . .''

"Enough, good Brother," said Bet over the delighted gig-
gling of her servants. "We may tell well enow how the tale
must end, and 'tis past time for the maids to be abed. Dawn
do break earlier now 'tis spring, and the cows're heavy and
near their time."

Chastened, men and maids slunk off to dairy and barn,
leaving the family sitting over the wrinkled last of the winter
apples. Brother Jerome pushed his stool a little back from the
board and studied his cousin's women-folk. Mistress Martindale
he dismissed as a wrinkled old beldame with flat dugs and a
sad want of humor. Mistress Elinor was prudish as her mother
and plain with it—why she'd no more breast or hip than a
boy. Jack's wife Mistress Mary was much more to his taste.
She'd laughed heartily at his tale and was a toothsome lass
beside, plump and brown as a dabchick, with the small red
mouth that betokens a warm and likerous nature. But Brother
Jerome decided that he'd rather swive her than wive her, for
her eye was hard and shallow, and there was a set to her full
lips that bode ill for Jack's domestic tranquillity.

"You've a fine family, Cousin Tom," said Brother Jerome
heartily. "Two stout lads to till your fields and another
generation of Martindales amply provided for. I hit the mark
full center, Mistress Mary, do I not?" He beamed upon the
girl, who blushed and smoothed down the apron over her
out-curving belly. "And Mistress Elinor, what of you? Are
you soon to be wed?" He looked down the board with bright,
interested eyes.

"Our Elinor be a right nun," said Mary, all sweet malice.
"There be no farmer in this parish fine enough for the likes of
she. Yet I'll tell thee one truth, good Brother, and that is
her'll never die a spinster, though she do die unwed."

Smiling blandly, Brother Jerome looked sharp to see if
Mary's barb had wounded, but Elinor's eyes were bent to the
apple she pared, and her face kept its own counsel. Nearly
twenty and yet a virgin. It was no wonder, if she were as
unskilled at other womanly arts as she apparently was at
spinning. What's more, from what little she'd said that day,
Jerome deduced that she was too clever for a country lass.

Fearful for the family peace, Bet cleared her throat to

speak, but Elinor forestalled her. "You said ye be a scribe, Brother Jerome," she said, clear and low.

The little monk preened himself. "Yea, Coz. I am at present copying the Gospel of St. Mark for an altar Testament."

"I'd fancy to write, Brother Jerome," said Elinor. "And read."

The monk looked helplessly from Tom to Bet to Jack and back again to Elinor, as surprised as if the old dog at her feet had desired to learn the catechism.

"Child," he said seriously. "What need hast such as thou for letters? Surely thy parish priest can read thee what prayers and devotions are needful."

Tom grew red about the ears and burst out, "So I've said time and again, Cousin, but the jade'll go her own gait. I can nor write nor cypher, and I do well enow. I makes me mark and I keeps me tally sticks, like as me father did, and that be all the learning a farmer or a farmer's wife be called to know." He turned to Elinor. "Thou'rt nineteen years old, daughter, which is enough years to learn thee that letters do make no cheese nor find no husband. Let be, wench."

"Indeed, my child," said Brother Jerome unctuously. "It is not good that women learn to read. The writings of learned men are meat too strong for woman's mind, which was made to dine on simple domestic matters."

"Aye," said Mary suddenly, her childish voice spiteful. "As Father hath said, thou'rt nineteen years old, and all thee herb lore a' caught thee no husband. Dost think young men'll turn a blind eye to thy laziness in making and mending if only thou'rt learned?"

Elinor looked up, her lips rigid with anger. "I'd learn writing to make receipts for potions and ointments. These be domestic matters, surely."

Brother Jerome laughed. "These are domestic matters indeed, and nothing to squander written words upon." He reached down the board to pat her hand and wiped his mouth as a signal that both meal and argument were done.

Chapter Five

KING LIONEL'S CHAMBERLAIN Lord Roylance was the oldest of His Majesty's advisors, having inherited the honor some fifty years earlier in the reign of Lionel's grandsire, King Stephen Lackwit. Being fourscore years and more, Lord Roylance did little now but huddle by his fire with his reedy limbs swathed in fur-lined gowns. The elder nobles swore he had once been a good chamberlain, precise in his keeping of diaries, honest in his tallies, and exceedingly careful of his master's wealth. But not long after King Geoffrey came to the throne, the Chamberlain's mind began to creak and labor as it worked, ponderous as a mill-wheel unoiled. And by the time Geoffrey brought a second wife to his hall, Lord Roylance was well embarked upon his dotage.

It was as well that Queen Constance had been both a powerful witch and an able chatelaine. From the day of her wedding, she had guided the royal household by spell and by diplomacy. At her first interview with the Chamberlain, she had professed an overwhelming fascination with the smallest details of householding, from the state of the larder to the price of candles and bed-linen. Each morning, she would summon him to her solar, and each morning he would linger there for an hour or more, feeding her spaniels scraps of meat and talking of wines, flour, and other domestic matters. So faithful was Lord Roylance's attendance on his wife that King Geoffrey was wont to jest with his cronies that alone of all her sex, his queen preferred a slippered pantaloon to a young and lusty husband.

When Queen Constance died, all the tight-wove spells of cleanliness and rat-bane, of preservation and orderliness that she had set on the castle began to decay like unsalted meat. Lord Roylance doddered on, keeping his diaries and his tallies, saying, "In good Queen Constance's day," and, "As Her late Majesty was wont to tell me." But seldom did he remember anything to the purpose, and Cyngesbury Castle, Harldon, and the smaller royal houses at Mayd's Fayreboyes and Spellingtre were left to run themselves as best they could.

Until plague struck, Cyngesbury Castle had stood up well enough, shored by the remnants of Constance's order; but panic and suffering threw down her gates, and soon chaos reigned unchallenged. Each visiting noble sealed himself prudently into his own chambers and sent his serving-men on hurried sorties to the buttery to seize a cold joint for his household. The morning of Holy Monday, William walked to the Lord Chamberlain's apartments through halls empty but for the mingled odors of incense, sickness, and death.

Lord Roylance's door was closed and the Royal Physician stood before it, clutching an orange stuck with cloves and a vinegar-drenched kerchief. A trickle of priestly chanting seeped from within the chamber.

When the physician caught sight of William, he began to wail. "He was an old man! Too old for the leeches, I told him, and too old for the cups. But he would be bled. He *would* be bled, and he has died of the bleeding, and Lord have mercy, what will the King say?"

"That Lord Roylance was an old man whose course was run," said William. "No one would think to blame you for this death, good Master Doctor."

"I know what you would say, young man." The physician dropped the orange and began to wring his hands. "Youth and strength are dying all around, and what is one old man's death among so many? Alas, you are right. And yet he was the King's Chamberlain, God rest his soul, and it's far too late to send word to Gallimand." And the physician trotted off down the hall, moaning "Lord have mercy" at intervals, as though he were telling his beads.

William stood for a moment in the empty hall and gnawed thoughtfully upon a knuckle. Then he nodded with the air of a man who has made up his mind and turned his steps to his

chamber. He had not yet emerged when King Lionel sent word to kitchen, laundry, brewery, dairy, and bake-house that William Flower was to be considered Master Steward *pro tempore* and that all were to obey him, for he spoke with the King's own voice.

This news sent the kitchen flock into a frenzy of bleating and head-wagging. Master Hardy swore by St. Iniqus that he hated ingratitude above all sins and heaved an iron pan clear across the room. Peter Rawlings, Hal Clemin, and Dick Talbot put their heads together, muttering, and a joint of beef began to singe where Jack Priddy had left it unturned. After a space, Master Hardy departed for the cellar, shouting that he would take orders from no lick-spittle half-man, and Ned slipped away from the hurly-burly and through the corridors to William's chamber.

The Steward *pro tempore* was seated at a trestle, twiddling a quill between his palms and gazing out his window at the roofs of Cyngesbury town. He turned when Ned entered and raised his brows at the boy's breathless haste. "Why, Ned. What is to do?"

"The King ha' said ye be Master Steward now."

William sighed, laid down his quill. "I would he had not done so. Well, lad, 'tis done now, and a broken egg cannot be made whole again. Where's Master Hardy?"

Ned giggled. "Him'll be down i' the cellars, a-drowning of his spleen. Us'll see nowt of him this day, nor yet the next."

"The best thing is to leave him in peace," said William wryly. "Then there'll be only Peter Rawlings to deal with, and Hal Clemin. The others will follow where'ere they lead. We must pray, Ned, that Master Hardy's pride cannot be quenched in two days, or even three." With the air of a knight at the edge of the lists, William squared his shoulders and descended to the battle, followed by his faithful esquire.

The uproar in the kitchen could be heard clear into the screens passage, but when William entered, every voice fell quiet. Pages, squires, knaves, scullions, undercooks, master cooks: all froze in their various postures of entreaty, amaze, anger, dismay, as though the Steward's fair countenance had Medusa's power.

Master Steward Flower stepped through the stony silence to

Peter Rawlings' side. "Master Rawlings," he said, and bowed full courtly. Peter, bewildered, returned the bow.

"While a single noble remains in health, we must stand ready to feed him. Master Rawlings, I would ask you to have the ordering of this kitchen while Master Hardy is . . . ailing, and to appoint successors in the event that you be stricken, which God avert."

Peter Rawlings stared down at the young Steward, his mouth gaping and shutting as various thoughts came and went in his mind. Upstart or no, what the man said was only sense, and Peter had the wit to realize that he would only look foolish if he were to defy him. At last the Saucier nodded curtly and turned upon his astonished underlings.

"Well, ye gawping lobcocks, ye've heard the Master Steward. No man, well or sick, can live without meat, and no man may eat in Cyngesbury Castle without we feed him. So cease your gabbling and fall to work. Jack Priddy, that joint'll burn to cinders an ye turn it not. Jump to, or I'll crack thy knave's pate for thee."

So Peter Rawlings took up his dominion of the flock. Master Flower, smiling, withdrew and left him to it.

With barely a fortnight to prepare for the Gallimand embassage, William turned his immediate efforts towards containing the plague. He arranged for every stricken servant, man and woman alike, to be carried to the men's dortoir, and commandeered three stolid brothers from Cyngesbury Abbey to nurse them. He persuaded Peter Rawlings to lace every dish he sent up to the hall with saffron as a prophylactic measure. He marched the kitchen knaves to the wash-house in a body and sternly oversaw their ablutions. Like a good commander, he could be found everywhere, and as he did not simply give commands, but turned his own hand to their speedy execution, it was not long before he gained the respect and willing obedience of the domestic rank and file.

On Holy Wednesday, the Master Cook staggered up from the cellar at last, pale and red of eye. Being stale-drunk, surly, and half-blind from the thundering in his temples, he was in no state to oversee so much as the boiling of an egg. But when he laid eyes on Peter Rawlings standing in his place at the kitchen's heart, tasting a forcemeat with Master Har-

dy's own horn spoon, the throb in his head gave way to a blinding surge of rage.

Now, each flock of sheep has its king ram, who owns the largest horns and the loudest bleat, who leads the wethers and tups the ewes, and woe betide any young ramkin that seeks to usurp his place. Such a ram was Piers Hardy. He bore his horns not on his brow but in his hands, in the shape of carving-knives and long-handled spoons and iron pots, and with these domestic weapons he was wont to keep the peace and settle questions of precedence. But when he saw Peter Rawlings standing in his place and tasting with his spoon, Master Hardy simply balled his mighty fists and made for the Saucier, snorting deep in his nose the while.

The kitchen being at the height of serving the midday meal, the clamor of pots and spits and voices hid the sound of Master Hardy's charge. All unknowing of his danger, Master Rawlings calmly nodded his approval of the forcemeat. As the cooks and prentices became aware of their leader's wrathful charge, they fell silent, so that Master Rawlings heard growling and pounding feet and thought a fight was toward. He turned to quell the disturbance, horn spoon sternly upraised.

With a roar that shook the pots upon their hooks, Master Hardy dashed the spoon from his suddenly lax fingers and struck him a mighty blow square upon his jaw. And then, for all that Peter Rawlings was an earl's legitimate son, he louted humbly to the King's low-born Cook, and slid down the trestle's edge to lie senseless at his feet.

Master Hardy stood triumphant over the vanquished Saucier. "Bring me yon stripling Steward," he bellowed, "that I may serve him likewise. By sweet St. Scelestus, I'll pay him double fee for his treachery! I'll pluck his nose, I'll scar his beardless cheeks, I'll dish up his liver roasted and feed upon his lungs raw. Treacher! Serpent! Judas!"

Awed silence greeting his boast, Master Hardy swelled with new curses to blast his flock into utter submissiveness. But barely had he drawn breath to begin, when a clear and solemn voice from the hall steps fell into the silence like the tolling of a bell: "Sir Andrew Melton is dead."

Master Hardy lifted his eyes to the stripling Steward. He clenched his jaw against the scorn he expected to read upon that pretty, hateful face. But Master Flower's countenance

was bland as a blanc-mange, or a good courtier's. "I hope
you be in good health, Master Hardy," he said briskly. "His
Majesty has asked particularly for the *henne doree.*"

The following day, fully half of the inhabitants of Cyngesbury
Castle groaned and sweated with fever, and the other half
groaned and sweated with fear of it. Through that sea of
panic, Mistress Rudyard moved calmly from makeshift infir-
mary to stillery to laundry like a great merchant vessel freighted
with a soothing cargo of clean linen, prayers, and herbs. No
stench was so foul, no delirium so wild as to breach the
bottom of her massive calm. But when her son Ned came to
her, shivering miserably and whimpering with pain, she dropped
her armload of linen heedlessly on the rushes, gathered him
up in her mighty arms as though he were still an infant, and
bore him to her own closet, where she bathed his face with
rosemary water, gave him honey and dragonweed to drink,
and sat by him wringing her hands while he tossed and
muttered. Dared she leave him? Dared she not? Oh, why had
she not taken him to the monks?

At last Mistress Rudyard got so far as to hover, still
undecided, by the door. Suddenly, Ned heaved himself up-
right with a great groan and scrabbled at his sweaty arms as
though they crawled with invisible maggots. Mistress Rudyard
wailed aloud and fled. Breathless she lumbered through corri-
dors and back stairs until she came to the stillery, where she
found William Flower consulting an herbal as he stirred a
strangely-scented mixture over a small flame.

The sight of this whoreson haughty kitchen-boy brewing
nameless potions in the very vessels she needed to prepare
Ned's febrifuge, went to Mistress Rudyard's head like
unwatered wine. Snatching the beaker bare-handed from the
flames, she cast its contents down the oubliette. "Our King
may think thee a very rose," she panted, wringing her singed
fingers. "But I see only a weed, William Flower, a rascally,
choking nightshade!"

The Steward said nothing, but turned upon her a gaze so
bleak and hard that she retreated hastily into the passage,
where she tore her hair and railed aloud until the remaining
scullions and prentices ran to see who was murdering the
King's Laundress.

Inspired by grief, Mistress Rudyard was more than willing to tell them. It was Master Flower who had caused the plague, she said, Master Flower who had by him concoctions and essences that were not part of any herb lore known to her. Even now, she had found him brewing a mysterious and most evil-smelling potion. Furthermore, he had put her out of the stillery while her only son lay dying for want of a posset. "If Ned dies," she shouted at the unyielding door, "his death will be on Master Flower's head." Then, declaring that the King should be told of his Steward's unnatural witcheries, Mistress Rudyard astonished the gaping scullions by rushing up the stairs to the King's privy chamber and demanding in a voice like an alarm-bell that the King hear her.

And hear her the King did, in spite of his men-at-arms' best efforts to bundle her back down the stairs. Lionel had spent the afternoon trying to make sense of Lord Brackton's proposed plan for a trade in wool and linen that he must unfold to Tellemonde as though the proposal were his own. Lord Brackton not being gifted with the art of clear exposition, Lionel was finding the task all but impossible, and was consequently in no humor to bend a sympathetic ear to a noisy and offensive suppliant. Flinging wide his door, he stepped into the corridor and glared royally.

Mistress Rudyard tore her arms from the guards' hands and flopped to her knees, her broad face poppy-red with anger. "Justice, Majesty," she wheezed. "Justice upon the he-witch William Flower, who slays innocent children with his foul potions."

The King felt himself seized by a cold rage. He glanced at the men-at-arms. "Take this woman to the pillory," he said. "We would have her reflect on the Ninth Commandment that forbiddeth her to bear false witness against her neighbor. She may also recall, when she hath leisure, that Master Flower brews his potions with our blessing and at our command. Therefore, we would have her reflect most closely on the crime of treason."

Belatedly, Mistress Rudyard realized that she had been both rash and over-bold. As the men-at-arms dragged her to the courtyard and locked the pillory bar across her neck and hands, she begged them to tell the monks that her son was lying plague-struck in her chamber. "As you are Christian

men," she wept, "surely you will not leave a child to die alone." But the soldiers only tested the lock and left her without a word of comfort.

The moon rose, the stars shone coldly above her, and Mistress Rudyard bemoaned her foolishness until the courtyard echoed with her lamentations. By moonset, both her tears and her voice had spent themselves, and she slumped stiff and miserable against the oaken post. Her knees would hardly bear her, but if she let them flex, her weight dragged at her neck and wrists and rubbed them raw against the splintery oak. When at last the sky began to pale, she was half-stupefied with pain, and did not see Master Flower until he touched her elbow and showed her the heavy iron key he held in his hand.

Dully she lifted her head to look at him, and dully she let it droop again. Because of his mother's plentiful want of wit, her son must have died, and here was the whoreson Steward come to compound her misery by telling her of it.

"Ned is sleeping, Mistress Rudyard," the young man said gently. "The good brothers have him in their care, and all is well with him."

She shrugged painfully against the weight of the oak. The dead are said to sleep, and all is well with those who go sinless before the throne of God.

He unfastened the lock and heaved up the bar. Mistress Rudyard collapsed at the pillory's foot, moaning. "Come, Mistress, see if you may stand," he said, bending to her; and though she thought of damning him to Hell, Mistress Rudyard found herself too weak and weary to thrust aside his arm.

When he saw her wrists and her abraded neck, William drew a hissing breath between his teeth. "Ah, Mistress, I repent me that any hasty act of mine should have brought you to this pass. Lean on my shoulder, and I'll support you to the kitchen."

So, entwined like lovers, Mistress Rudyard and Master Flower made their slow way across the courtyard to the pantry door and up the flagged passage to the kitchen. When Master Hardy saw them edging towards the great hearth, he went to meet them, took the plump Laundress into his arms and half-carried her to the settle. She was deathly pale, and the marks of the pillory showed livid on her skin.

While Master Flower went in search of herbs and bandages, the Master Cook himself brought Mistress Rudyard a cold slice of meat and a draught of ale from his private store and a wet cloth for her tear-streaked face. Then, with rare sensitiveness, he left her alone. Silently, she swabbed her cheeks, ate, drank, and suffered the Steward to poultice her wrists and neck. Then, "Would you see your son, Mistress?" asked William softly. Catching her breath, Mistress Rudyard nodded and hauled herself to her feet, intending to confront loss bravely.

The men's dortoir was a long room, crowded now with pallets laid in rows like sheaves of straw; between them moved the black-clad Benedictines, stooping now and then to wipe a brow or give a sufferer to drink. Mistress Rudyard groaned when she saw them, and the flushed, twisted faces of the men and women they tended. But William coaxed her from the body of the hall and towards a pallet set near the door, a little away from the others. Upon it lay Ned, one thin arm flung over his tousled hair. His breast rose and fell in the deep, calm breaths of healthy sleep. His cheeks were no redder than they should be, and his eyes opened clear and sane.

Falling on her knees beside her son, Mistress Rudyard began to weep afresh. "Our Lady bless you, Master Flower," she cried and, seizing William's hand, kissed it before he could forestall her.

"A thousand, thousand blessings on your bright head!" She lifted her eyes to William's scarlet face and smiled damply at his confusion. "See how the lad blushes!" she said fondly. "Thou'rt a rose indeed, Master William, the fairest Flower among serving-men, and I bless the day thou cam'st among us."

Chapter Six

IT WAS AN EARLY May morning in the year of Queen Constance's death. The road between Nagshead and Hartwick Wood was dark and fragrant with spring. A thin mist haunted the new corn, cuckoos were rioting in the hedgerows, and bold-voiced larks shouted aloud for the sun to rise and show himself. In the midst of the birds' sweet noise, Margery, Jane, and Kitty tripped along the lane, chattering and swinging their baskets. As became Love's suppliants, they were dressed all in white, and their long, loose hair was gauded with violets and cowslips.

Behind her mother's dairy-maids walked Elinor all alone. She was tall and slender as a birch-tree, and her face was solemn. It could not be said that she went eagerly into the wood that May morn, but neither could it be said that she lagged. She went like a priest to church, unhurried and intent. And when the little party came under Hartwick's dark eaves, Margery, Jane, and Kitty hung back, and Elinor strode out before.

At first, she simply led her companions down the woodcutter's wide path leading to the coppice. But past that, the trodden way dwindled, branched, and branched again through the underwood. Elinor chose one of these faint tracks and followed it through brambles and flowering thorn to a small open glade, pearly with mist and may-blossom.

With the mist billowing ghostly about their knees, the four maidens moved reverently about the edges of the glade, cutting branches from the rowans and plucking new leaves from the birches. The branches Elinor wove into a shallow nest that Margery lined with rows of leaves tightly over-

lapped. Carefully, Kitty and Jane brushed dew into cupped leaves and tipped them into the basin until it was full. By the time all was done, the sky had warmed to sunrise. Kneeling then in a ring around the quicksilver mirror, each maiden awaited with a beating heart the call to look within.

Margery was the first of the four to start and turn color. She leaned forward over the basin, dipped her fingers in the dew, marked her lips and eyelids with three pearly drops. Low-voiced, she recited:

> Hart to hind
> Cob to swan
> Cock to hen doth turn
>
> May dew find
> True love mine
> That may love return.

Most earnestly did Margery search the basin, and most earnestly did her companions search her face for some shadow of what she found there. A breathless pause, then her eyes widened and a new-moon smile rose on her lips. Joy transformed her round face so that she shone like some rustic goddess, rose-lipped, berry-cheeked, crowned with vernal flowers. Then she sat back on her heels and was Margery again.

Twice more the charm was said; twice more a maiden sought her fate in the living water. Kitty smiled ruefully and shrugged as she drew back: she had hoped to see another face, but she could fare farther and do worse than marry John Blunt the brewer. Jane, who was walking out with a tanner's prentice, laughed and nodded over the still water, her dearest hopes confirmed. The three maidens exchanged smiles, sisters bound by a common joy, then turned their eyes on Elinor, who knelt with her head bowed and her hands knotted in her lap.

A small dawn breeze awoke and rippled the basin's surface like fine silk. Slowly, Elinor knelt up, dipped her fingers, spoke the charm. Her face in the growing light was pale; her voice was faint and halting. She leaned over the basin and her grey eyes glittered, crystalline. A shadow fell upon the enchanted water: a stranger's face, long-jawed and homely,

framed in corn-gold hair. His eyes were fixed, staring, blank as idiocy or death, and blood spangled his yellow hair. Elinor cried out and covered her eyes; the sun cleared the trees, the mirror blazed golden, and the spell was ended.

Trembling, Elinor plunged her hands wrist-deep into the basin and bathed her face in the dew. After a moment of silent confusion, Margery and Kitty and Jane performed the same pleasant ritual, then rose to fill their baskets with may-blossoms. As they cut the foaming white branches, the shadow of Elinor's terror lifted from their hearts and vanished into the sunrise and the green smell of the may. Laughing and singing, the three maidens retraced their steps to the coppice, scarcely aware that Elinor lingered behind them to unweave and scatter the basin of leaves.

That same May morning, a little after sunrise, a knight rode along the forest edge, whistling "As I went a-roving," merry as a blackbird. A good song for a knight errant, rich in honor, and you had only to look at him to know he was rich in naught else. Though his horse was a gay brown gelding, the knight was not gaily clad. His jerkin was of fustian cloth, marked with rust from his mail; his cloak was stained and worn; his boots were much cobbled. At the end of a long tether he led a sturdy grey mare slung like a pack horse with baskets and bundles. As to his face, it was brown and weathered as a nut within his scarlet hood. His cheeks were lined, his eyes were wrinkled from long squinting at foreign suns, his jaw was heavy and square, and taking one part with another, his destrier had the comelier of their two faces.

His name was Sir William Flower, and he was newly come from the North, where he had served his lord so well against the Brants that his lord, Earl Maybank, had bestowed the manor of Hartwick and its living upon him and upon his heirs forever. He was riding towards his demesnes, and his heart sang within him.

By and by, this rag-tag knight turned away from the trees onto the dusty lane that led from Hartwick to the town of Seave. As he ambled along, he saw a young maid upon the path ahead, dressed in white and bearing on her hip a round basket full to overflowing with flowering thorn. Sir William urged his horse to a faster pace and soon drew near her.

"Good morrow, good maiden," he greeted her. "God bring you cheer this fine May morning."

Seeing him, the maid started and stared so wildly that Sir William stopped his horse and asked if anything ailed her.

"Nowt in the world, sir," said she.

"Have you yet far to go? Would you ride thither? You need have no fear of Paladin; he goes gentle as a cart horse when I bid him."

Elinor stroked the horse's brown cheek and smiled as Paladin lipped her shoulder. "I've no fear o' he, kind sir. But indeed, 'tis not far." She bobbed him a country-girl's curtsey and turned to walk again.

It seemed then to Sir William that the birds fell silent and all the morning brightness paled. "Wait," he said, a little louder than he intended, and swung down from Paladin's back to stand beside her in the narrow, sunlit lane. "At least I may carry your basket a space." He heard his voice falter inexplicably between question and command, and under his hood, his ears grew hot and red.

Silently Elinor gazed on him; his ears grew hotter still. Then, "Thank'ee," she said and held out the basket. Sir William took it, lifted it up to Paladin's saddle, and paced slowly on beside her, holding it steady with one hand.

As they walked, he studied her sidelong. Never had he seen a comelier maid. She was nigh as tall as he, long and big of bone, with a fine broad brow, white teeth, and hair as fine as yellow silk. Her step was firm and her voice was deep and warm.

"Do you know aught of Hartwick Manor?" he asked.

She looked at him curiously. "Something east and south of here, within the fringe of Hartwick," she answered. "It hath lain empty this many a year, and all the fields be gone to bramble."

"Then I have much to do," said Sir William, smiling ruefully. "Well, those fields will soon be plowed, fair maid, for I am Lord of Hartwick now."

"Ye give me grace, my lord," said Elinor coolly, and halted. "Here my way parts from yours, my lord. Follow along to the standing gallows, then east over the lea to a rocky stream. 'Tis an easy ride from there, across the stream and to the south. I doubt ye'll miss the way." She reached up

to take the basket from Paladin's saddle. His heart all a-stutter in his breast, Sir William laid a hand on her outstretched arm.

"I'll have sore need of my neighbors' goodwill," he said, thinking that her skin was cool and smooth and soft as fine linen. "For I have spent my life in foreign wars, and know little of husbandry."

"My father be Tom Martindale of Nagshead Farm. Cousin Jack's husbandman now, seeing Father be more than three score and his knees stiff as sticks, but there be no man knows more of barley and kine nor Tom Martindale."

Sir William laughed. "There be no man knows less of them than I, so I'll thank him if he would consent to share his wisdom. I had never thought to own house or land, being my father's youngest son and bred to the sword, and I am but ill-provided to begin housekeeping."

"Ha' ye no wight to attend ye, sir?" Elinor peered around Paladin's laden rump to the riderless grey horse behind as if she expected to see an esquire, a train of men-at-arms, and carts of household furniture strung along the lane.

"Devil a one," said Sir William ruefully. "Nor so much as a joint-stool to sit upon."

As the sun rose and burned away the morning mist, the day grew warm as June. The scarlet hood weighed heavily on Sir William's head; he pushed it back upon his shoulders and ran a hand through his damp yellow curls. Elinor caught her breath and the blood drained from her cheeks. The basket tumbled onto the path, spilling white flowers at Paladin's feet, and Elinor would have followed had not the knight caught her around the waist and held her upright. "Come now," he said gently. "Let me set thee on my horse and carry thee to thy parents."

She did not answer him, but stood stiff and still in his embrace. Fearing he might have offended her, Sir William loosed his arms, and then he was sure she was hurt or angered, for he saw that her eyes welled with tears. She shook her head impatiently and rubbed at them with her fists. "Thankee, sir," she said. Taking her thanks for permission, Sir William tossed her up on Paladin's back, willy-nilly.

There she perched for a moment as if about to take flight, then shook out her rumpled skirts and settled herself against the saddle-bow. "My basket, sir," she said. Awkward as any

country hobbledehoy, Sir William gathered up the may-blossoms, tumbled them into the basket and set it on her lap. Then he took Paladin's bridle and led him forward.

"I'm thinking," said Elinor after a space, "there's much ye'll be needing an you'd sleep in Hartwick Manor this night. It being within the wood and so long left untenanted, I fear there'll likely be foxes nesting in the hall."

"And owls in the bower and mice throughout," said Sir William. "My first hireling must be a good hound to go like a squire before me and clear my way. Know you of a hound, keen of nose and white of tooth, who seeks employment?"

Elinor knit her brows as if considering the question seriously. "Trey's Blanche's George be lately weaned. Ye may chaffer wi' he when we do reach the farm. Ye'll be needing a scythe, too, for to cut a way to the door. The bracken ye reap can serve 'ee for a bed, an ye pick out the brambles. But ye'd best not light a fire, for sure the chimney'll be blocked."

"Alas, I fear me I shall lie easier in the fields than in Hartwick Manor," said the knight sorrowfully. "For in the fields, at least, I may find straw for a bed and wood for a fire and need turn neither fox nor mouse out of doors."

Elinor laughed. "Meseems ye be over-tender for a soldier, sir knight. 'Tis fitting that the fox sleep in his earth and the mouse in her nest. House and hearth be for a man."

"Aye," he said.

They paced on in silence through the bright morning and soon they came to a second lane cutting through the hedgerow. Sir William turned onto it and found himself looking out over a wide hollow to a stone-built farmhouse surrounded by outbuildings. Beyond it, he saw a field with oxen yoked to a harrow and two laboring men coming after to break the clods. Another field showed a blush of green; cows were visible in a third, grazing on new grass: it was a prosperous stead.

"I'll walk from here, sir," said Elinor suddenly, and made as if to slide from Paladin's back.

"We'll walk together, then, for my intent is to call upon your father and chaffer with him for a cow and a scythe and the loan of a laboring-man until market day. Is there a hiring-fair at Seave?" He turned and met her gaze. Would she dismount and walk on ahead, he wondered, leaving him to trail after like a stray dog?

For a timeless space he stared and she stared, eye to eye and motionless until it seemed to Sir William that there was no face in the world but the face of that maiden, and no greater happiness he could hope for than to kiss her and call her his love. It came to him then that he would wed her, if she'd have him, for she was all unlike any other woman he had ever known, dear and familiar and beloved.

Elinor broke the heavy silence and brought him back to himself again. "The hiring-fair be done and gone two weeks since," she said. "But I doubt not Mother'll help ye to servants. Ye'd best make haste if ye'd find her, for May morn or no, there's the butter to churn and tomorrow's soap-making day."

Although her words could not be called lover-like, Sir William's heart began to pound and stumble with joy. She had not sent him away; she had promised to help him: what better start to courtship? Laughing, he seized Paladin's bridle, and strode toward the farm at such a clip that when at last they came into the dooryard, he was streaming sweat and scarlet as his hood.

"Hoy!" he panted. "Holla within there!" An old farmwife appeared in the farm-house door and peered out, her round face puckered with age and worry. He smiled at her. "God give you joy," he said.

When Bet saw her daughter perched high on a steed that could only be a warhorse, led by a tall, ugly man in rusty leather, she hobbled out to meet the ill-assorted pair as fast as her aching legs would take her. Some five steps from them she halted, quirked her withered lips, and set her arms akimbo. "Elinor, child, what wast thinking on, to bide in the woods so late? Margery, Jane, and Kitty be all come home this hour and more. Well, Mistress Gad? What hast 'ee to say for theeself?"

Gathering his courage, Sir William stepped forward and bowed. "Mistress Martindale? I am Sir William Flower. I am come to live in Hartwick Manor. I . . ." What should he say? That he sought to court her daughter, though he had only just now learned her name? Before this wizened, bright-eyed beldame, Sir William's brave discovery of love seemed to dwindle into a cowardly desire for a woman to cook and clean for him by day and warm his bed by night. It is not thus, he

told himself, but only time may prove that I am right and she is not.

So Sir William smiled bravely at his true love's mother and said, "I met Mistress Elinor upon the road, and it seemed to me that she was weary and pale. I pray you will not scold her, but give her meat and drink and let her sit at ease." He lifted Elinor from Paladin's back and, releasing her waist with courteous speed, addressed himself again to Bet. "If you will tell me where your husband can be found, Mistress, I would speak with him."

"Hal!" Bet shouted, never taking her eyes from the knight's face. "Hal Martindale!"

A lad's round face popped up at the corner of the building. "Aye?"

"Bid thee nuncle come hither, for there's one would speak with 'un. Bestir theeself now!"

"Good Master Hal," called Sir William after him, "prithee lead my horses to water, and see they do not founder themselves. I'll seek thy nuncle where he bides and not trouble him to come to me."

"He be in byre wi' Jack, master. Old Daisy hath a bee in 'er titty."

Bet exclaimed on Hal for a gadling and a wag-jaw, but William only laughed and strode off towards the byre, scattering chickens as he went. A strange knight, Bet thought, at once lordly and humble, ragged as a beggar, but commanding. And he had honest eyes in that long spade-face of his. That he loved Elinor was easy to be seen. Such a marriage between high-born and low was not to her liking, but as for that, who was there to swear that the girl was not, in truth, as well born as he?

While Bet mused, Elinor made for the farm-house, her face pale and rigid, her hands trembling upon the rim of the basket of mayblossom. She walked as one who dreams open-eyed, and when Bet saw her, she had set her foot upon the door-sill and was on the point of going in.

"Daughter, daughter, what dost thee?" Bet fairly cackled in her fear. "Wilt go in a-doors with that may?"

Crying out, Elinor thrust the basket from her as though it bloomed with fire.

Mayblossom in the house means death and misfortune, and

no witch—yew-tree or willow-leaf—has power to turn the omen. The girl stood as if struck into stone, twisted in the open door, one foot poised on the stoop, one still planted safe upon the bare dirt of the yard.

"Well," said Bet at last. "I doubt us'll take much harm from thee carelessness, as thee hasn't properly crossed the sill. There be naught us can do, anygates."

Then Elinor began to weep aloud, great heaving sobs that sounded both angry and sorrowful. Thanking heaven that Mary was in the dairy, Bet led Elinor to the stillery, sat her down on a bench, and held her while she sobbed and wrung her hands. A storm so violent must have been long in the building, she thought, and such storms are better left to storm themselves out. It was seldom enough that Elinor wept at all.

At last Elinor, thick-voiced, began her complaint. In broken phrases, she gave her mother to know that she would not tie herself to a horse-faced stranger with a nose like a black-pudding, hair like barley-straw, and not a farthing to bless himself withal. She was not a child to be affrighted by visions seen in a bowl of water. "It showeth what may be, not what must perforce come to pass," she declared. "So, I choose not to wed wi' he."

Puzzled, Bet shook her head. "Choose or not choose, what must be, will be. What thee saw'st was truth, though truth do oft come masked, they say." She paused, then asked, "This Sir William Flower was then the lover the may-bowl did show thee? Be there another wight thee lov'st better than he?"

"No," said Elinor. "There be no other. I'd liefer not wed at all."

Bet, losing patience, took her by the shoulders and shook her. "Not wed, quoth'a! What dost think upon? Not wed? A yew-tree witch not wed? Who will birth the babes of this parish when I do lie in grave? No goodwife will suffer a virgin at her child-bed, nor be it fit for a virgin to be there. Would'st leave them all to Mistress Nan Carver, has nowt but a rowan-leaf behind 'un? Sound the death-knell for Seave, then, for there be no babe so lusty as can out-live Nan Carver's handling!"

Elinor pulled herself away from Bet's grasp and stood at the stillery door, her back stiff and defiant. A moment passed

and then another while Bet wondered whether the time had come for her wish-created child to dissolve into rain and leave her. Leave she must in any case, for the time had come when Mary could no longer live with Elinor under the one roof. Sorrowfully, Bet sighed and shook her head. It was a knot too tightly drawn for her to unloose.

"Hartwick Manor be a sorry place," said Elinor.

"When I were a little lass it were fair enow," said Bet carefully.

" 'Twill be long labor to clean and make it fit for dwelling in."

"Then 'tis best he begin soon, that the roof be sound by winter."

Elinor nodded. "I'd have him stay and take his dinner here, Mother, if thee be'st willing. He'll find cold cheer at Hartwick, and a full belly's a good friend when there's work to be done."

Solemnly, Bet agreed, and followed her daughter out into the sunny dooryard.

Chapter Seven

THE DAY OF the Gallimand Ambassador's arrival crept nearer and more near. Each morning, Flower's servant brought the King accounts from city mercers and makers of buckram and felt, lists of musicians and tumbling troupes, requests for sums of money to be sent to the Dukes of Trinley and Greenhaugh in payment for kine and sheep and unground corn to be delivered at Reddingale Field before May Day. Lionel set his hand to these bills as readily as he had once set his hand to the bills presented by Lord Roylance, but he was mightily puzzled by some of them—especially those to the account of the felt-makers. What use were three thousand ells of fine felt in keeping Ambassador Tellemonde comfortable, safe from contagion, and entertained?

Yet daily proof of his steward's industry appeared in the ample feasts that covered the boards noon and night, the herb-fragrant fires that gave off healthful savors in each inhabited chamber, and the constant to-ing and fro-ing that made the number of serving-men in Cyngesbury Castle seem twice as many as usual despite the depredations of the plague.

In a beehive, the honey is made out of sight, deep in the waxen corridors of the bees' wicker castle. When the bee-keeper observes his bees swarming in the meadows and around the door of the hive, he knows he may take the honey on faith. But Lionel, who had never before thought to concern himself with Cyngesbury Castle's internal economy, saw his servants buzzing through the halls, laden with plate, furniture, and linen, and tried to believe that the end of all this activity would be Ambassador Tellemonde's good will.

Finding that belief comes easier if not too closely examined, the King flung himself into sport. He rode out hawking with his favorites daily, and challenged them to sweat and strive with him in the practice-yard. He belabored Sir Edmund Sewale's shield with a wooden sword until the young knight laughingly begged for mercy, and played at quarterstaves with Lord Molyneux.

One morning found the King and Lord Molyneux out in the practice-yard, stripped to shirt and hose, thwacking at each other with a will while the dust rose in puffs around their feet. Eyes locked fast in a fighter's teasing, challenging gaze, they circled, feinted, aimed the long staves at belly, head, or legs, each doing his utmost to send the other sprawling in the dust. Lord Molyneux was not so stout a stavesman as Lionel, but yet he rapped his monarch's ribs once and then again. At the second touch, the King had dealt the young lord a shrewd blow to the ear, which felled him flat and ended the bout.

Heartily the King laughed to see Lord Molyneux sitting spraddle-legged in the dust of the practice-yard, shaking his head wherein a nest of bees hummed merrily. "Good sport, my lord!" cried he, then gave him his own royal hand to help him rise, and embraced him most brotherly. Then, feeling pleasantly stirred and heated by his exercise, Lionel called for his pages to attend him to his chamber.

The shortest way from the yard to the royal apartment led past the state chamber wherein Ambassador Tellemonde would lie. Lionel saw the door standing ajar and stopped to look within. For a moment his mind rejected the testimony of his eyes, for where he had thought to see splendor, there was only desolation. Bedstead, chests, tables, hangings, the very candlesticks and ewers had been removed from the room, and it stood empty but for a pile of half-rotted rushes and one monstrous spider-web dotted with the husks of an army of flies.

Lionel's belly twisted with rage and he stormed from the state apartments and through the halls of Cyngesbury Castle, looking upon them with newly opened eyes. Everywhere tapestries had been stripped from the walls and chests and chairs and carved wooden tables had been removed. Paintings, cushions, jeweled salvers and ewers, all those appointments that served to soften the grimness of a drafty old

fortress, all had been spirited away. Raging, Lionel returned to his rooms and sent Thomas Frith to fetch Master Steward Flower immediately into the royal presence.

In the wide embrasure of the privy chamber's window stood a long table where the kings of Albia had long been accustomed to conduct their business. The royal apartments lying in the castle's oldest quarter, this window gave onto the courtyard, with a prospect of the front gate, the stocks, and a small flock of the royal chickens scratching for insects in the dust. Fuming, Lionel gazed blindly over the familiar scene. He had been over-whimsical in his choice of Steward. What could a nameless kitchen-boy know of protocols and the entertainment of dignitaries? Sir Andrew may have been a sot and Lord Roylance a dotard, but Sir Andrew and Lord Roylance were gentlemen born who had understood the courtesies due to their monarch. Even Lord Roylance had presented to the King his plans for a feast or a tourney, waiting for royal approval before he would presume to act. That the King had scant interest in such plans was immaterial. Young Flower should have come ere he was sent for.

A knock, respectful but firm, broke in upon his musings. Lionel clenched hands and teeth against a burst of rage and turned from the window to see Master Flower bowing before him. In his arms he carried a most daunting sheaf of documents.

King Lionel frowned mightily at both documents and Steward. "Well," he said. "We have seen the state chamber, how you have made it fit for the lodging of rats and spiders but not of human men. An we do not house them under our own roof-tree, what in God's name would you have us do with these Gallimands?"

In the course of this speech, the King's voice swelled to a very roar. The young man did not quail, but only unfurled upon the table a careful map of the royal city and its surrounds. "We will erect a city of tents by the river in Reddingale Field," he said quietly. "During Lord Tellemonde's embassade, Your Majesty shall hold his court within these pavilions. The site itself will constitute the heart of the Ambassador's entertainment, a *court champêtre* to honor the spring."

Scarce able to credit what he had heard, Lionel glared at the man. Did this kitchen-knave think that Tellemonde's spies would not discover the true cause of this farce? "If, sirrah,

you would suggest that we conceal this plague from our royal brother's envoy, then you go in sore danger of your miserable life. We did not appoint you Steward to hear such kitchen counsels from your lips.''

"Your Majesty mistakes my meaning. Certes, it would be both wrong and foolish to seek to hide the presence of fever in Cyngesbury, but there is no need to make public declaration of our plight. A word in the Ambassador's ear will assure him that only servants recovered from the fever will wait upon him. Your Majesty may also tell him that his meat comes from the Duchy of Trinley, where there is no breath of plague. I mean to protect him from the contagion, not conceal it from him.''

"Hmph," said King Lionel, and began to turn through the papers.

Page after page of fine linen paper was covered with the Steward's neat hand. There were lists of furniture and food-stuffs, plans for a masque and a public tournament, documents laying out where each tent was to be erected, who was to be housed therein, and how their baggage, horses, and servants were to be disposed. After a space, Lionel shrugged. "This is very well, Master Flower, and we commend your ingenuity. But Ambassador Tellemonde is known to be a most punctilious man. How are we to be properly ceremonious in a tent? What if it rains?''

But Master Flower had an answer for this, too, having found in the royal archives accounts of splendid councils held by former kings of Gallimand in similar encampments. As for comfort, he protested, these were no campaign tents, cramped and bare and leaking like sieves, but water-tight pavilions most sumptuously appointed. And when, feeling cornered, the King complained that eating out-of-doors was unhandier than the juggling of an armless man, the Steward became positively animated in expounding his plans for feasting *al fresco*.

At length, King Lionel laughed aloud and begged him to hold his peace. "Enough, enough, good Master Steward. We are content to leave it all in your hands.''

Master Flower gathered up the scattered papers while Lionel, in a fine high humor, lounged back in his chair and

watched him. The lad had done well, he thought. A nobleman born could not have done the thing more courtly.

On a sudden impulse, he leaned forward to catch William's hand and turn it palm upwards. A man's hands may reveal whether he is a knave or a lord, a scribe or a swordsman. The skin of William's hand was a little coarsened from his labors in the kitchen; the middle finger was stained with ink. But withal it was a shapely member, strong and supple and warm in Lionel's grip: a beautiful hand, a hand to be relied upon. "A fair hand," said the King as he released it. "But none the less strong to execute what plan your wit may suggest in the service of your king. It was a happy day you came among us, Master Flower."

The Steward's pale cheeks flared scarlet as a girl's. As he bowed himself hastily out the door, the King smiled. This Master Flower was a comely lad, a welcome change from aging courtiers and wrinkled councillors who were forever frowning and looking solemn. And unlike Lord Molyneux and Sir Edmund Sewale, this man had wit and learning and a steadiness of purpose they would do well to learn. Yes. He'd wrought wiser than he knew when he'd made William Flower Steward.

King Lionel conferred with his new steward on the Feast of Philip and James. On the Tuesday following, a messenger rode into the court before dawn to say that Ambassador Tellemonde had landed at last, and was even now riding to Cyngesbury with an escort of knights and retainers to the number of two hundred men.

This news set in motion a machinery of ceremony that William had painstakingly designed and set in place not two days earlier. Within the hour, grooms had caparisoned the finest horses in the royal stables and led them to the forecourt where those nobles who were well enough to ride hurried to mount them. When the Ambassador approached Wyrmford a little before noon, King Lionel and his chief advisors were at the bridge to meet him, decked out in their gayest attire and garlanded with spring flowers, looking as careless as larks. The King trotted his tall grey horse onto the stone span and met the Ambassador upon the bridge's crest. Rising in his stirrups, he embraced the old man, and with his own hands,

placed a garland of marguerites and green laurel upon his grizzled head.

"*Le printemps est arrivé*," said the Ambassador, touching the chaplet. "You do me grace, *mon roi*, crowning this snowy capital with green spring. It is a good omen." The Albian court politely applauded the Ambassador's conceit, then two ladies, dressed as nymphs in gauze veils and garlands, rode forward to escort him. Other ladies crossed the bridge to bestow chaplets of flowers upon the rest of the Gallimand lords, and soon the whole company—lords and ladies and knights and all—rode flower-crowned to the Field of Reddingale.

At the crest of the hill above the field, the Ambassador stopped and clapped his hands in wonder. "Ah!" he cried. "*Comme c'est beau!* Never have I seen such loveliness set forth to welcome me! *Mon roi, je suis enchanté!*"

Enchanted indeed was that prospect fair. Tents of scarlet and russet and celestial blue clustered around a great central pavilion, white as snow and swagged with cloth of gold. Bright pennants flew from the apex of each tent, and the grass around was smooth and green. On the road between hill and encampment stood a group of players, who struck up their lutes and fiddles as the royal party came into view and melodiously welcomed the Gallimands to Albia in the name of Queen May.

That afternoon, when King Lionel and the Ambassador sat down to dine, the King's opinion of William Flower grew more golden still, for Tellemonde could not sufficiently praise each detail of the *court champêtre*. From the end of the grace to the removal of the first course, Tellemonde exclaimed with Gallimand enthusiasm over the delicacy of each dish, the elegance of his quarters, in fine, the universal grace and comfort of his entertainment.

Nor did that impression fade as the days lengthened into weeks. No lack of meat, no awkward rainshower, no shadow of sickness or death came to cloud that bright encampment spreading like an animated rose window under the clear May sky. Each day brought its own diversions arranged and deftly managed by the Steward: hawking, river expeditions, wrestling, passages of arms, masques, pageants, feasts, games, races. A tourney was proposed for the Feast of St. Augustine,

and the Albian and Gallimand knights set up mock jousts in preparation. The King broke lances with them cheerfully, and was heard to say that it had been too long since there had been a public tournament. Seeing him pound down the lists, shouting as he rode, Lord Brackton and Baron Carstey began to hope that their worrisome monarch was at last come to his kingly senses.

In fact, that same *court champêtre* went far to heal the wound left by Robin Wickham's death. Lionel himself was largely unaware of the cure, for it was accomplished by his being allowed to forget that he had been wounded. When he knelt at Mass in the May-green fields, Robin's half-finished sepulchre did not stand before him to reproach him. When he stripped to wrestle with the wiry Gallimand lords, there was no familiar move in this novel exercise to remind him that it was not Robin who strove with him. Dancing la Volta on the grass and eating with the vault of heaven above him was not as poignant of other dances, other feasts, at which Robin had danced and eaten at his right hand.

For three weeks, the King of Albia held holiday, and then, reluctantly, settled down to the real business of Tellemonde's visit. Master Flower appointed one grass-green tent as a council chamber, and there King and Ambassador retired to discuss the question of alliance.

The steps of the negotiations, though complex, were as fixed and inevitable as the measures of a sarabande. The situation was as Lionel had feared it. Trade and military treaties, loans of gold or influence, even the bare assurance that King Arnaud would never seek to invade or annex the kingdom of Albia, all depended upon King Lionel's agreeing to marry la Haulte Princesse Lissaude and make her Queen of Albia.

Policy, Ambassador Tellemonde assured Lionel, had nothing to do with this stipulation. After seeing a portrait of King Lionel at the chateau of the Duchesse du Frise, the Princess had conceived an undying passion for him. Lissaude would marry King Lionel of Albia, she had declared, or she would enter a convent. All the world knows that a princess cannot enter a convent, so her loving father had determined to bring the marriage to pass. Having recounted the history of Lissaude's *coup de foudre*, Tellemonde shrugged delicately and waved a

perfumed hand. "The Princess is a woman," he said. "What mere man can pretend to comprehend the workings of a woman's heart?"

Next, perhaps in the hope that a similar bolt might strike the King, Tellemonde presented Lionel with the Princess's portrait. It was a study of her head and bust, almost life-sized, painted in the realistic manner of Liscard. If the portraitist could be believed, Lissaude's lips were full and as red as blood, her skin as fine and white as snow, her hair as smooth and black as ebony. Without duplicity, Lionel declared that no monarch could want a fairer queen, and listened carefully to Ambassador Tellemonde's rhapsodies on the lady's youth, modesty, and piety. The gaps in the envoy's encomiums made him suspect that the girl was as bone-witted as she was fair, and stubborn above both. She spoke no Albian.

But in addition to her blank mind, her lovely face, and her well-tended soul, Lissaude intended to bring her husband two rich duchies, a considerable sum of gold, her father's good will, and the services of a powerful and respected wizard, who was also own brother to the High Bishop of Estremark, whose influence in Irridia and Liscard Lionel could not afford to ignore.

Thus the love King Lionel bore for Lissaude's dowry overcame his indifference to her person, and after a day of polite hesitation, he acknowledged himself enchanted to become her husband. On the eve of the great St. Augustine's Day tournament, Lionel set his seal to the marriage settlement, agreed that his wedding be held in June a year hence, and celebrated his bethrothal to la Haulte Princesse Lissaude de Gallimand in a feast of four courses and forty dishes. Among the superstitious, it was hailed as a fortunate omen that on that day, no one lying sick in Cyngesbury Castle died, and the most recently stricken rose from their beds, well men.

The morning of the tourney dawned brisk and clear. As the King's chamberer dressed him in scarlet hose and a new cotehardie embroidered with lovebirds and orange-flowers, the King thought wistfully on the knights girding on their vambraces and their tilting helms. Soon they would be tilting for Albia's glory and their own, while he must deck himself out in bells and motley like a very fool and sit idle in the

stands, exchanging pleasantries with Tellemonde (who was a great bore) and smiling upon all and sundry until his face ached again. Well, thus it was to be King. Lionel threw back the sides of his short mantle, crammed a golden circlet over his sunny hair, and comforted himself with the thought that the prizes were sufficiently noble to ensure noble jousting. A fine bay courser with all his furniture would go to the first knight in the field, a jeweled girdle to the second, and a tiercel falcon to the third. Three years ago, Robin Wickham would have taken the horse and himself the golden girdle.

Ay me, thought Lionel as he strode from his tent and into the festive hurly-burly of the morning. Prince Lionel the Golden, bold and fancy free, was as dead as his dead friend. The prince who won jeweled girdles at tourneys would never have been cowed into marriage with a convent-bred peahen. Why, he'd as soon wed the Countess of Pascourt as the Princess of Gallimand. They were virgins both, and much of an age, and at least the Countess would understand him when he spoke to her.

The lady Alyson Pascourt was just fourteen and, as Lionel recalled, very fair, and a lively minx besides. Her marriage was in the royal gift, and Lionel had once thought to bestow her on Robin: indeed, before the Brantish war, they had been formally betrothed. The County of Pascourt was a prosperous honor, contiguous to Robin's own inheritance, and even though she was then but twelve years old, Robin had found the maiden's person very much to his taste.

When it came time to choose the tournament's Queen of Love and Beauty, the King naturally bethought him of the young Countess, and sent Thomas Frith to pluck her from among her flower-bright companions and lead her forth to be crowned.

"Ah, *la petite Alysoun*," said the Ambassador approvingly. "*Une fille forte belle* and ripe for her marriage-bed. Shall we wed her to a Gallimand lord and let her wait upon the Queen?"

"She's young yet to wed," said Lionel shortly. Robin had preferred his paramours young, with unripe breasts, small, round bellies, and only a few soft curls upon their privities. There had been one whore in particular, a Cyngesbury girl, who had warmed Robin's bed for a month or more. On the

eve of the march to Brant, he'd brought her to Lionel as a
kind of celebratory gift, and the three of them had sported
half the night, all together in the royal bed like puppies in the
straw. Ah, she'd been a fine piece, Lionel thought: small-
breasted and narrow-hipped and lewd as a sparrow. How
she'd laughed when Lionel had grabbed for her and caught
Robin instead!

The young Countess of Pascourt smiled prettily as she rose
from her courtesy and was astonished to see the King turn
color as he smiled in return. Trumpets flourished as he crowned
her with early roses, then led her to a flower-decked throne
and bade her be seated. A little over-awed, she sat between
King and Ambassador like a good child, chattering happily
and exclaiming over the town ladies' outlandish gowns.

Below the royal party's canopied stand, the field and lists
swarmed with all sorts and conditions of men. The lords and
ladies of the court were banked in tiered stands like many-
colored flowers, drinking wine and laughing among them-
selves. City guildsmen and their wives sat in separate state
beside the lists and consumed quantities of fruit and hot pies.
Around and among them all milled such good-for-naughts as
are drawn to such a gathering like iron filings to a lodestone—
laborers, prentices, beggars, mountebanks, cutpurses.

Not long after the tourney's Queen was crowned, a motley
troupe of riders entered the lists, dressed in particolored
tunics, short capes, and hoods with long liripipes flapping
behind their wearers' heads like pennants. They flaunted
jeweled daggers at their waists like coxcombs, but their flut-
ing voices proclaimed them to be a disorderly congress of
Cyngesbury's finest whores. Trotting saucily to and fro, they
promised impossible pleasures and ogled the knights. King
Lionel laughed heartily and threw the handsomest a rose
before signalling his herald to sound the tucket and call the
jousters forth onto the field.

Fifty knights tilted before the King that day, the finest
jousters in Albia, Gallimand, Rin, and Capno. From terce to
none, they broke lance after lance upon each other's shields,
and many a good knight was carried off with broken head or
arm or rib. Sir Edmund Sewale unseated a young *chevalier*,
but fell soon after to a Gallimand charge. Lord Molyneux ran

four courses unscathed, but was struck from his horse at last
and helped away by his squire, limping heavily.

Many were the brave charges and mighty feats of arms, but
by the time the shadows lengthened, it was clear to all
observers that the undisputed champion of the day was one
Sir Lawrence Ostervant, a knight of the King's own house-
hold. Mounted on his great red destrier, he had reaped each
knight he rode against like standing grain until he alone
remained unhorsed when the final tucket blew. The herald
called his name aloud and summoned him in all honor to
receive his guerdon from the hand of the Queen of Love and
Beauty.

Sir Lawrence rode up to the royal stand, doffed his tilting
helm, and pulled back the mail hood underneath, baring damp
curly hair and a narrow, saturnine countenance. Solemnly,
the little Queen crowned him with bay and gave him her
white hand to kiss, which ceremony he performed with a
flattering fervor. Lady Alyson smiled somewhat nervously,
but allowed her hand to remain in his while a groom led his
prize—a noble bay courser—down the lists and to his side.

King Lionel having coached her, she spoke her part clearly
and without hesitation. "Sir Lawrence Ostervant, pray accept
thy well-merited prize from my hand, and be thou ever as true
a knight in the service of Love and Beauty as thou hast shown
thyself this day."

"Madam, I will," answered Sir Lawrence. But rather than
taking his horse and leading it from the lists, he continued to
press Lady Alyson's hand until at last she pulled it away
impatiently.

"Fie, sir," she said, half angry, half laughing, wholly
scarlet with embarrassment. Then came an awkward pause
while Sir Lawrence sighed and Lady Alyson bit her nether lip
and looked askance at him.

King Lionel took pity on her. "Yield place to your second,
Sir Lawrence, and leave the poor maid be. She is a thing too
young for such gallantries." Then he signalled to the herald
to call the name of le Chevalier Henri du Croix, who had won
the golden girdle, and the prize-giving continued. At the feast
that night, Alyson danced la Volta with the tongue-tied Che-
valier du Croix. She would not so much as speak to Sir
Lawrence, who retired to his solitary tent and reflected on the

unwisdom of conducting a real courtship on the poetic model of courtly love.

Four days after the tourney, Ambassador Tellemonde departed for Gallimand with his knights and retinue, beaming with good will. In his wallet, he bore signed treaties for King Arnaud, and for Princess Lissaude, a jeweled likeness of her betrothed.

The court lingered briefly in the encampment, but by the first of June, only a little more than one month after the plague had begun, King Lionel rode through the streets of his city to Cyngesbury Castle. His first act on his return was to ask the Archbishop to offer up a High Mass for the souls of those who had died of the plague, and his second was to make William Flower Chamberlain of the Kingdom of Albia.

Summer

Chapter One

EARLY IN JUNE, Margaret's plaguy draft returned, sulky as a whipped child. No sooner had it begun to enjoy itself, it whined, than its play had turned to toil. The power of its mistress's spell-wrought pestilence had declined near her daughter; as the witch's influence had spread through the castle, the devil's had shrunk. So it had left. A devil is not a donkey, to labor when the labor is fruitless.

Dismissing the devil, Margaret sought her mirror. Again her raven-clad daughter nodded to the yellow-haired executioner, and again he threw the vixen into the flames. Again Margaret gripped the frame and wrestled with the image until the iron scored her fingers and her hair writhed about her head like fire. But though the full, burning power of her will was strong enough to bind eighty-and-one demons, it could not so much as dim the prophecy. Margaret lifted her head and howled, a long cry of pain that fed and was fed by her rage.

The vixen, tentative, pawed at her knee. Snarling, Margaret released the mirror and dug her bruised fingers into the coarse, living fur of the vixen's ruff. The vixen's blood beat quick, fluttering in time to Margaret's own raging blood. For a moment she crouched there, caressing the little fox with a guilty gentleness. Since her daughter was still alive and puissant against her, then she, Margaret, was in sore need of counsel. The horn was useful only for controlling her winds; the mirror had been her teacher and advisor. Alone and without guidance, Margaret was defenseless against her enemy. As weak as he had been, Magister Lentus had at least controlled his talisman.

Magister Lentus! Margaret strode from chest to cabinet to enspelled casket, collecting a brazier and a small white bone, a scourge of leather thongs, vials of arcane powders, sticks of rare woods and chalk. Lentus had made the mirror; Lentus had sworn to unfold its mysteries. Well, he had not kept his oath thirty years ago, so he must keep it now. The child who threatened her was, after all, of his getting. Grimly, Margaret stripped off her gown and smock, drew the pentagram, and lit the unholy fire.

Necromancy is both like and unlike sorcery. Like, in that both demon and wraith are summoned from Hell and manifest themselves in an uncertain prison of black fire. Unlike, in that a demon has never lived and can be summoned by abstract powers: words and notes of music. Human shades, whose unbodied substance still remembers bodily pleasures, will only rise to more fleshly lures. Naked, Margaret knelt beside the inky flames and scourged her breasts and belly. The flail was many-headed as a hydra, with a human tooth knotted in the end of each thong. These teeth bit sharply, and within a few strokes, blood stood on Margaret's white flesh like a web of dark rubies. She wiped her hand across her breast and passed it, smeared with blood, through the tongues of black fire. Thrice she called Lentus' name, and on the third calling, her former master's face rose in the dark fire's center. He leered at her.

"So you summoned me, sweeting. Have you tired of your demon lovers at last? Have the embraces of incubi drained you? Do you long now to embrace the dead?"

His dead voice was melodious still, but it sent a shiver of disgust through Margaret's flesh. The bare sight of him turned her stomach like rotten meat, but she kept her gaze bent steadily upon him, and through clenched teeth, said what she wished to say.

"The mirror you made for me. Its magic is mine, but its making was yours. You vowed to teach me. You died before your vow could be accomplished. By our oaths as master and apprentice, I conjure you to reveal all that you know concerning that brazen mirror."

The ghost of Lentus pouted, its lips writhing and bunching like maggots. "I can tell you nothing," he whined. "All my sorcerous wisdom is gone, and my acquaintanceship with

devils has grown more intimate than profitable. If you desire to hear what it is to have your brain drawn fold by fold through your ear and stuffed into your mouth like head-cheese, I can expand on the theme for centuries. But of that twice-cursed mirror, I remember nothing.'' His face began to fold and flicker. ''One secret alone can I say of it.''

Margaret clenched her hands on the scourge's haft. ''Speak, then. I command you.''

In the heart of the flame, the face of Lentus congealed, grew solid and fleshly-seeming. ''It will damn thee,'' he said gravely. ''The only comfort that sustains me among the torments of damnation is the certainty that soon thou shalt share them.'' The ghost stretched white fingers from the flame and pattered them over Margaret's blood-streaked breasts. His touch was like a viscid rain, cold and clinging. ''Hurry to me, my love. I burn with longing for thee.''

Hastily, Margaret smothered the dark fire and the shade of Lentus vanished, leaving behind a rank smear of grease down her breast and the stink of roasting flesh. With more haste than care, Margaret scrubbed grease and blood from her skin, fumbled on her smock and gown, called up a breeze to scour clean the air, and locked away Lentus' necromantic apparatus.

As she laid the scourge and the bone in iron caskets, Margaret thought that Lentus' magic had always been gross and filthy, and as tricksy as the shadows he commanded. He had been too dependent upon his demons, had used them not as slaves, but as familiars and companions. He had confided in them and sought counsel from them, and they had repaid his affection by sucking his body dry and dragging his soul to the hottest deeps of Hell. A master who relies on the fidelity of slaves will in time become slave to them.

This was a lesson Margaret had learned well, and for nigh on thirty years, had loved only her mirror and her vixen; for these were part of herself and could not, she thought, betray her. For counsel, she had had her books and the wisdom and knowledge stored therein. But now her mirror was blinded by fire, her codices and texts of magic of no more use to her than if they had been blank. Below in the chamber of whispers, eighty-and-one imps, sprites, demons, fiends, and devils waited on her word, and she had no word to give them. It would not be long, she feared, ere they scented her confusion. And all

this confusion, dumbness, blindness, was caused by one mis-begotten bastard foundling flaunting her legs and her small herb lore through the halls of Cyngesbury Castle.

Dark and chill as deep water, panic rose in Margaret, threatening to drown mind and sense. The hounds breathed death upon her: she wanted to turn and rend. She reached for her horn, and within her breast a hellish music swelled. In it, some note of triumph caught her ear, and an echo of Lentus' voice, whispering: "Hurry to me, my love. I burn."

Deliberately, Margaret turned away from the horn, seated herself in her carved chair, smoothed her skirts, and folded her hands. The vixen peeked out from a hidey-hole, sniffed questioningly, then clicked towards her mistress across the flags, her bushy tail rippling behind her as she trotted. When she reached Margaret's feet, she sat upright before her, barked sharply, and cocked her head. What now, Mistress? her onyx eyes asked. What will you do now?

Margaret rose, sat, tapped her fingers on the wooden arm, rose again, and began to prowl the chamber, running her fingers over the leather and parchment bindings of her books, moving jars and caskets so that they were more evenly spaced, arranging globes and bowls and vials in graduated rows upon the shelves as if each of these objects were an idea and the tower room her skull. Words jostled one another in Margaret's brain like the meaningless syllables of a demon's name: Daughter. Blood. Fire. Demons. Death.

Demons. All her power was manifest in her demons. She had been hoarding them up like coins, counting them over by candlelight, unwilling to spend them or risk them, as though, like Lentus, she were servant to their power. Was she not mistress here? Did not the demons' only value lie in their usefulness, their strength to serve her? Being witless, imps and goblins were useful only for menial tasks, but imps and goblins were only the groats and farthings of her hoard. Now she owned a golden mark, an ingot, a diamond beyond price in her arch-demon, her duke of Hell. Dukes are not witless, she said to herself, though they may be willful. And her will had already proved more than a match for his.

The mirror gleamed at her balefully, reminding her that her "I will" was not absolute. Margaret shrouded it and turned its face to the wall. Then she took up her horn and sounded

the arch-demon's five signal notes. An icy gale sped up the steps and swept through the chamber, sending the woven unicorn writhing wildly above the fireless hearth.

"Peace," Margaret commanded. "I have summoned thee hither as counsellor, not jester."

The gale coiled itself and became an almost visible column twirling restlessly in the center of the chamber. Parchments fluttered around the whirlwind like moths around a ghostly candle, and everything in the chamber—the vixen's fur and Margaret's hair, the tapestry and the mirror's drapery, even the lecterns and the heavy tables—seemed to incline toward its still violence. Hypnotically it swirled and swirled. After a time, Margaret found that she had risen to her feet and was bending a little towards her servant as though in homage. She sat abruptly, tucking her heavy skirts around her knees. "I grow impatient, slave," she said.

From the vortex came a low, rushing voice like a wind-blown flame. "Lady," whispered the demon, "a slave can have no thought apart from his master's. You must needs be wiser than I, or you could not summon me; stronger than I, or you could not hold me. How then can I advise you?"

"A fool may find the penny a wise man overlooks." Margaret's blood beat in her ears so that she could scarce think, but her voice was even and calm. "And a slave must do his master's bidding, whatever it may be." Now that the time had come to explain herself, she found she knew not how to begin. Well, simplest is best, and no stray words for him catch hold of and use against her. "I would destroy my daughter," she said.

"Your daughter! Your daughter is not your greatest foe, Lady." The crackling voice fell to a confiding rush of air, and the tail of the whirlwind crept across the stone floor to Margaret's chair. The vixen, her ruff raised stiffly behind her ears, barked and snarled from the shelter of her mistress's skirts. Margaret leaned forward to catch the wind's whisper.

"Your daughter is only a country witch; she knows nothing of you. But the King of Albia will soon take a wife."

Puzzled, Margaret sat back among velvet cushions. "What is that to me, slave? The King of Albia is less to me than a hare my foxes kill. Why should I be concerned with his leman?" She paused, suddenly anxious. "Unless he will

marry my daughter? But he does not even know her to be a woman!''

The demon's laughter snapped like a spitting log. "No, Lady, he does not. King Lionel is to wed Lissaude of Gallimand. This Lissaude is the niece of the Wizard Venificus, who is brother to the High Bishop of Estremark and hates sorcerers and necromants no less than his brother hates the Prince of Hell himself. When Venificus comes to Albia, he will be down upon you and your demons like an owl upon a nest of mice."

Margaret felt the dull claws of fear catch at her belly. Then she saw that this tale of a mighty wizard coming to supplant her was nothing but a slave pulling at his chains, and her fear transmuted into anger. "I summoned up a mighty tempest," Margaret said tightly, "an arch-demon, a duke of Hell, to lead my airy host and be my faithful servant. And lo, I hear this tempest prate of danger and wizards and owls and mice as though it were the veriest capful of wind. Surely, imp, thou hast answered a call not meant for thee."

A lull fell, taut with wounded pride, and the mothy parchments crumpled to the stone floor. "Enough," Margaret shouted, sending her rage like lightning into the stillness. "Never sulk at me, slave, or I will bind thee into a bellows and loose thee only in little gusts to heat my cook-fire."

The air shifted; the vixen's fur settled along her back. Now, when the demon was chastened, was the time for graciousness. "I will forgive thee thy impertinence," Margaret said after a space, "for thou hast been too long idle and must chafe at thy confinement."

"You, too, have been closeted from the world over-long." The demon's breezy murmur floated close beside her ear. "Albia should learn to know your strength, Lady, and fear you as it is your right to be feared."

Margaret considered the demon's words. Power she knew abundantly, but not temporal power. What would it be? Would all of Albia cringe and shiver at her feet like the outlaw chief? She imagined a crowd of stinking, horny-handed men kneeling before her, their hard faces all blubbered with terror. She grimaced and shook her head. What was the use of such homage? What knowledge, peace, or order would it give her? The very notion was distasteful. But the demon was still

whispering. "Scourge the land," Margaret heard him say. "Let no man rule in Albia. No princess will wed a king who is king of nothing."

"And my daughter? What of her?"

"Your daughter is advisor to the King. The favor of kings is very taffeta, changing its color with every movement, every breath of wind. If his kingdom does not prosper, Lionel will look about him for one he can blame, and his eye must inevitably fall upon he who stands closest. King Lionel may banish your daughter, or he may have her murdered or imprisoned or beheaded or hung. In any case, your hand will not have shed her blood, and she will trouble you no more."

Margaret nodded thoughtfully. There was truth in what the demon said: had not her father beaten her elder brother whenever the iron was brittle, whether or not Simkin had been responsible for its tempering? There was yet one question to be asked. "The King. Of what color is his hair?"

"Yellow, Lady. His hair is as yellow as corn."

There, Margaret thought, it had been the King the prophecy meant all along. But she would not strike directly at him as she had struck at her daughter's husband: she was not one to repeat a blunder. "You have given me good counsel," she said. "I will set a plague upon the people of Albia."

Closer crept the rustling voice until it buzzed in the very porches of her ear. "I could show you such spells and curses as would make of Albia a festering wound, a running sore upon the face of the earth. Men would cry out that Hell were a better place and Lucifer a tenderer lord than Lionel."

"No." This arch-demon, Margaret thought, began to overreach himself. "My knowledge of banes, cankers, and poisons is not so slight that I must suffer myself to be lessoned by such as thee. Leave me."

When the whirlwind had departed, Margaret threw open the heavy shutters and looked out upon the grim canopy of Hartwick. Dusk had fallen as she took counsel with her demon. Dark trees rolled like clouds to the horizon, hiding deer and boar, wolves and hares, men and the world of men from Margaret's eyes. She turned away from the window, roamed restlessly through her chamber, halted by a table that had an earthenware pot upon it, took it in her hands and turned it slowly, silencing her thoughts as she had learned to

do when seeking demons' names, waiting for the proper measure to sound within her receptive quietude.

The pot was round and squat, stolen from some tinker's pack. The potter had scratched a rough garland of leaves into the clay before firing it. The design's rough edges rasped Margaret's fingers.

"The King," she heard her father say. "The King recks nowt o' we. A hard year? Tax th' nobles! An do'st Earl Marshall loose 'is own purse-strings? Bugger a bit! Earl Marshall do tax we in 'is turn, and not so much coin in all t' parish together as 'ud buy a pipkin o' sour ale!"

Margaret's shoulders twitched uncomfortably, recalling the beatings that had followed such speeches. Like his anger, her father's hand was impartial. His poverty, his wife's minginess, his children's obstinacy, the brittleness of his plowshares, the bitterness of his life, all had been Margaret's doing, her brothers' doing, his wife's doing, his lord's doing, his king's doing.

Carefully Margaret set down the pot and smiled to herself. Why make of Albia a festering sore, as the demon would have her do? Such wholesale evil became the mind of a demon, but it was as unsubtle as it was unfrugal. She need do no more than fill Albia with little, niggling ills, and soon every prosperous lord, guildsman, and freeholder in the land would be carking and grumbling like a villein blacksmith. When that was done, she would see what she would see.

It was evening when Margaret thought of her campaign, and morning before she had completed the plan, but despite her weariness, she would not sleep until she had sent her airy troops into battle. As dawn crept still and warm through the ivy-shrouded casements, Margaret vested herself in her starry robe, and, like a careful cook preparing to serve up a great banquet, assembled the appropriate texts and spells and set out her materials. Powders and rare earths, oils and unguents and potions, all stood around her in bowls and platters of bone. Methodically she pounded and mixed, melted, stirred, and dissolved, until one large table was covered by vials filled with distillations of disease and madness. That done, she drew a large pentagram, lifted her horn, and called up her army.

Standing in the midst of the pentagram with her vixen at

her feet, Margaret was the still center of a whirling chaos. Windborne devils whipped the tapestry and rattled globes, alembics, and crucibles on their stands. Fiends rocked the vials so that their contents sloshed against their earthen sides. Breezy sprites lifted the cushions on her chair and rippled the mirror's veil; imps whistled in the cracks of the shutters. With her horn Margaret claimed them all, dividing them into regiments to sow discontent throughout Albia. One company she sent to the east, to blight the crops and poison the waters. Another she sent to the north, to make the women and the livestock barren. Others she sent to the west and south, bearing small diseases and irritations of the skin that would make men pick and mutter at the sorry state of their world.

Far into the night, Margaret winded her brazen horn without cease. Not until the last insinuating breeze had been sent on its way did she drop the horn from lips that cracked and swelled and bled. The table stood empty; the last vial was taken. She had done what she could, and she had done it, she thought, well. Now she must wait until her airy scouts returned with their reports, and rest so that she could command them.

Drained and defenseless, Margaret dared not leave her pentagram while she recovered her exhausted strength. She curled herself within its protection, the vixen cradled in her arms, and warmed herself in the fiery pall of her hair. Outside her tower a lingering breeze fingered the ivy and whispered to itself in a voice like a wind-blown flame.

Chapter Two

JUNE CAME SOFT and smiling to Albia that year, promising fat sheep and generous cows, tall corn and heavily bearded wheat. The auspices were favorable: the court was well fed; the King was to be married; the plague had not taken so many lives as it might. New faces appeared among the household to replace those who had died, and their ignorance and curiosity demanded that the tale of the plague and the *court champêtre* be told again and again. At the center of that tale, and at the center of speculation, too, stood Albia's new Chamberlain, William Flower.

When the King was within earshot, the court praised Master Flower's unvarying calm, his rule of cleanliness and order. But when the King was not nigh, the nobles were inclined to grumble and grutch. The post would more fittingly have gone to one of the elder lords of the kingdom—the Earl of Brackton, perhaps, or even old Baron Carstey—than to some upstart kitchen-knave. What was the world coming to, when a man was not acquainted with the Royal Chamberlain's ancestry? Things would not have fallen out so in King Geoffrey's time. So said the nobles, shaking their heads darkly.

Their ladies, in whose eyes Master Flower's person bulked larger than Master Flower's parentage, praised him with whole hearts. They admired every part of him: his grace, his courtesy, and, above all, his sensitive attention to the plight of four-and-twenty women languishing in a queenless court like lapdogs in a hunting-kennel.

"He must have been married," said Lady Dumbletan as

eight of the four-and-twenty sat together in the Solar over
their tapestries. "Or else been brought up among sisters.
Fresh rushes on the solar floor every second week! It is as
pleasant as it is prodigal. Why, court has not been so com-
fortable since Queen Constance died."

Lady Elizabeth Rawlings, Countess of Brackton, curved
her plump mouth and set another stitch in an altar-cloth. She
was growing heartily weary of discussing Master Flower's
kindness and Master Flower's wisdom, not to mention Master
Flower's shapely leg and Master Flower's fine grey eyes.

Yet she was forced to admit that the court was more
comfortable than it had been of late. At table, the pages
regularly brought hippocras and syllabubs and even barley-
water to those who preferred these lighter potables to wine.
The minstrels had added *troubades* and *chansons* to their
store of drinking songs and martial ballads. Often there was
dancing after the boards were cleared, and the court Fool's
jests were less blushfully ribald. So, "Yes, Lady Dumbletan,"
said Lady Brackton, and smiled, for it is not wise for lapdogs
to nip and snarl at each other. Furthermore, Lady Dumbletan,
whose wire crespinette gave her drooping face something of a
spaniel look, could not help her want of wit any more than a
spaniel could.

Eight silver needles dipped and soared above eight ex-
panses of white linen. "It is passing strange," said the young
Baroness Carstey, "that Master Flower should so choose to
hide his history and his origins. Who can he be?"

If Lady Dumbletan was a spaniel, thought Lady Brackton
idly, what was Grisel? She considered the girl, who was
looking brightly at her companions with her needle poised
and her head cocked as though her question had not been
asked and left answerless a thousand times before. A squirrel,
she decided: black-eyed, eager, long-toothed, greedy for gos-
sip, and constantly chittering.

"Well," began Lady Dumbletan, "he cannot be *base* born;
that, I think, is certain, so . . ."

"If Thomas Frith is to be believed," Alyson Pascourt
interrupted her, "our Chamberlain is both a commoner and a
bastard."

Seven needles hovered as the ladies exchanged startled

looks, then stooped again to the linen as they bent their heads, frowning.

"As for me, I think he is too beautiful to be of low birth," Alyson continued, threading her needle with a strand of wheat-gold silk. The subject of her embroidery was allegorical: the maiden Youth beseeching the knight Virtue for his favor. She had dressed the knight like a court dandy, all in green and rose, and was ready to begin on his hair. "Thomas Frith also says the King would have made him Lord of Airley, or at least Sir William, as well as Master Chamberlain, but he has refused all honors."

Lady Brackton studied her niece's demure countenance with rising alarm. "I cannot like him," she said sharply. "He is all too humble, too modest, too prim. He stinks of mystery, niece, as a coxcomb stinks of civet."

"You are very severe, Countess," said Lady Dumbletan.

"I do not think so, my lady." Each fierce dip of Lady Brackton's needle punctuated her words with a soft pop. "We know nothing of him but that he cooks well, has a gift for running a large household, and is secretive almost to churlishness. Such reticence may become a knight in a minstrel's tale, but it can only be evil in one who is, after all, little more than a bombasted kitchen-boy."

The older ladies looked thoughtful at this speech and Lady Tilney nodded. Alyson's mouth drew into a stubborn pout. "And why should that concern us, if it does not concern the King?"

Grisel—two years Alyson's senior and a full year wed—felt called upon to enlighten her. "My Lord Carstey says that Flower may be Master Chamberlain today, but he need not be Master Chamberlain tomorrow. If King Lionel finds this youth is not so perfect as he had thought him, my lord says that he'll strip the rogue of favor and rank as fast as he bestowed them, and possibly of his life as well."

Without lifting her eyes from the golden curls of her silken knight, Alyson sniffed loudly. Girls are so wearisome, thought Lady Brackton. Never had five sons so bedevilled their mother as one niece bedevilled her now. Five years she had had her in care, and those five years had made her grey and old.

At that moment, Alyson peeped up at her aunt, glanced at Grisel, bared her front teeth in a wicked mime of the Baron-

ess' habitual expression; Lady Brackton hid unwilling laughter in a hasty, sputtered cough. What a minx her brother Pascourt had left her!

Alyson was just fourteen, small and fine-boned, her brown hair shaded with red like a lark's wing. Since the Earl of Toulworth's death had ended her betrothal, every young man who sat above the salt had been courting her with madrigals and sighs. Had she been older, such homage might have turned her head, but being little more than a child, Alyson had accepted their honeyed words with an amused and impartial impudence.

In recent months, however, the number of her suitors had dwindled to one, that being the fierce Sir Lawrence Ostervant. His sharp lance and sharper tongue had silenced the other aspirants to Alyson's favor; the sharpness of his passion had silenced Alyson herself. But Lady Brackton was inclined to fear that it was only a matter of time before Sir Lawrence's dark beauty and obvious devotion began to erode Alyson's indifference. Fourteen was not too young for a maiden to give her heart, and Lady Brackton would not have a mere knight-at-arms receive a gift that was by law not Alyson's to bestow.

Even less would she have her niece fall prey to the beauty of the Royal Chamberlain. This latest fancy of Alyson's might be no more than a child's fascination with the mysterious, but Lady Brackton had no intention of allowing so much as a flirtation between the impressionable young Countess of Pascourt and the fatherless Master Flower, be he King's favorite or no. Better Sir Lawrence than that.

Lady Brackton shifted her comfortable bulk upon her padded stool and sighed. The truth was that she had been grey when Alyson came to her. But she feared that she'd be worried into an early grave long before her niece was safely wed.

It was as well for that careful lady's peace of mind that Lady Brackton did not hear her niece coaxing pages and serving-men to gossip about the new Chamberlain. In this way Alyson learned a great deal about his habits and his peculiarities, but nothing to explain his mysterious attraction. From Dolly Whitlow, her aunt's tiring-woman, Alyson learned that it was the talk of the laundry how Chamberlain Flower had made Mistress Rudyard scour out the washtubs with lye,

though wash-tubs are *wash*-tubs, and always clean. From the King's page Thomas Frith, she learned that Chamberlain Flower thought himself too fine for pomp, and above being served by any but a bastard, greasy, gangle-pate scullion. Ned himself, when she questioned him, only grinned like an ape and scampered away on his master's mysterious business.

Thomas Frith and Alyson had played together as children when first she came to court, and as he was two years her junior, she treated him as her playmate still. When she saw that he looked greenly upon the Chamberlain, she urged him to confide in her and he was glad of the chance. Tale after tale he told of Master Flower's perfidy, but what Thomas meant as venom, Alyson drank like sweet wine. Was the Chamberlain's reticence pride, as Thomas said, or was it a very Christian humility, like that of the knight Courtois de Lyon, who gathered wood for a peasant woman and washed the Lady Wilane's muddy feet? No way of telling unless she spoke to Master Flower herself.

One bright morning, Alyson sat in an open window in the long gallery. It was hot for June, and she held her clinging skirts away from her legs and wished that like a farm-girl she might go bare-legged in warm weather. She let her skirts drop when Thomas appeared in the arch at the end of the gallery. "Ho, Master Thomas," she hailed him.

Thomas started, looked about him guiltily, grinned when he saw Alyson sitting in the window, and climbed up by her on the broad wooden seat. "Lady Alyson," he said.

" 'Tis merry June outside, and yet 'tis April with thy face, young Thomas. What has Chamberlain Flower done today?"

Thomas snorted. "He said he'd teach me a new way of tuning my lute. With wax polish, no doubt, and some herb upon the strings to make the cat-gut smell, and therefore sound the sweeter. I said as much when he offered, and my King chid me for impertinence, even while he praised my wit."

" 'Tis he has been impertinent, and not thou at all," said Alyson indignantly. " 'Twas a very pretty conceit. What can it concern the King's Chamberlain how the King's page tunes his lute? His Majesty has always liked thy playing well enough."

Thomas shrugged, petulant. "He likes it not so well of

late. 'Tis all Master Flower with him now. Why, he wears him round his neck as though 'twere a pomander and all his former friends, infections. I go in search of him even now, that His Majesty may sniff of him.'' Thomas slid down from the window seat and gave Alyson a weary little bow, his pertness all fallen from him. ''Indeed, I must find him soon, Lady. 'Tis my ears will feel the King's fist if Master Flower tarries, not his.''

''And where dost thou seek him, sweet Thomas?'' asked Alyson. ''If he meddles so with other folk's affairs, how canst know whether to inquire for him in the dungeon or in the tower?''

''That's easy enough, Lady. If he's not in his closet, then he's in the kitchen, and if not there, then in the herbary. 'Tis a musty, fusty place by the inner curtain, with not so much as a good climbing tree to recommend it, but he goes there often.''

So it was that the next day, Alyson sat perched on a stone bench with the dusty fragrance of sage and thyme and chamomile in her nostrils. She was carefully dressed in sea-blue and amber, to set off her hair, and she carefully held her embroidery to set off the curve of her neck and the pretty droop of her eyelids. If Love entered at the eyes, as all her suitors had assured her he did, she would warrant him easy entrance to Master Flower's heart. The only false note in the picture was Lady Brackton sitting massively beside her, waving away gnats, wincing from bees, starting at butterflies, and shifting uncomfortably.

When her aunt had questioned her on her sudden love of nature, Alyson had grimaced. ''O Aunt, need you ask? The solar's as hot as Hell-mouth, and Lady Tilney's tongue grows sharper by the day. One more day in her company, and I will do I know not what, I promise you.''

Since the ladies of the court were indeed peevish with heat and inclined to yap and nip at the girl, Lady Brackton could not deny her niece permission to sew without doors; but she could wonder why she would choose the herbary over the other gardens blooming within Cyngesbury's walls. When Lady Tilney or the Baroness Carstey wished to take her ease in the green shade, she generally had recourse to the Rose Walk, the North Garden with its beds laid out like *fleurs des*

lis, or the Queen's Garden, walled, tiny, and private. Only scullions and gardeners came to the herbary even though it had been laid out with an eye to beauty as well as use. Carved stone benches stood here and there, and the walks were planted with hardy thyme and camomile so that each step bruised fragrant leaves.

In fine, the herbary was the perfect place for a secret assignation, in part because it seemed so workaday. Suspecting that Alyson was planning to meet Sir Lawrence or some even more ineligible flirt, Lady Brackton agreed that it was indeed unpleasantly warm in the solar, and announced that she, too, longed for a fresh breeze with the scent of herbs upon it. For three days, therefore, Lady Brackton subjected her backside to the hardness and straitness of a stone bench, and in that time, not a soul approached Alyson or herbary excepting a startled and respectful scullion, who hardly stayed to pick the rosemary he'd been sent for before leaving the ladies to their solitude. It all seemed innocent enough, if somewhat uncomfortable for a lady of middle years; so Lady Brackton retired gratefully to the solar, leaving Alyson to stitch alone.

Two weary weeks passed without bringing the Chamberlain to the herb-garden. Truth to tell, after the first week Alyson had all but forgot her plan to meet Master Flower, and came to the herbary because she found it pleasant to sit alone and unobserved. A particularly fragrant bank of golden-yellow foliage had become her seat of choice, and the last day of June found her cross-legged upon it, her skirts rucked up to her knees and her shoes and hose in a heap at her side. She had finished the knight Virtue and now was embarked upon the maiden Youth, whom she had modeled upon herself. Her hands sweated in the close air; her needle squeaked and caught in the damp linen. Through a haze of heat and gnat-song, she heard the garden gate open and shut. Absently, she pulled a fold of skirt over her bare legs and glanced up, half-expecting a scullion, or Dolly Whitlow come to fetch her within.

The figure that met her eye was no elderly servant-woman or ragged kitchen-boy, but a slender young man clad all in green, a young man crowned with wheat-gold curls brighter far than those of her silken knight. Her heart beating so that

she felt it must be visible, Alyson bent her scarlet face over her embroidery and devoutly wished that she were elsewhere. A pair of neatly turned legs in parti-colored hose stopped before her. She must look up; to ignore him would be an insult. She could not look up.

"Your pardon, my lady," said a sweet tenor voice. "I fear I disturb you."

Alyson started, pricked her finger, dropped her frame, and turned, if possible, even more scarlet than before. "Oh, no, Sir," she stammered. "I was only . . ." She tugged at her bunched skirts, then looked shyly up into his fair face and, taking some courage from its grave smile, said, "The thyme smells so sweetly here."

William half-knelt and retrieved the embroidery. "Indeed, my lady, you have chosen an odorous bower for your work. But I fear that what you smell is lemon balm. See, you are sitting on a bank of it. And behind you is sage, and salsify, and comfrey. The thyme is planted yonder, by the eastern wall." He smiled, put the work in her hands, rose, and bowed a graceful adieu.

"Wait," cried Alyson, all in a panic to think that she had driven him away. His cotehardie was embroidered with flowers, white and red like a meadow, and it fit his slender figure closely. She did not want him to go just yet, and sought desperately in her mind for something to keep him. "Thomas Frith tells me that you are a better cook than Master Hardy." This sounded pert, though she had meant only to praise him, and she blushed again.

William shook his head and smiled. "It is not true, Lady, but it is kind of him to say so."

"He says also that you are an herb-master, and know the names and properties of every plant that grows."

"Not every plant, Lady, but many. Have you an interest in herb lore?" Alyson nodded eagerly; he seated himself beside her and pulled a sprig of sage from the bush at her shoulder. "Here, my lady, this is sage, which the learned call *Salvia*. Its leaves are whitish, or sometimes greyish-green. They are toothed at their edges and covered with tiny hairs." Obediently, Alyson stroked one long oval with the tip of her finger; it felt like hard-woven wool. She peeped at William across

the branch, but his clear grey eyes were fixed studiously upon
its leaves.

"Its humor is hot and dry, and it is good for the head and
the brain, for the bitings of serpents, and for binding women
who are wont to deliver before their time."

"Oh," said Alyson. "That is good for a woman to know.
Is there more?"

His light voice went on, making poetry of the facts that
sage is good in stew, and maketh a goodly seasoning to an
oxtail soup. But Alyson, lost in the grace of his slender,
white hands and his shapely lips, heard nothing of this wis-
dom. She gazed and he spoke until he had said all he knew
concerning *Salvia*, and then he fell silent. Alyson started a
little, took the sage from his hand, and thanked him, hoping
shyly that he would continue the lesson at another time. A
heartbeat later, William had agreed, risen, bowed, and Alyson
lay back among the lemon balm, held the sage to her lips, and
thought what a wondrous thing it was to fall in love.

Chapter Three

WHEN SIR WILLIAM Flower had sated himself on Bet's mutton-pie and Tom's good advice, he rode to Hartwick Manor and found it, as Elinor had warned him, in as sorry shape as it could be and still be standing. Rats, mice, and spiders there were in abundance, and evidence of larger vermin as well, in the shape of dung and bones and bloody feathers. The wooden staircase drooped and creaked when he put his weight on it, and the doors fell from rotted leather hinges. Beyond the crazy outbuildings, the coppices were overgrown and the fields at the edge of the wood had gone to wild meadow. But yet the walls and floors were sound and the soil was rich and black, so Sir William was well pleased with his domain, and set to work with a will to reclaim it from decay.

The month of May passed by in a flurry of scrubbing and building, felling and hewing, plowing and sowing. Sir William visited each of his tenant-farmers in turn, asking after their welfare, drinking their beer, and coming away from their cottages with baskets of food and promises of aid in putting his fields into heart again. His tenants found him an easy man to like, this ugly, rag-tag knight, for he was neither too familiar with them nor too high, and told them frankly that, for this year at least, he would sooner have their labor than their rents. Hob Reidy and Simkin Black and all the tenant-farmers who owed their living to Hartwick Manor willingly helped their new lord to break ground and harrow it, lent their oxen to his plow and their backs and arms to the sowing. But for advice and household furnishing and seed-corn, no one gave him more than the Martindales, who owed

him nothing. And his chiefest help of all was the Martindales' unwed daughter.

While Sir William labored without doors, Elinor Martindale labored within. Almost daily, she could be found in Hartwick Manor with her golden hair tied up in a clout, scrubbing the flags of the tiny hall with sand or overseeing the hanging of the pot-hooks over the kitchen hearth. It was Elinor saw to it that the doors were properly hung, the chimneys swept, and shutters fitted to each window against the coming winter. Janet the Nagshead dairy-maid told her gossip Mistress Nan Carver that Elinor Martindale could not do more in her ordering of Hartwick Manor if she were mistress of it.

"Elinor Martindale did always take much upon herself," said young Mistress Carver. "But her'll overstep the mark one day. Do she think a landed knight'd wed with the likes of she?"

"Well," said Janet, considering. "She be over-proud to be any man's whore. And there was sommat in the scrying-bowl, May Day morn, did make her cry out and hide her eyes. I'd not wonder if t'were the sight of yonder knight's monstrous nose did make her start so."

June came and went, and by July, Hartwick Manor stood neat and clean as a new pin, if somewhat bare. There was little occasion now for Elinor to come there, but she made excuses to visit now and again, if only to see that Sim Thompson kept the kitchen as it should be kept. One hot afternoon, Sir William saw her crossing his dooryard with a basket on her arm.

"Good morrow, Mistress Elinor," he said cheerfully. "Glad I am you've come this day. Might you come into the byre and cast your eye over Tess? Susan Reidy has told me she will not let down her milk, but kicks the bucket and lows most piteously. I'd thought to call on Jack, but he's busied with haymaking."

"Susan Reidy be a great mimkin," said Elinor severely. "Happen it be nowt but a sore titty from her clumsy milking."

In the byre, brindled Tess stood patiently with her head tied up to the manger, swinging her tail against the flies. Elinor pushed her rump aside, entered the stall, and stroked firmly down her bony flanks. As her hand passed over the cow's bulging udder, Tess stamped uneasily with her hind leg and mooed. "Sore titty it be," said Elinor. "And shame to Susan

Reidy that it should be so. A bit of broom-bud'd soothe her,
but I've none by me. Softly, softly, sweetheart, while I let a
drop of thy milk. Thoul't feel less dole when 'tis done.''

Elinor hunkered down in the stall and gently squeezed out a
jet of milk. Tess bellowed with pain and jerked away; Elinor
fell forward under her hooves. In sudden fear that his love
might be trampled, Sir William thrust Tess aside; but as he
grasped at Elinor's shoulder to pull her up, he slipped himself
on the straw and dung underfoot. There was a great confusion
of scuffling and heaving, and then Sir William found himself,
smeared but unhurt, standing pressed against the wall of the
byre with Elinor caught between himself and the restless,
complaining Tess.

Gently he ringed Elinor's body with his arms and prodded
at the brindled flank. Tess shifted a little away from his
hands. Elinor, ducking under his arm, took his hand and drew
him hastily after her out of the stall. Like a game of thread-
the-needle for two dancers and a cow, he thought wildly. She
laughed, and he felt himself grow red-faced as a maiden as
his own awkward feet sent him stumbling against her. She
caught him and sang, somewhat breathless:

> Here's a flower and there's a flower
> In my lady's garden.
> If by chance your step you miss,
> Your lady fair your cheek will kiss.

Then she turned her face to his and kissed him full on the
mouth. Her lips were sweet as green leaves; her hands lay
lightly against his chest. Breathless, Sir William clasped his
hands about her waist, closed his eyes, and gave himself up
to delight.

After a moment, Elinor stirred in his arms and he released
her. "Be ye not ashamed to kiss in a byre like a very
clodhopper, sir knight?" she asked, but there was a trembling
in her voice. Touching his cheek lightly, she ran from the
byre with Sir William following close behind. He thought he
would like to kiss her again.

But now that he no longer held her in his arms, Sir William
was overcome with doubt. He knew little of the ways of
womankind. For all her forwardness, he reminded himself,

this was no soldier's slut, to be kissed and fondled at will. Still less was she a plucked and painted demoiselle like those who had laughed at him in Lord Maybank's hall. Her gown was coarse; her cheeks, lips, eyes, brows were as nature had made them, untouched by paint or pincers. If her person was without artifice, might not her manner be also? Was any maid as uncomplex and artless as this maid seemed to be? He had thought Elinor shamefast, timid, a little cold perhaps; yet she had kissed him with inside lip, so that his blood was stirred and his breath came fast.

In the dooryard, at the stone well, Elinor wound up the bucket and pulled it onto the coping. Having drunk of the clear water, she filled the dipper and carried it to Sir William where he stood bemused. Her face was calm, but her cheeks were red and her eyes shied away from his.

At the moment when he took the dipper from his true love's hand, Sir William Flower made up his mind. Though she'd said nothing but nonsense, yet she looked on him tenderly. Words may lie, he thought, and kisses, too. But not looks. Sir William cast dipper, water, caution and all into the dust, took her hands in his, and prepared to speak his heart.

"I am younger son of Sir Henry Flower of Flowerdale in the north. I've fought in Estremark and Kelusham and in Albia against the Brants. I'm thirty years old, I love not gaming nor any kind of lewdness, my teeth are sound, my appetite good, and at present I'm nigh as poor as a year of famine. I own Hartwick Manor, a trestle table and one chair that your father has lent me, one pease straw mattress, the horses Paladin and Griselda and their furniture, a suit of mail, two swords, five unbroken lances, a silver lamp from the sack of Boresia, two books, and twenty marks in gold. All this, and my heart's dearest love besides, will be thine if thou wilt but consent to marry me."

Elinor's mouth quirked up at the corners, but her voice was grave as she answered him. "I will be twenty come St. Bartholomew's Day. I bake and brew and make good cheese, and be well learned in herb lore. I love not spinning nor sewing nor any kind of needlework. My portion be good—sixty marks of silver money stamped with the King's own head. My mother'll give me a featherbed and a bedstead to hold it, and I doubt not my father'll give thee that chair if I

ask 'un. I accept thy heart, and what goods go with 'un. Provided thee do learn me to read.''

When she had done, Sir William nodded dazedly, then kissed her to seal his troth.

After a space, Sir William held her at arms' length and looked at her, his head all to one side like a puzzled dog's. ''Do you not love me, then, but only my learning?''

''I do love thee, sweet William my lord, *and* I love thy learning. Husband and wife is one body, they do say, and I would have us one mind as well. But I'll not mend thy shirts.''

At the first of August, as soon as the banns might be called, Elinor Martindale and Sir William Flower of Hartwick Manor were married in the grey stone church at Seave. There was feasting at Hartwick, and the bride and groom were not bedded until past midnight. But next morning betimes, Sir William was in the fields again, for John Barleycorn cares nothing for the throbbing heads of the revellers he has made merry the night before, but must be harvested when he is ready.

All the day long, Sir William reaped the golden stalks with his sickle, and Elinor his wife worked beside him. With her kirtle girded above her ankles and her sleeves rolled high, she gathered the straw into long sheaves and laid them across the bands for the banders to tie and stand in stooks. The soil being rich, the harvest was good, even allowing for the lateness of the planting and the ignorance of the farmer; the lord and lady of Hartwick went into their first winter comfortably if not abundantly provided for.

A farmer's daughter knows that the business of a farm is sowing and harvest. While the good weather lasts, the demands of field, dairy, and garden take precedence over all else. Plowing and sowing the rye, threshing and storing the corn, slaughtering pigs and cows and salting down the meat, these things demanded all Sir William's attention and Elinor's as well. But sometimes after dinner, while Elinor picked over her herbs and tied them into bunches for drying, Sir William would read to her.

One of his two books was the diary of a Boresian farmer done into Albian, with all plans and plots and lists of imple-

ments and planting times intact. It was very dull, Sir William told her, and he would not read her from it, although she often teased him to. So she turned over the pages herself, staring at the plans and drawings as though the intensity of her gaze alone would force them to give up their meaning to her. Once she came across the likeness of a round maze or labyrinth, which the good farmer had caused to be cut into the turf in a far quarter of his garden, "for gayme, for increase, & fore delyghte."

"Why made he this thing?" Elinor asked Sir William, showing him the plan. "What means he by it? What do the writing say?" She was half laughing, half pleading, and so pink in the cheeks that Sir William would almost have said that his country wife was abashed.

"He means nothing by it, sweetheart. 'Tis a maze, a kind of game Boresians play at seed-time and harvest-time. A maid in white stands in the center, so, and all the lads race to see which can come to her first and kiss her." He saw Elinor's mouth quirk as though she would laugh aloud. "Come, wife, what's toward?"

" 'Tis witchery, husband, and not to be spoke of before men," she said primly, but when he made as if to take the book from her, she laughed and answered: "When a woman be brought to bed and the child comes not, labor she never so hard, the midwife do use to draw this figure"—she pointed to the maze—"in dirt under the bed and traceth the path from center out. If the midwife be strong enow, the woman will be lighter anon. Mistress Gittings did learn me the way of it. 'Tis little done nowadays."

By now, Sir William was more scarlet than his wife had been, having little stomach for talk of birthing and labor, not even of kine. He had proved a good husbandman, careful and hard-working, but when he was not in field or byre, he read poetry and courtly romance, not husbandry.

In the latter days of his service with Lord Maybank, Sir William had spent a month's pay to have four such poems copied and bound in fine leather. Of these, Elinor best liked the poem called "Margarite." "Sir Piers and the Scarlett Kynge" she thought foolish, "for no proper man would put his wife so in harm's way, be he scarlet of skin or green or azure blue." She liked the "Parlement of Foure Graces," but

was puzzled by "Le Lais de Joyeau," that was writ in Gallimandais. Sir William said that when winter came, he would teach her that language, too, but she only laughed and said that Albian were enough for one poor woman to burden her mind withal, and wondered that learned men could sleep o' nights with so many tongues jostling one another in their heads.

By little and little, Elinor learned to know the look of the words her husband read, and soon could puzzle out passages of the Boresian diary for herself, as well as a receipt for a wound dressing compounded of mouse-ear and bastard balm, which his mother had given Sir William when he was a knight bachelor. By the time she began to grow big-bellied with their first child, Sir William had honorably settled upon his wife the first part of her promised jointure—that he should teach her how to read. The second part, the writing, must wait on the harvest and the winter sowing, and so was put off and off until Christmastide.

On Christmas Day, they feasted. All Sir William's tenants, their wives and children, Father Mark and his prentice John crowded into the manor's tiny hall to eat a fresh-killed ox and a fine array of stews and forcemeat pies, a compote of dried fruit and a great Christmas cake, the products of Lady Flower's skilled hands. A little dazed by their elevation, Tom, Bet, Hal, Jack, and Mary sat on the dais with the lady and her husband. Sir William felt their unease, and sought to assuage it with friendly cheer and deep drafts of the good wine of Rougevin, sent to his son by Sir Henry Flower as a kind of wedding-*cum*-Christmas gift, along with a fine arras of the Triumph of Judith, which now hung behind the high table.

From the top of his hall, Sir William beamed good will at his wife, her family, his tenants and household, at the holly and juniper garlanded upon the stone walls. All was well with the world. The food was abundant, the wine excellent. He had even procured three musicians to saw merrily upon their viols in the gallery and a minstrel to sing "The Boar's Head" and "I Saw Three Ships." And when the feast was over and a troupe of mummers came out to play the Geste of the Second Shepherd, Sir William pressed his wife's hand and professed himself the best-contented man in Albia. Not even King Geoffrey, he thought, could offer a more generous hospitality.

After the mummers had done their play and sat down to their Christmas ale, Sir William proposed a game of Hoodman Blind. Exercising his right as Lord of the Revels, he tied a napkin around Elinor's eyes and led her to the hall's center. She lurched here and there, following him as he pinched and danced just within reach until he came to the stairs, where he swept her up, still blindfolded, into his arms and bore her aloft into the bower. Laughing, he set her on her feet and turned her round and round about, and as he turned her he sang:

> A gift, a gift, a gift for thee;
> A kiss, a kiss, a kiss for me.
> Ope thine eyes and rob the nest.
> Kiss the lad ye love the best.

He whipped the napkin from her eyes with a flourish and ceremoniously handed her to the trestle he had set ready by the fire. Eager as a boy, he watched her touch and exclaim over the gifts he had laid there. One was a tablet of wax with a sharp wooden stylus. The other was a chessboard, arrayed with sixteen small figures like armies opposed across a chequered plain. On one side, the pieces were carved like Albians, armed in white with scarlet crosses on their breasts. Facing them was an army of Moors carrying curved swords like scythes in their ebony hands.

"The one is for thy pleasure," Sir William told her, indicating the wax tablet. "The other is for mine. I took this gaming-board and its pieces at Kelusham, and played often on campaign and when I dwelt with Lord Maybank. It is called chess, a soldier's game, and though I am now a husbandman and a keeper of kine, I am still a soldier, too."

Elinor rose and they embraced in the firelight. Dizzy with joy and rougevin, Sir William stared over his wife's shoulder at their doubled shadow. With a kind of owlish wisdom, he thought that shadow an emblem of wedlock, man and woman reciprocally sustained, cradling between them the fruit of their union, their pledge to the continuance of life and land and love. He sighed and tightened his arms around her; she turned her head on his shoulder and kissed his ear.

"These be princely gifts thee'st given me, husband," she

murmured. "Be they for use or only for looking?" Trust his Elinor to get to the heart of the matter, Sir William thought. Smiling ruefully, he released her and scratched her name "Elinor" into the soft wax of the tablet. He guided her hand as, one by one, she copied the letters and then he carried her to bed, leaving their guests below to finish their revels however and whenever they wished.

For the rest of the winter, part of each day was given over to chess and writing. At first Elinor complained that a stylus was as bad as a needle for slipping and sliding and going awry, and she spent whole hours laboriously copying single letters into the wax. Gradually, her fingers nimbled, and she began to copy parts of the Boresian diary and "Margarite," first into the wax, then onto some precious scraps and tatters of paper, using a goose feather and ink Sir William made from soot and oak galls. It was a great day when, unaided, she first inscribed "ELINOR FLOURE WRITTE THYS" in large, angled letters like a scattering of twigs. It was a great day, too, when she first wormed a black knight up to Sir William's white-and-scarlet queen and took her captive.

"The two things be alike," she told him once. "Each be like a dance with measures set and ordered, and to misstep be to throw the pattern awry. In chess and writing, too, I must know the steps without thinking on them, lest the steps alone take all my mind, and so the pattern be lost."

Sir William looked at his wife with some wonder. He would expect a school-man or a mage to speak thus gravely of dances and patterns, but not a woman. Were all farm-maids in Albia thus philosophical, wanting only learning to keep them from filling book upon book with womanly wisdom? Yet now that Elinor could write, she wrote no philosophy, but only receipts and lists of herbal properties, accounts of candles burned and loaves of bread baked and eaten. "Poetry be for men," she said. "Women must tend to graver matters."

In April, two months before her time, Elinor miscarried of a son. Afterwards, she wept not at all for her loss, but froze into a woman of stone, hard-faced and silent. She would not set foot in her stillery, nor tend her herbs, nor read, but only cooked and swept like a serving-maid. Sir William, grieved by her melancholy no less than by the loss of the child, first

petted her, then left her alone to heal in her own time. But when harvest-time came without her having thawed, he lost patience at last.

"If you cannot bring yourself to touch your husband, who stands as much in need of comfort as you, at least you might take pity on the poor cows, who have done you no harm. They are beset with mouth-rot, and there is none to physic them but only you, and you too wrapped in grief to care."

"Damn thee and thy cows to the depths of perdition!" shouted Elinor in answer and cast a stone mortar through the stillery window. Then she wept bitterly for a space while he held her to his breast, kissed him when she was done, and turned her mind to the cows. By the time she had decocted the potion and dosed the herd, she was to all appearances recovered of her grief, and the cows were much improved.

The seasons turned, and Hartwick Manor prospered. Before five years were out, Elinor ruled a household of thirty. Her days were spent overseeing kitchen, stillery, and herbary, and she served the parish as midwife and herbwife. With all these calls upon her time and skill, only Mary cried shame upon her for not spinning and sewing as well.

When Thomas died at the age of three-score and ten, Jack became master of Nagshead and Mary its mistress. With no father-in-law to cow her, Mary fulfilled the promise of her shallow eye and stubborn mouth and grew into a scold who beat her children and chid her husband until he could scarce sit peacefully at his own board. Goodwife Gittings dying at last at ninety, Bet took over the Measuring of girl-children, but was content to leave healing and midwifery in Elinor's younger, stronger hands. For, despite all that herbs and witchery could do, Bet's legs and hands had gnarled like tree roots, and she was at last reduced to nodding by the hearth or in the stableyard, watching Jack's four children at their play and shielding them when she could from Mary's shrewish tongue.

In pity of her mother's plight, Elinor would have had her at the manor, but Bet would not be moved. "Here I've lived these three-score year and more, and here I'll live another score," she said. "If only to spite Mistress Mary."

When he was seventeen, Hal married Susan Reidy, not caring that she was a great mimkin. Sir William wanted to give them her father's farm in freehold, and this wedding gift

was the occasion of some discussion between Sir William and his wife. Hartwick Manor was not a rich holding, and though they lived comfortably enough, there was ever little silver in their pockets. The rent from Tom Reidy's farm would be sorely missed.

" 'Tis nip and tuck with us now," complained Elinor. "Each month we sell five gallons of butter at five shillings the gallon and give it up again for candle-wax, not to mention the laboring-men's wages and the alms for the poor and the King's taxes on the land. Paladin grows old and stiff, and soon will no longer carry thy great weight, and a destrier costs fifty pounds or more, as thou well know'st. We be skint as tinkers, husband. Thee cannot think to stint us further."

"Sweet Elinor, I can," said Sir William, shamefaced. "Hal's thy brother, or close as makes no matter, and I will not take rent from my marriage-kin. As for the silver, Paladin can carry me yet, despite his great age and my great weight. The manor is furnished and garnished, and the dairy-maids are dowered. We've the rents of Flowerdale Farm and Swale that are my inheritance from my father, and though brother Giles has no love for me, he'll not take them from us. We have enough, sweetheart. Let be."

Elinor sighed, shook her head, kissed her husband, and ruffled his yellow hair. "Thee bee'st soft, husband, as I have long said. But this softness do become thee. Hal and Susan shall have their farm."

In nine years of marriage, Elinor buried six children. One died in the birthing, two were untimely slipped, a son John lived three days, another, Edmund, lived four weeks, but all died in the end. One cherished daughter, Alys—a weak, puling infant—lived a full six months before following her siblings to the churchyard. Elinor never again entombed herself in grief, but each of these losses took from her some of her youth and her mirth, and often she wept when she saved a child alive from its mother's womb. As for Sir William, he grieved over each small death and turned all his fatherly care on the fields and tenants of Hartwick Manor: peasants and cows, field and forest, these were his children.

Then, at the age of seven-and-twenty, Elinor found herself again great with child.

In the usual course of things, Elinor was not a woman accustomed to regard her own health. Sir William might see her frown over an aching head or cough an hundred times before she would consent to lay rosemary water to her temples or swallow the draught of horehound she would have forced upon him long since. But when her belly rounded for a seventh time, Elinor Flower took grimly to her bed and wrote to the College of Midwives at Cyngesbury, inquiring whether one of their number practiced near to Seave. Such a midwife would be costly—to bring her, to board her, and to pay her fee—but Elinor declared that she would put no more trust in the skills of rue-leaf gammers who knew more of the farrowing of sows than of human births.

When Elinor was eight months gone, one Jane Gotobed, a bay-branch witch and trained in Cyngesbury, journeyed from Barton to attend her lying-in. She saw her through the last month with sage and salt, and when Elinor was at last brought to bed, turned the babe in his mother's womb so that he should not back into life, but meet it head-on as a proper man should. Thus it was that on a September midnight, Elinor was safely delivered of as fine and lusty a man-child as ever caused his mother to cry out in the bearing of him.

After Dame Gotobed had tied off the cord and washed the babe, she swaddled him in bands of white linen and carried him into the hall to present him to his father. Sir William took the scarlet atomy gingerly into his arms and smiled somewhat tremulously down on his son's crumpled face. "I will call him Henry Thomas," he said, "in memory of both his grandsires. And I will pray for his continued good health and for that of his mother. It is a great and wondrous gift you have given me this day, Dame Gotobed, and I know not how I may well repay you."

The midwife smiled and shook her head. "The forty shillings is sufficient thanks, good sir. In any case, your thanks are due not to me, but to your wife, who has had the peril and the pain of travail."

There was rejoicing in Hartwick Hall that night, and cause for rejoicing thereafter. Thanks to Dame Gotobed's good care, Elinor suffered no fever and was able to rise from her bed to see old Father Mark christen the boy in Seave Church. Young Henry was a fat and rosy infant, and Sir William

swore he was as beautiful as his mother, although even at two weeks of age, his nose gave promise of growing, in time, to be as lordly as his father's.

When Henry was a month old, Sir William rode to Barthon to sit upon the King's jury and stayed there four days while the King's sheriff heard an accumulation of civil cases. He returned to Harwick Manor on a Saturday, and found Elinor in the stillery, compounding an ointment for her mother's painful joints while Henry slept in his cradle-board on the bench beside her. Sir William kissed his son softly and swept his wife up into a sweated and road-dusty embrace. After he set her down, he commenced to fumble through his sleeves and wallet, and at length pulled out a bulky packet sealed up with wax.

"I have a gift for thee," he said.

Elinor looked from packet to husband and back, then broke the wax seal and unfolded parchment and soft lamb's wool to reveal a small plain casket, which she opened gingerly. Lying amid a bed of blue velvet was a splendid jewel that blazed in the golden afternoon light like a smaller sun. Her mouth fell a little ajar, her hands trembled, and Sir William thought she would drop jewel and casket and all from very surprise.

"It is beautiful, my dear," she said at last, "but far too rich and fine. It must have cost as much as a new arras, an hundred crowns or more." She raised her eyes, joy and distress both clear on her face. "It is too fine for me."

Sir William took the jewel from its casket and laid it in her hand. On one side was an "E" and "W" entwined, picked out in rubies set in the gold. On the other was a miniature portrait framed with tiny seed pearls. "It is but thy husband's face, love, and that is plain enough, surely. And as for the expense, I have laid by for it since we were wed. As thou hast labored to bring forth the living image of our love, so I have labored to bring forth this. Thy labor was the more painful, I know, but mine was the longer."

Chapter Four

THROUGH JULY, THE unseasonable heat that had given Alyson an excuse for taking her embroidery to the herbary did not break or falter, making each day as close and pricklish to the temper as a penitent's hair shirt. In Cyngesbury town, old men told gloomy tales of drought and famine, while young men brawled uneasily in the taverns. Game was scarce; the King stopped riding out to hunt and his courtiers grew bored and snappish. In the solar, bickering declined into brangling, and the ladies sought their own solitary chambers to escape its thundery atmosphere. Alyson, unmindful of heat and ill-temper alike, sat in the herb-garden and diligently conned her lessons in herb lore and unrequited love.

At first, William came almost daily and sat with her for an hour together, teaching her the properties of common herbs. He spoke to her only of leaves, humors, and aliments, but Alyson took hope in the fact of his constancy. If he did not love her, why would he come to her? Surely herbs alone could not so interest him. William's restraint she named modesty, his impersonal discourse, respect; and the coolness of his manner could be explained by the natural delicacy of his character.

These persuasions were for when he sat near her, his eyes straitly bent upon the leaves of the herbs he held in his long hands. When he was not by, Alyson wore out the hot hours picturing to herself how he must suffer under a love he dared not reveal. All the romances she had heard were filled with young men who gradually lost their taste for food and amusement, who paled and trembled when they saw their

ladies, who, finally unable to curb their passions, threw themselves at their ladies' feet to rain hot kisses upon their white hands. It was not beyond belief that living men should behave so. Why, had not Sir Lawrence acted in just such a manner at the Reddingale Tourney? And certainly the silly man was wan enough now. If she but waited patiently, William would do likewise, and from him Alyson would not pull away her hand.

Such fantastical reflections as these enabled Alyson to bear cheerfully with the heat, with Lady Brackton's massive disapproval, and with Lord Brackton's embarrassed lectures on responsibility.

"You are not only the Countess of Pascourt, but also the King's ward," he told her. "The King will tell you whom you may love and when you may love him, and he would never disparage you to wed you with a serving-man, no matter whether he favors him himself. If you cannot cast your eye upon a lover suitably born, keep it upon your embroidery. Love is for minstrels to sing of, not for daily use." And Alyson would laugh and kiss her uncle's cheek, and hurry back to the herb-garden, where she stitched and dreamed and waited for William.

Whenever he spoke with his wife's niece, Lord Brackton's anger at her self-absorption struggled against a kind of bemused envy. Oh, to be so young again that love seemed more important than the size of a harvest! As day followed desert day, neither rain nor news of rain came down to Cyngesbury from the north, but only a trickle of grim-faced messengers on blown horses. In council, the King was inclined to scoff and say that their claims of drought and famine were the overblown fruit of panic. But Lord Brackton, who was old enough to remember other dry summers and lean winters, frowned and shook his head over the young King's unconcern.

By mid-July, the trickle of ill-tidings had become a spate, and Lionel could no longer deny that Albia was beset. First, the Earl of Longmeadow wrote of blasted wheat, rusty beans and impending famine. Then, Eustace Oxbow, Baron Hedly, sent word from his moorland demesne of impotent rams and a plague of foxes. At the same time, Lord Avonlea reported a siege of tenants complaining of dry cows, mangy ewes, rotting crops, spotted fevers, and a wasting flux. As the weeks

went on, it became increasingly clear that no earldom, barony, or fief was exempt from the general woe. From the Brantish border to the southern ocean cliffs, Albia groaned under fever and want. His nobles turned to their liege lord and clamored for aid.

It was to King Lionel's credit that, once persuaded of the reality of their need, he never thought to stint his nobles, but dispatched what comfort he could with a free hand. Forgetting that gold cannot buy corn when there is no corn to buy, he poured forth treasure from his privy purse until it threatened to shrink like a beggar's budget. A week or two of this brought Lord Molyneux, who was Lord Privy Purse, to the edge of despair. Where would the money come from to finish the Earl of Toulworth's tomb, if his Majesty spent all on bootless charity? At last, remembering Master Flower's lists and plans, King Lionel called the Royal Chamberlain into council to ask his advice, and in a matter of days, all extravagance went the way of the rats that had once nested in the royal pantry.

Like Master Hardy and Mistress Rudyard before them, the nobles of Albia were forced to acknowledge that, for all his youth and his undoubtedly vulgar origins, William Flower was able. Day after day, they listened to his clear voice suggesting remedies so practical they seemed almost simpleminded. If sheep died of the staggers in Hedley, then they must be moved to Carrock, where there were only foxes to contend with. If fevers crept from standing water, then the water must be drained. He even knew how that draining could be most quickly and cheaply achieved. Day after day the landless, nameless kitchen-boy mounted ever higher in King Lionel's esteem. And while his nobles might admit to the grace and agility of his climb, they could not be expected to enjoy the spectacle.

One evening towards the end of July, Baron Carstey and the Earl of Brackton sat side by side at the end of the High Table, full of roast piglet and lark pie and uncomfortably aware that they had dined over-well. At the King's left hand, the Master Chamberlain was toying with a gilly-flower pudding while His Majesty recounted—with the help of his trencher, his goblet, his finger-bowl, and his jeweled dagger—how

he had killed a boar last autumn, single-handed but for the beaters.

Old Baron Carstey, deliberate and wrinkled as a tortoise, flicked a rheumy glance up the table. "Behold him," he said in a voice thick with loathing and malmsey.

The Earl of Brackton craned his neck to follow his friend's gaze. When he was comfortable and sober and easy in his mind, Alfred Rawlings, the Earl of Brackton, Baron Ekwall and Lord Brooke of Brooke was a neat, brown man with bright dark eyes like a hunting-hound's. He liked court life and gossip and policy, and was content to leave his lands in the competent care of his eldest son Walter. Tonight he was not so neat as usual. The news from Brackton Hall was not good, and he was of two minds where his strictest duty lay. He was a little drunken. "Behold whom, Carstey?"

"Flower. The King's pretty boy. I mean," said Carstey, glancing around in sodden alarm, "the Master Chamberlain."

"I do not wish to behold him," Brackton complained. "I behold him each day as he chatters at the council table, as full of notions as an ape is of nuts." He put his goblet to his lips, found it empty, swore, beckoned to a page to refill it, then peered into the cup unhappily. After a space, he frowned and muttered, "Jackanapes!" with such violence that he woke the Baron, who had begun to nod.

"I know not why," said Brackton, "but I cannot like our chamberlain." He spoke as to himself, but loud enough for Carstey to hear him, for he was puzzled enough to require enlightenment, and drunken enough to seek it in company. "He is pleasant and courteous enough, and gives age and experience their due. But he is never angry, never mirthful, never plays faction or Hot Cockles. The man's not human."

"Yea," said Carstey gloomily. "And he will drink only thin canary and barley-water. I cannot trust a man who will not share a friendly cup of wine." He pulled deeply from his own goblet.

Brackton shrugged and returned to his complaint. "Peter tells me he laughed no more in the kitchen than he does in the hall. In season and out, the man's as sober and grave as a monk in Lent."

He brooded for a while, his high forehead knotted over the inequities of fortune. He had been friend to Queen Constance,

advisor to King Geoffrey, and had trotted the infant Prince Lionel on his knee. It would have been right and proper for the King to make him Lord Chamberlain when Roylance died issueless, and it galled Lord Brackton mightily to lose the honor to an upstart, unknown commoner. Why, the man looked little older than Alyson, Brackton thought, and grimaced: his wife's skittish niece was no sweeter a subject for contemplation than the Chamberlain. Indeed in some measure, they were the same subject. What if the King so far forgot himself as to give Alyson to Flower? What honor was there in being marriage-kin to such as he?

While Brackton brooded, Carstey was growing garrulous. "Yea, a monk in Lent, that's our chamberlain to the life. For one thing, he's uncommonly shamefast, as though he'd taken vows of modesty. He will have no train of servants as would befit his rank, but only that scullion-boy to wait upon him. He's as beardless as an eunuch, too, though they say he's five-and-twenty." Carstey leaned close to Brackton, breathing stale wine and onions. "I hear Mistress Rudyard called him a witch," he said.

"And what of that?" snapped Brackton. "Witches in Albia are as common as fleas upon a cur, and a measure less harmful. The High Bishop of Estremark's own cousin is a wizard; King Geoffrey kept a court Mage. There is no shame in being a witch. A sorcerer is another matter, but there has not been a sorcerer in Albia for an hundred years."

The Baron wheezed. "There is no shame in a *woman's* being a witch," he said. "Chamberlain Flower is reputed to be an herbmaster. Who has ever heard of an herb*master*? And since he has become Chamberlain, the castle is kept so that I would swear there is a spell of cleanliness upon it, as there was in the old Queen's day.

"It's the talk of the pages how he railed Monday last at the serving-man who left the hall rushes unchanged though they had lain only a month." Carstey's voice rose in tipsy puzzlement. "Have you ever heard of the man who would make a pother over a few rotted rushes? And though any lady in the court would be glad to company him, he ever sleeps alone. If he sleeps at all, spending day and night in the King's chamber as he does."

Suddenly the Earl of Brackton felt quite sober. "Edric

Carstey,'' he said severely, so that the old man blinked and retracted his bald head between his high shoulders. "Are you suggesting that he we speak of is the King's, ah . . . minion?''

"You quite mistake my meaning, my lord." Carstey's voice was querulous. "Flower is the King's chief counselor.''

"Exactly. And you have all but said that he counsels the King with woman's counsel.''

"I but spoke of his cleanliness and modesty, Christian virtues both.''

"But what of your talk of beards and scullion-boys and his spending night and day closeted with the King?''

Carstey mumbled at the rim of his goblet to the effect that he'd meant no harm.

"If you mean no harm," said Brackton shortly, "you had best water your wine or drink barley-water as our chamberlain does. For what you have said this night sounds perilously like treason to me.''

Carstey drained his malmsey at a gulp, withdrew his bald head further into the neck of his robe, and fell asleep upon the table. But Lord Brackton stared uneasily up the table at Chamberlain Flower and wondered yet again what manner of man this was who sat so quiet and courteous and sober at the King's right hand.

Margaret slept for a day and a night in her pentagram, sunk by exhaustion into a stupor like death. On the second morning after she had loosed her army, a sound penetrated her slumber, a creaking like stiff leather, which resolved itself, as she rose to consciousness, into her vixen's distressed whimpering.

At first, Margaret could not recall why she should be couched on the stone floor, nor why she should be both bone-weary and sodden with sleep. Opening her eyes, she saw her brazen horn resting by her outstretched hand. She blinked, moved stiffly, raised her fingers to lips that were cracked and swollen, then smiled painfully as memory returned. Her war was begun; her daughter soon would be vanquished. The thought came to her that she had hurled a thunderstorm at a fly, but she dismissed it half-formed. She was the Sorceress of the Stone Tower; she had the right to use her power however she chose. Who was there would dare say that her choice was unwise?

The vixen continued to whimper. Margaret sat up and stroked her, but the vixen shook off her hands and barked towards the shrouded mirror. Following her obsidian gaze, Margaret saw the iridescent veil stir to a small breeze; a scouting imp had returned. Margaret broke the pentagram, rose, and halted to her chair.

"Report," she commanded hoarsely.

The vixen's fur ruffled as the breeze approached to comply. There was little for it to tell, and its report was no more than a dutiful recitation of the deployment of her host and the spells they carried.

Margaret knew a moment of weary irritation with the mindlessness of minor demons, who must constantly be assured that what they do is right. As she dismissed the imp back to its commander. she began to suspect that war was a tedious business, filled with waiting. Well did she know the long moments that pass between the casting of a spell and its fruition, the days that pass between knowing a demon's name and calling it, moments and days lived in the shadow of fear. Margaret had early learned to hide that fear, to bury it so deep that she herself was hardly aware she felt it. Patience was all: patience and calm endurance. The events of her life—her father's cruelty and Lentus' lust—had taught her the uselessness, the danger of impatience. Demons know that impatience implies uncertainty; only the fearless can afford to bide their time.

Margaret rose, stretched, and descended to her bedchamber to bathe and sleep again. Endurance was, after all, one of her greatest virtues, and fear a companion rendered almost dear by its familiarity. No one, she thought with pride, could wait more patiently than she.

So Margaret waited in her stone tower while her demons blew havoc through Albia. The waiting was at once easier and more toilsome than she had foreseen; for her days were so filled with brewing new plagues and irritants that she had little time for fear. Demons freed to roam the countryside are not as biddable as those pent up in a stone chamber, and Margaret found herself increasingly occupied with councils of war and the suppressing of petty rebellions. From time to time she regretted her lost peace. But she had only to look

upon her mirror—banished to a dark corner, shrouded, turned to the wall—to rekindle her purpose.

Because Cyngesbury sheltered her enemy, Margaret vented her hottest rage upon it, sending wave upon wave of sickness and hauntings and scalding winds to beat upon Lionel's capital. The duchies of Trinley and Greenhaugh were devastated; Wyrmford and Reddingale were singed with their desert force. But, to Margaret's uncomprehending fury, Cyngesbury remained unshaken.

At the end of July, Margaret recalled her arch-demon from the north. Force and weight of numbers had availed her nothing. She sent her most powerful servant alone to Cyngesbury to see what stealth and wit could do, commanding him not to return until he could report the city laid to dust and her daughter humbled in its ruins.

Chapter Five

AUGUST TROD HOT upon the heels of July, worse news followed bad, and want camped beneath the walls of the royal city, along with an influx of folk escaping from Greenaugh and Trinley and Wyrmford. As the poor and displaced swelled the numbers of Cyngesbury, the company at court dwindled. Baron Carstey left first with his wife Grisel, then the Lords Laver and Crowdycote, and the young Baron Foley and his invalid mother. By ones and twos they slunk off to salvage what they could of their lands and their wealth, and soon the King of Albia was left with no one to advise him but the aged Archbishop of Cyngesbury, Sir Edmund Sewale, Lord Chief Justice Giles Higham, the Earl of Brackton, and Master Chamberlain Flower.

Near mid-month, the air over the capital suddenly grew, if possible, more heavy than it had been, and smothering as a featherbed. The abbey bells still rang the canonical hours, but their sweet voices labored and clanged so that men hardly knew whether they should close their windows and swelter or open them and endure the noise.

Alone in his privy chamber while the bells tolled for vespers, Lionel clapped his hands to his ears and swore. He swore louder yet when the edge of the document he held scratched his cheek. Angrily, he wadded the stiff parchment between his hands, sighed, smoothed it roughly, then tossed it onto the shoal of similar missives banked high upon his worktable. Variously blotted and courtly and blunt and ill-spelled, these documents were to his eyes as alike as grains of sand, for they all bore some tale of disaster, some request for

152

succor, some thinly veiled intimation that Lionel was not wise enough or strong enough to rule Albia as his father had before him.

Hard by the table, the portrait of Lissaude stood upon a tall easel. From her gilded frame she smiled out with a vacant coquettishness, her small white face lost between thickly coiled braids, her small white hands folded demurely around a damask rose. Her eyes were dark and bright, like oiled wood; an ebony and pearl cross hung above her swelling breasts. Lionel bowed his golden head in his hands, and tears of despair clotted in his throat.

A knock; the King shrank behind his bank of parchments, wishing whoever knocked at the devil. There was no living soul he wanted to converse withal, and he thought longingly of hermits and anchorites and knights errant, who, whatever else their trials, were seldom discommoded by unsettling documents or knocks upon their doors. Inevitably, the door opened, and Lionel jerked himself upright, flushed and glaring.

A boyish figure, weighted down by a wide gold chain and a dark gown, stepped into the antechamber. "Majesty?" inquired Master Chamberlain Flower with a graceful reverence. "May I speak a word?"

"A pox upon your word, Chamberlain," said Lionel peevishly. "I have before me words enough. If your word is more news of plague and famine, I will not hear it."

Undeterred, William approached the table and, gathering a random handful of parchments, held them up before the branch of candles illuminating the table. "I have had a thought, Your Majesty, which might help uncover the cause of these misfortunes."

Lionel sighed deeply, shrugged broadly. "Then by God's holy wounds," he commanded, "speak your word and be done."

While Lionel tapped his fingers on the table's edge, William read silently, glancing from one document to another. All at once, he made a small, satisfied sound, and laid one creased dispatch before the King.

"See, my liege, here in this letter from Baron Hedley, he speaks of 'a great winde that doth blowe continuallie, that ye rammes knowe not whatte they would doo, but waxe woode and byte ye ewes they shudde tuppe.' And here"—William

tapped another parchment—"Lord Avonlea writes of 'a fowl breez that bloweth contagion from the fennes and causeth the skin of evry wighte to breake forth intow such tedders and spots thatte it were grief onlie to see them.' Lord Heanor also reports a blasting wind, and so does Foley . . . and Nidd . . . and Maybank.''

One by one he dealt the dispatches out on the table. Then, brows lifted expectantly, he turned his grey eyes on the King. Feeling that the heat must have dulled his wits, Lionel rubbed his hands over his damp face. "Your pardon, Master Chamberlain," he said unsteadily, "but do you mean to suggest that Albia's ills are caused by a universal flatulence?"

Ignoring this frivolity, William spoke carefully, as though he tested each word ere he uttered it. "Your Majesty knows that there have been no sorcerers nor necromants in Albia since the Sorcerer Plaidus was burned in the reign of Your Majesty's twice great-grandsire, John the Mage." Lionel nodded.

"And Your Majesty knows that this John the Mage set such safeguards upon Albia that no practitioner of these dark arts could endure to dwell within her boundaries or breathe her clean air." Again Lionel nodded without real interest. This was all school-boy knowledge, common as wood.

William leaned his hands upon the edge of the table, his beardless face a-gleam with heat, candleglow, and earnestness. "Those safeguards are long outworn. The last court Wizard was Magister Lebbaeus, who died before Your Majesty was born. Your Majesty's archives hint that although he went through a form of renewal, he lacked the power to complete the spell."

Lionel's indifference left him, to be replaced with understanding and a growing apprehension. He sat upright, the heat forgotten. "Do you mean to tell me, Master Chamberlain, that my country is cursed by a plague of demons?"

"Yes, my liege." William leaned closer over the table and lowered his voice to a murmur, as though half-afraid of the words he spoke. "And here is another thing. In the forest near the village where I was born is a tower built of stone. It has these properties: that nothing will grow near it; that no man that goes to look for it can find it. These, my liege, are properties of a sorcerer's den. Furthermore, it is whispered in

the village that a woman dwells in that tower, a woman who consorts with foxes and summons up unnatural storms. Winds blow continually around it, even when all other parts of the forest are still.''

"So." Lionel's thoughts jangled at random like an untuned lute. He raked his hands through his yellow mane and uttered the first of them that came to his lips. "We should write to these lords, Master Chamberlain, and tell them to complain to this sorceress, and not to me, for I have no skill in exorcising demons.''

William straightened silently, and Lionel felt that he had somehow fallen short. Nervously, his gaze flickered from his Chamberlain's solemn face and across the parchment shoal to the portrait of Lissaude. "There is little we can do, I fear, until my bride brings Magister Venificus to Albia. For without her dowry, I am too poor to hire even the most minor of magicians.'' Hearing his voice crack and quiver, Lionel flushed: a king does not whine like a beggar or a downy-faced boy. Yet a king is a man, he thought, and a man is prey to wanhope.

"The Duchesse du Frise," he said at random, "writes that la Haulte Princesse labors to learn Albian and has requested an Albian confessor to hear her sins. If things go on as they are, the bird-witted wench will have stuffed her head with a language there is no one left to speak.''

William stood in shadow now, for only the candles on the desk were lit, and the long summer dusk had deepened into night. "Indeed," he said blandly, "the Princess is not reputed to be a scholar, my liege, but your Gallimandais is excellent, and you will have many years to be her loving tutor." His voice was a courtier's voice, cool and detached. "Has Your Majesty given thought to a bride-gift for his queen?''

Lionel was grateful enough for the turn in subject even to embrace the thought of his impending wedding. Hastily, he cast through what he knew of Lissaude. He could see that she was comely; he had heard that she was pious. "A chapel for her private use?" he ventured.

"A new chapel could hardly be begun before next spring. In any case, the Earl of Toulworth's sepulchre is not completed, and there is not gold enough in the royal coffers to

decorate it and a chapel as well.'' Lionel winced a little. Robin had cost him so much, and there was so little, at the last, to show for it. An unfinished tomb, an impoverished country.

William moved the candles so that their light fell more fully upon the portrait. "See the rose in her hand, my liege, and the posies the artist has painted behind her head. From these things we may infer that the Princess has a taste for flowers. A private garden or a maze would not be a difficult thing to lay out in the time left to us, and its cost would not be more than the privy purse could bear.''

"A maze could not grow very high between August and June," said Lionel doubtfully. "I fear it would look but a paltry gift.''

"A maze newly planted is still a maze, my liege,'' said William. "And statues could be placed here and there in its corridors and blind ends.'' William was smiling now, gazing into space, his hands clasped tight before him as though he must restrain them from molding the vision his eyes beheld. "In the center of the maze you must place some prize worth achieving, some emblem of your bride's heart.''

Reluctantly removing his eyes from William's transfigured face, Lionel once again turned his attention to Lissaude's portrait, to her ebony cross and her prim scarlet mouth. "A stone saint," he said glumly. "St. Lucy or St. Catherine. Or perhaps an angel.''

William frowned and shook his head. "A woman's nature is not all on one note like a drone, Your Majesty. Marriage is an earthly sacrament as well as a heavenly one, and however pious the Haulte Princesse may be, she would doubtless prefer a secular heart to her bridal maze, a heart that reflects her lord's love.''

At this, Lionel's jaw tightened. He had let slip one ill-considered phrase, and now the man dared to lesson him as though twenty years separated him from his king rather than two, as though the King of Albia were but a man, fallible and ignorant as other men. Oh, how he longed for Robin, who always gave him due respect, who had known his heart without need of words between them.

"Instruct me not upon woman's nature," Lionel snapped. "Well do I know that it is as various and as variable as the

sea. Shall we therefore put a satyr at the center of my betrothed's maze, or an armed huntress?''

"I had thought a hart, Your Majesty, or a figure of Psyche,'' said William calmly. ''Or perhaps a knot garden, which she may plant with whatever flowers please her.''

Taken with this conceit of a maze within a maze, Lionel forgot his temper. "The notion pleases me, Chamberlain,'' he said, then frowned. ''But is there any among our gardeners or master builders capable of laying out such a garden? We cannot afford to bring a man from Gallimand or Irridia only to oversee its planting.''

"Well, old Tom Gatham knows weeding and pruning and staking and sowing, and no man can grow finer fruits in his orchard than Tom can grow in his glasshouses. But he can no more set out a flower bed that is pleasing to the eye than he can change straw into gold.'' Here William paused, and Lionel saw his long ringless hands tighten upon one another. "I can draw a maze, my liege,'' he said softly.

"You can?'' Startled, Lionel glanced up to see his chamberlain's cheeks stain with rose as he nodded. "Light more tapers then, and the flambeaux, quickly!'' He began to search among the drifted documents for clean paper, ink, and quill. "Here, then,'' bundling them into William's hands, "show me how it is done. We will begin Lissaude's bride-gift this very night.''

For a moment William stared at him with his lips hovering between a smile and a frown, as though he debated whether the King were mocking him. Lionel grinned broadly back and seized a branch of candles to give him light; so William bore the shifting mass to a small table beside the cold hearth. He sat, sorted inkpot and quill from paper; hesitantly, he dipped the quill. Lionel set the branch upon the table and, leaning over the chair back to observe what he did, steadied himself with one hand upon William's shoulder.

"One begins a maze in the center, my liege, and works outward. Most mazes can be unravelled by laying either the left hand or the right against the hedge and never lifting it as one walks.'' He looked around at the King, his white brow very close to Lionel's bearded lips. "There are ways to complicate the task.''

Lionel shook his shoulder lightly. "You have said that my

bride is no scholar, Master Chamberlain. I would not have her wandering forever, lost in her own garden.''

"Then we will give her a silken clew so that she may always find her way to the heart of it and back. Or perhaps we could plant chamomile or thyme along the proper path so that her nose may lead her footsteps aright. See, here is a simple maze, my liege, without subtlety.''

Lionel studied the plan William had drawn. "I confess, Master Flower, that it does not seem so simple to me. But stay.'' He reached over William's shoulder and traced the path from entrance to heart with a hesitant finger. "Yes, I see. The path doubles in upon itself, but offers no choice of directions; there is no possibility of losing the way, even in jest.'' He lifted his hand, replaced it on William's shoulder. "That is too simple, Chamberlain. Try again.''

Brushing the side of his nose with the tip of the goose feather, William thought for a moment. Then he dipped the quill and slowly began to draw. Lionel felt behind him, found a stool, and pulled it up to the table. There was a small, concentrated smile on the Chamberlain's face, and his cool grey eyes were shaded by his lashes, golden and soft as fox-fur in the candlelight.

The pen spluttered. "Tailor!'' William cried, dropped it on the paper, and wiped a spot of ink under his eye into a long smear across his cheek. "The plan is spoiled.'' He shook his head ruefully, turned over sweaty hands. "My fingers slip upon the shaft, and I swear the ink steams and bubbles on the point.''

Lionel laughed. "Draw on, Master Flower,'' he said, mock-stern. "My bride comes in ten months, and I would fain have her garden prepared.''

William mended his pen and took another sheet. The next maze was larger, filling the paper with complex meanders. William drew it with deliberate care, often lifting his pen and drawing in air or trying a corridor on a blank corner before he committed it to the pattern growing in the center. Darkness crowded around the small table, the heat pressed close, and at some point between the heart of the maze and the third ring of branching paths, William shrugged the heavy overgown from his shoulders, unbuttoned the neck of his cotehardie, and loosed his shirt strings so that the column of his white throat

was revealed, gleaming with sweat like polished marble. He talked as he worked, half to himself, half to Lionel.

"We do not want to plant the hedges with yew, for yew grows in churchyards and signifies death. It is very slow of growth besides." He lifted his eyes to Lionel's. "Your Majesty would not want a maze that would only reach a graceful height when Your Majesty's grandchildren were grown." Lionel shook his head silently, equally fascinated by the unfolding of the plan and the unfolding of this new William Flower.

William bent again to his drawing. "The box tree is a fair tree," he continued, "and often used in gardens. But the leaves have a loathesome smell, and the tree itself has no virtue." He paused over a long corridor, closed it off, smiled to himself, then blew upon the ink to dry it. "But the juniper is of an exceedingly sweet savor, and each part of it has its own virtue. The ashes of the bark are good for diseases of the skin, an infusion of the berries will stop a cough, and the smoke of the leaves and the wood will drive away plague and infection."

Lionel was abruptly reminded of the documents lying neglected upon his table. "Would that every hamlet and town of Albia had been fenced around with a hedge of this wondrous tree," he said bitterly.

William looked up. "The people of Galentia take a decoction of the berries in the stead of other drink, and do live in wonderful good health, they say." He spoke softly, like one laying a balm to a festering wound.

Obscurely comforted, Lionel sighed. "Then let the maze be wrought of juniper, good Master William," he said, "so that my bride may walk in a sweet savor of health, even when she loses her way." His broad finger, calloused from sword and bow-string, hovered uncertainly above the diagram. "Even seeing all, I cannot find the path. How will Lissaude ever come to the center?"

William leaned back in his chair and stretched his arms over his head. Although the abbey bells had long since rung for matins, his eyes were clear and bright with pleasure. "This maze is like a woman's heart, sire, for the goal may only be achieved by one who seems not to seek it." He traced the route, which turned this way and that, branching and

returning, at one point, almost to the entrance before winding past blind ends and meandering tracks to the central pleasaunce.

"Once when I was a child," William said absently, "I went to pick berries for my mother in the wood. I wandered further than I was wont, and lost my way, and could not come to any glade or path I knew. To keep from retracing my steps, I began to mark my path, and at length I came to a place where the trees grew more thinly, and then ceased altogether. I stood at the edge of a somber glade where nothing stood but a thing like a tower, so shrouded in ivy that at first I thought that it was the ruin of a mighty oak."

Bewildered, Lionel asked, "Would you have me put such a tower in the center of the maze? It sounds like a conceit from an old tale."

"No, sire," said William, startled. "That was the Sorceress' tower." Despite the heat, he shivered, as if with the memory of an old, curious fear. "Though it was still in the wood, the winds blew strong around the tower, for I could see the ivy fluttering."

"Ah, yes, the Sorceress." Lionel found that he could contemplate her now, as a man on the eve of battle can contemplate his death more equably when he lies among his comrades, shriven and fed. "Have you finished the maze?"

William nodded, wiped the quill clean on the hem of his gown, then seemed to notice for the first time that he was sitting in his king's privy chamber, dishevelled and unbraced, long after midnight. He blushed scarlet and tied up his shirt strings.

"No, Will," said Lionel. "Do not put on Master Chamberlain Flower, with his unwrinkled manner and his unwrinkled gown. The man I have seen this night, inky and discoursing upon trees, could be his king's friend as well as his counsellor, and I tell you truly that I have sore need of both. Since Robin Wickham died, I have had no man I could wear in my heart's core, no man of just and honest conversation to whom I might bare my thoughts. So lay aside thy chain, Will, and tell me what to do."

"Your Majesty honors me with his confidence," said William. He hovered uncomfortably at the edge of the chair, looked from the maze to Lionel's worried countenance, then sat back deliberately and stretched his long legs before him.

"We have not the power to root out the begetter of this plague of winds," he said thoughtfully, "but I think we may weaken the plague itself. There are some small spells against the mischief of lesser sprites that are easily performed by any village witchwife. There are also charms and rituals that render common simples more potent against unnatural diseases. These I will set down and send to your nobles to give to those who may best use them. By such makeshifts, we may survive until spring, and Magister Venificus' arrival."

This was counsel indeed, and gave Lionel hope unlooked-for. "Only survive, Will? Can we not hunt the Sorceress down and raze her thrice-cursed tower?"

William merely shook his head and rose to pour himself a cup of wine. The candles guttered and paled; Lionel heard the abbey bells struggling against the heavy air, calling the faithful to lauds. All at once, he felt lead-limbed and sand-eyed, and his shirt clung damply to his back.

"By God's wounds, Will," he said, yawning. "I'm over-watched, and stupid with heat. We will speak of this anon." William bowed, gathered up his gown, and moved towards the door. "Wait." Lionel was oddly reluctant to end the interview, yet hardly knew how to continue it. "Dost play chess?" he asked.

William halted with his hand upon the latch and smiled, his face soft and unaccountably sad. Lionel thought suddenly that the Chamberlain, too, must be weary. "Yes, sire. Time was I was very fond of the game."

"Then thou shalt come to me in the evenings and play, for since Lord Roylance is dead and Lord Molyneux has returned to his estates, there is not a man at court can give me a game."

"Yes, sire, at your pleasure." William shook himself. "Shall I send for Your Majesty's chamberers?" Lionel, lids drooping, nodded. He heard the door hush open and closed again, then slipped into an uneasy doze where he dreamed that he wandered in a prickly labyrinth, and that he could not come to the heart of it, even though his steps were led by a thread of white silk, which he wound into a soft ball as he walked.

Chapter Six

WITHIN A WEEK, William had redrawn the maze upon a ruled
grid so that Tom Gatham and his helpers could lay it out with
sticks and rope at the edge of the North Garden. They set to
work with a will; and before the month was out, the maze
was planted with junipers, knee-high and lusty, dug wild
from the hills south of Cyngesbury. Lord Brackton, haunted
since his talk with Baron Carstey by uneasy thoughts of
Sodom and Gomorrah, was pleased to observe that the King
took an admirable interest in the progress of his queen's
bride-gift. The heavy afternoons often saw him striding through
the maze, now tracing the paths, now pushing through young
hedge or stepping over the ropy skeleton of a section yet
unplanted, chattering of topiary and statues and hindering the
'gardeners.

Nor was the King's new-found passion for horticulture
confined to the maze. Late in August, when the nearby
demesnes of Trinley and Greenhaugh sent back news that folk
treated with the Chamberlain's simples had thrown off their
fevers and their agues, King Lionel ordered the still-room
enlarged. Further, the King had taken to walking in the
herbary, where he could confer with his chamberlain undis-
turbed. It was true that at first the little Countess of Pascourt
seemed always to be springing up before them, clutching a bit
of embroidered linen and curtseying. But after a few days,
she disappeared, and thereafter Lionel had both herbs and
William to himself. They walked to and fro on the fragrant
paths, bruising thyme and chamomile under their feet and

talking, talking of sorcery and of witchcraft, of trade and law and governance.

Tourneys and hunts aside, Lionel had found being a king a tedious business at best. Political economy puzzled him; policy made him impatient. But William's discourse translated trade and taxes, lawsuits and guild-rights into a complex, mutable pattern akin to the subtleties of chess. Of course Lionel loved Albia; a good king naturally loves his country, just as a good Christian naturally loves his fellow man. But Lionel's native passion was reserved for Albia's songs and legends that he had suckled with his mother's milk: her ancient pride and her storied past. Under William's gentle tutelage, he grew to know Albia's present as well.

In King Lionel's day, town and castle had little to do with one another except in the way of trade. Jewelers, mercers, tanners, weavers, smiths, armorers, coopers, whores, all depended upon the court for their livelihood, but few (except the whores) had entered the castle in pursuit of their trades. Lionel was not wholly separated from his people: when he was Prince, he had often ventured into Cyngesbury town with Robin to drink, to whore, to wager silver pennies on the fall of a die in stinking, smoky taverns. Knowing only the lowest and meanest of his subjects, Lionel thought little of the people he ruled. "Battle fodder," Robin had called them, "fit only to die for their country," and Lionel had always agreed.

Now King Lionel visited guild halls and law courts and talked to burgesses and artisans and street beggars, giving ear to their complaints, redressing their grievances when he could. Thus, he learned that not all common-born men are thieves or rapscallions or bawds or the kind of roaring lad whose finest end is to leave his body upon a battlefield. Somewhat to his surprise, Lionel found his subjects to be civil, sensible, shrewd, and better informed of the true price of corn in Greenhaugh than the earl of that manor. Around Cyngesbury, dry winds might howl, but within her gates, Lionel discovered that the besieged were strong and hopeful.

In her stone tower, Margaret was growing restless. She hungered for news, for nourishing visions of plague and discontent, but with her mirror blinded, all she had to feed her

starveling hopes were the niggling, unsatisfactory reports of her imps and a dwindling faith in her arch-demon's strength. Upon this slender diet, Margaret grew thin and peevish. She scoured already immaculate chambers and berated her attendant breezes until, unbodied and immortal though they were, they feared to come near her.

A week dragged by. A day was added to the week and yet another day, and Margaret's furious industry gradually congealed into a paralysis of fear and indecision. She cursed the useless mirror, cursed the demon's spiteful obedience to the letter of her command that he should not return without clear news of Cyngesbury's fall. Was her general mated or stalemated, was he on the verge of victory or of rout? Margaret did not know, she could not know, and she would not send to know lest her summons reveal her fear. So she sat motionless in her chair, locked in a kind of still frenzy, a false, intense calm as ominous and oppressive as a thunderhead. And she waited.

Hours or days later, the demon returned of his own accord, and humbly reported utter failure. His words fell upon her like hail upon thin ice.

"I had thought thee a mighty devil," she said. Her voice was brittle, and her eyes were fixed upon the vixen in her lap. "I had thought thee a fell power that could topple kingdoms with a breath. Now thy word is that all thy dread might cannot raise so much as an unnatural draft in the streets of the capital, that thou art bested by a boy-king and a hedge-witch."

The wind that was an arch-demon and a duke of Hell hissed and cowered. "O my mistress, have pity on my shame. My spells fall abroad of their mark like ill-fledged arrows, and my plagues die out ere they light. I hurl myself like a scalding desert wind at Cyngesbury's towers to scour them to pebbles, only to find myself creeping through the gutters, chilled and weak. She is blood of your blood, O my mistress. I have no power near her."

But Margaret had heard that excuse too often in the past three months, had used it herself for nine-and-twenty years. Her belief in it was outworn as an old smock, cut up into rags for scrubbing, and finally worn down into holes and rotting threads. "Thou thyself hast said, slave, that she is a country

witch, ignorant and untaught. If she is my daughter, then should I have more power over her, not less; if her blood is mine, then may I spill it at my pleasure. Did I not slay her son, in whom my blood also ran?''

Anger roared within her, consuming her as fire consumes dried leaves, and her fingers tightened upon the vixen, which yipped in pained surprise. Rising, she cast the animal aside as the blaze of her rage broke forth from her eyes and hair. Margaret flamed and roared like a very demon of Hell-pit, and the whirlwind fled in a whistling rush that tore the leaves from the ivy overhanging the window.

Slowly, reluctantly, Margaret banked her rage. Its flames stilled; its embers dulled, cooled, hardened into fear. She had unleashed a duke of Hell against her daughter, and still her daughter was untouched. This hedge-witch was no fly, but a lioness, a dragon, a leviathan among witches, and a danger beyond calculation. And gnawing at the back of Margaret's mind was another thing, something Margaret herself had said, which her fury had burned from her memory. Crouched in her chair, Margaret shivered and moaned softly, and the vixen limped across the flags to comfort her.

Autumn

Chapter One

WHEN A CITY is first besieged, there is panic and bustle within. Merchants count up their stores; captains plan sallies; householders look to their larders and seneschals to their wells. Every street corner is a council-chamber, and every waking thought is of preparation and endurance. But if the city's wells are deep and clean, if the stored grain is plenteous and equitably distributed, if the walls hold firm, the people are steadfast, and the city's lord be worthy of his honor, then there will come a time when privation and hunger and even the fear of sack and rape are absorbed into the rituals of daily life. Men and women will gossip with their cronies, quarrel and couple and scold their children, ply their trades and pray to their God, weaving the busy pattern of their lives in despite of the army without their walls.

By autumn, such a state of embattled normality ruled Albia. All the country mourned a barren summer and expected a lean winter, but use had taken the edge from panic. There was even reason for hope, for the weather was more kindly than it had been. In the south, rain had brought some small crops of wheat and barley to harvest, and most of the plagues and omens had abated their force. Men began to feel that the enemy, discouraged by long waiting and costly skirmishes, pressed less heavily against Albia's embattled walls.

There was one breast, however, in which not even a tempered hope reigned. As August withered into September, Alyson's heart, like the garden's dying leaves, withered into a restless melancholy. Lady Brackton contemplated summoning the court Physician to her, or better still, some Cyngesbury

herbwife who might physick Alyson out of her fidgets before she drove either herself or the ladies of the court distracted. The girl could neither sew nor play her lute for ten minutes together before she would be leaning out the window or wandering about the solar, picking up a book here, a sheet of music there, telling Lady Tilney that her stitches were too coarse and darting off again before that astonished beldame could gather her wits to scold her. There was no living with her in this state, and nothing to be said that would comfort her.

Alyson herself half-thought that she was falling into madness. Through July she had wooed Master Flower shamelessly; through August she had pined for him. So much the ladies in courtly tales did, and then died of their love or bestowed it upon some more grateful swain. Alyson had done neither.

The first love-sickness of a young maid may be tedious to its beholders, but to the maid herself, it is pain inexpressible. Alyson's days dragged their slow pace through an endless wasteland, peopled by inconsequent shadows. Often she wished that she might indeed die of her love, for she knew not how she might be well and happy again in a world that held William Flower and he indifferent to her.

On a night in September when winter's chill first nipped the air, Alyson sat huddled upon her bed, curtains drawn against her maid-servant's prying eyes, gazing by the light of a guttering candle into a silver mirror. For the hundred-hundreth time, she asked herself whether her love would not love her because she was foul to look upon or whether there was some other fault in her that her mirror could not show. In all truth (she thought as she minutely appraised hair, lips, eyes, cheeks) she was foul enough now, with her face linen-pale and blotched from much weeping. Yet her eyes, drowned though they were in tears, shone through the bitter salt, and her mouth had not loosened in grief, but held a certain melancholy gravity that almost, she thought, became her. No, Alyson decided at last, even grief-struck she was passably fair. Why, then, would William not love her?

Petulant, Alyson threw the mirror upon the rumpled furs and laid her cheek against her tear-damp pillow. She felt her body yearn for him with aching loins and nipples hard against

the stuff of her bedgown. He must be told that she was no longer a child, but a woman, with a woman's passions and desires.

Alyson blew out the candle, stealthily pulled a corner of the bed-curtain aside. There was Margery, dull wench, snoring on a pallet by the hearth. It would take more to awaken her than the soft hush of slippered feet upon the rushes. Alyson crept to the clothes-press where a heavy mantle was draped, and wrapped herself in its dark folds. Silently she flitted through the castle's shadowed halls, across galleries and down passages, around corners and up steps, until at last she stood where she desired to be: at the door to the Chamberlain's apartment.

Trembling with cold and the panicked thudding of her heart, Alyson pressed her hands against the iron-bound wood that stood between her and her heart's desire. Her pain would end tonight, she told herself, one way or another.

A small autumn wind moaned in the hall; the torches flickered and flared. Alyson's hand shook helplessly as she pushed open the door and slipped inside the room beyond. Gently, holding up the latch so that its rattle would not betray her, she shut the door behind her and stood against it, the blood beating in her ears.

Within the outer chamber, the air was still. A hump of cloth and fur was Ned, his back to a small brazier, sleeping with his mouth ajar. Alyson thought she could hear the small wind moaning under the heavy oaken door. Her flesh crawled and her hand clenched upon the latch to lift it and flee. The sound swelled into a low and anguished sobbing. Alyson's hand released the comforting metal of the latch and she crept towards the inner room like one bewitched.

She stepped soundlessly into William's bedchamber and halted just within the doorway, quivering with fear and a strange leaping excitement. The sobbing choked and ceased. Crimson embers glowed in the hearth, painting the hangings with a faint bloody light. The bed-curtains were drawn close; the chamber was airless, cold, and very still.

Bating her breath, Alyson listened. A terrified gasp ripped the silence, then the bed-frame creaked under a restless weight.

"O, sweet Jesu, no, no!" very soft. Then, mourning, "Dear my love, my fondling, my heart, I will lack thee

forever,'' and, on a rising note, ''Henry, my son, my precious son. Have they slain thee, too, and left me naught to wrap thee in?'' and, ''Oh, the blood, the blood! My bed swims with blood!''

These last words were borne upon a shriek like a damned soul's, a shriek that banished from Alyson's mind all ardor, all curiosity, all passions but terror. In a trice, she had gained the corridor—all but trampling Ned, who was sitting up on his pallet with his mouth agape—banging the door behind her in her haste, tripping over the folds of her mantle in her scramble to regain her own safe bed. Once there, she huddled under the covers and wept herself insensible.

Next morning, Alyson rose pale and weary. William's moans, his fear, the aching shrillness of his voice when he cried out ''Oh, the blood, the blood''—these had cooled her passion and torn her heart with a pity that much resembled awe. She understood his words to mean that her William had fathered a son, and lost both mother and child in a single night, bloodily. The agony of such a loss was beyond Alyson's grimmest imaginings. She still loved him, still yearned over the thought of him, but her love was tinged with reverence and fear, as if she presumed to love a saint or a hero of legend.

Silent and meek as a turtle-dove, Alyson returned to the solar and to her interrupted embroidery. Lady Brackton eyed her narrowly, and fairly growled at Lady Dumbletan when she would have twitted the girl on her late freakish moods. For Lady Brackton saw that Alyson's disease had not abated, but merely taken a new form, as baffling and untreatable as the last. Sighing, she threaded her needle and addressed herself to her own work, wishing half-guiltily that her brother Pascourt had had another sister to mother his wayward child.

Chapter Two

ON THE EIGHTEENTH of October, King Lionel sat in the royal apartments with his feet stretched out towards the fire, studying the deployment of beautifully carved ivory chess-men on a beautifully inlaid board. The day had been tedious, filled with councils and suppliants and judgments and a lengthy High Mass in celebration of the Feast of St. Luke and St. Jude. Lionel was weary. His king stood in jeopardy to William's queen. His thoughts would not stay on the game, but like errant moths, circled wearily around the mysterious Sorceress. What could she want? What did she hope to gain? Why did she not show herself? What manner of woman was she?

Lionel glared at the black queen. "I would that I had an enemy I could fight," he said suddenly. "Charms and prayers are well enough, but all that we achieve through them is to nip at the Sorceress' skirts." He sighed, considered his position, took one of William's knights. "Give me a pitched battle, with knights and yeoman archers and the fear of death to inspire my strategies. I have no stomach for this skulking, coward's war."

William moved a pawn. "The Sorceress is a solitary, my liege. She deploys no knights or yeoman archers, but demons called from Hell, and she does not leave her tower. If you would engage her, you must flush her from her earth. But first you must defeat her troops."

It was an exchange that had worn with repetition into an antiphon; Lionel took up the response. "Without a mage behind me, I can do nothing. The Archbishop is old, besides

being astray in his wits: the rituals of exorcism are beyond his abilities. God's bones, man, I know neither the key to her power nor the path to her stronghold. Force of arms I can understand; sorcery bewilders me.'' The King took William's rook. "No. I will wait until Lissaude's tame wizard arrives, and take on the Sorceress when I can be sure of vanquishing her.'' Suddenly, he slapped the table and set the chess-men dancing on the board. "By God's bloody wounds, Will, I like none of this!''

"Indeed, there is little in it to like, Majesty,'' said William quietly. There was a pause while the logs upon the hearth spat and hissed and the two men, their minds elsewhere, stared at the board between them. William took a sweetmeat from a tray set handy upon a low stool, bit into it, then spat and laughed.

"Now Master Hardy has left both the sugar and the cinnamon out of the figeyes,'' he said in answer to Lionel's inquiring look. "When last he made them, it was only the cloves. What a rascal is Sir Cupid, to set both kitchen and laundry by the ears. Did you mark, sire, that of late your linen has savored more of sage and citron than of lavender?''

Lionel, right willing to be distracted, leaned back in his chair and watched the play of the firelight on William's bright hair. The erstwhile undercook had often regaled the King with kitchen epics and romances, and all the rams, wethers, and ewes of the domestic flock had become known to him by their proper names and attributes. "And who is the cruel fair? Rosy Bess? Lovely Joan?''

"The lady is not so fair as Bess, nor so young as Joan, but neither is she cruel, so the negatives fall more in Master Hardy's favor than not.'' William paused, his face boyish with mirth. "No, it is into Mistress Rudyard's toils that Master Hardy has fallen.''

"Mistress Rudyard?'' said Lionel, incredulous. "The royal Laundress? That great, melancholy sow who called thee a witch?''

William nodded. "She is not so melancholy as she has been, my liege, and short commons have pared much of the fat from her bones. As to the manner of their loving, 'tis thus. She and Master Hardy have shared Your Majesty's domestic offices for these ten years without incident or encounter,

moving as it were like planets in their separate spheres."
William picked up a goblet for Mistress Rudyard and a nut
for Master Hardy and circled them around each other. "It was
the plague forced them to work together, conjoining their
influence." He brought goblet and nut together. "As they
worked, they looked; as they looked, they smiled; as they
smiled, they blushed, and on through the amorous progres-
sion to kissings and strokings and professions of love. He
calls her 'Molly,' and 'honey-cake,' and his 'little pig's-eye.' "

Lionel began to laugh. "Little pig's-eye?"

"Aye. And they clip and kiss behind the still-room door."
William put the nut in the goblet and set it down. "I doubt
not there will be a little brother or sister for Ned within the
year, and perhaps a father, too."

At the thought of the irascible Master Hardy bouncing an
infant on his foot and owning a nameless servant-boy as his
stepson, the King roared with mirth until he was red and
gasping for breath. He choked, coughed, groped at his empty
cup. William leaned across the chessboard to refill it.

Lionel looked into the fair face stooping so close to his
own. Suddenly the King was seized by a desire to tangle his
fingers in the bright locks that lay upon William's neck, to
kiss his shapely mouth. The hot blood sang in Lionel's loins,
and his heart labored in his breast. Slowly, he reached his
hand across the board.

A log popped and settled in the hearth; Lionel started and
pulled back his hand to cover the mouth of his goblet. He was
sweating as with fever and trembling with desire. "That's
enough wine, Master Flower, and enough chess, too," he
said gruffly. "I grow a little mazed, and should sleep."
William set down the flagon and began to gather together the
chess pieces.

"Leave that," snapped the King, and William frowned. "I
am tired, Will, and fretful," said Lionel more softly, "and I
feel the need for solitude." So William bowed gravely to his
lord, took up the tray of sweetmeats, and left the King alone.

Now Lionel of Albia was not a man accustomed to examine
the workings of his soul. He knelt to his confessor once a
month or so, when he wished to communicate at Mass, but
his confessions were *pro forma* affairs, expressing regret for

angry words, for blasphemous oaths, for willful overindulgence in roast swan. He thought of himself as a decent if not a pious man, lusty as any son of Adam and untroubled by vicious appetites. He kept no formal mistress, but when he was so moved, he took a Cyngesbury courtesan to his bed, and left the wives and daughters of honest folk in peace. Like Robin, he preferred his whores young, hard-bodied and agile, and found their sporting a pleasant pastime.

But no whore's body had given him the wild release of a battle-charge, or even the quieter joy of riding knee to knee with a boon companion in quest of game or battle. And since that time when first he had lain naked in a woman's arms, no whore's tricks had inflamed him as did the bare thought of his hands upon William Flower's white body.

The night aged while Lionel paced and brooded and tried to reason out the cause of his incomprehensible passion. Could it be some spell of the Sorceress, to infect the soul of Albia's King with a mortal poison? Or was William Flower indeed the witch Mistress Rudyard had named him?

How could a man be a witch? Witchery was not learned, but inborn, and only women were born witches. Men studied long to become mages or wizards, and even mages and wizards grew old like other men. And there was this mystery of his age: young Flower had sworn that he was all of five-and-twenty, but one had only to look on his fair face to know that either he lied, or else employed some witch's spell to keep the grizzle from his cheek. No man of five-and-twenty (thought Lionel, studying his own weathered countenance reflected in the window's darkened glass) has a rose and cream complexion like a page-boy's or a girl's. And yet Will was no mincing Ganymede, no silk-and-satin half-woman, pouting madder-stained lips. No, his Will was a proper man. And it was just the marriage of hard and soft in him, the paradox of square jaw and curving cheek, of arrow-straight body and graceful hands, that called to Lionel, stirring his blood as no gentler beauty could.

Between appetite and disgust, Lionel began to tremble. The man must be a witch, to move him thus; or a sorcerer or cursed necromant, seeking to damn the King of Albia's soul to the bottommost reaches of Hell.

Lionel turned blindly from the window and into Lissaude's

portrait, which tottered upon its stand. "Damned, simpering nun!" he shouted, and with one wide sweep of his arm, sent portrait and easel clattering across the floor.

In the silence, Lionel sat heavily at his table and burrowed his hands in his hair. He was not, he told himself, behaving rationally or reasonably or kingly. Rationally and reasonably, then: had William Flower in truth bewitched his king, tempted him or enticed him into an unnatural affection?

As best he could, Lionel called to his mind midday walks and midnight confidences and examined them for subtle seductions. He summoned up every look and gesture that had passed between him and his chamberlain, every word of sympathy or instruction or friendship. In all honesty, he could find no fault in William's actions. Never had he leaned too close or looked too meaningly, never had he offered to return those comradely embraces with which Lionel was accustomed to honor his intimates. Why, Lord Molyneux, even Robin Wickham, had touched more freely than William.

But there Lionel's honesty went to ground. No, William was the first, the only object of his passion, and William had comported himself exactly as a good servant should, without familiarity and without forwardness. The sin, if sin there were, was Lionel's alone.

A grey and misty dawn was breaking over Cyngesbury by the time the king had finally threaded his mental meanders through to their unprofitable heart. When he saw the light growing, Lionel snuffed the guttering candles and threw open the window to air his musty wits.

Already the household was stirring: a scullion trotted across the yard with a pair of empty buckets, and two men-at-arms stood yawning and drinking small beer over an open fire. Soon the Gentlemen of the Bedchamber would be tapping at his door with clean linen and ale and meat, and soon after that, the King's Chamberlain would be presenting himself at the door of the King's cabinet with his papers and his plans and his clear grey eyes. Suddenly, Lionel knew that he could not bear it.

"I will go hunting," he said to himself, and his weariness left him as the words left his lips. "I will go hunting alone."

Some four hours later, Lionel rode his tall grey courser under

the eaves of Hartwick Wood. He had set the household by the ears by demanding that Glaucus be saddled without delay and provisioned for a full day's absence. Then, reluctantly, he had sent for William and given him the Royal Seal to hold, which interview, impersonal as it was, had left Lionel flayed with anger and need. Fleeing the memory of William's puzzled grey eyes, he had slipped from the castle through a postern gate, ridden to Wyrmford by the nearest way, and galloped over Reddingale Field towards the eastern edge of Hartwick Forest.

Blasted by his enemy's sorceries, Reddingale Field was now a scorched plain sadly different from the bright mead whereon Ambassador Tellemonde had danced and Alyson Pascourt had been crowned Queen of Love and Beauty. Beyond it, miraculously, Hartwick Forest stood unscarred by drought and wind. Lionel's heart lightened, and as he passed under its whispering canopy he rose up in his stirrups and sang: " 'What a glorious death to be honored with sounds, / Of a fine brazen horn and a chorus of hounds!' "

His song fell into Hartwick's silence, which swallowed it without echo. Lionel laughed nonetheless, for the lust now heating his blood was for the safe and familiar: the careful stalk; the long, scrambling chase; the sweet consummation of the kill; the hunterly tasks of paunching and flaying the beast.

There were ample signs of fox and hare, but Lionel ignored them; his hunger was for larger prey. Heretofore, he had stayed to Hartwick's borders, seldom penetrating beyond the coppices and glades managed by his foresters. Heretofore, when the King had wanted to kill a pig or a deer, trackers found it and beaters drove it to him. Today, he thought recklessly, the King would serve as his own tracker and himself brave the pathless depths of the wood. Yes. He would take his royal privilege and kill a hart if he could find him, a herd-king, crowned with branching horn.

As his father had long ago taught him, Lionel examined the forest floor for spoor. Here he saw the print of a slotted hoof; there a low branch nibbled bare. He followed the deer-sign deep into the wood, now riding, now leading Glaucus and stooping over the elusive trail, blind to the white flicker of rabbit scuts in the undergrowth, deaf to the nearby bark of a

fox. All his senses were attuned to the faint musky odor, the soft red-brown hide, the moss-muffled step of his prey.

By mid-afternoon, having lost the trail in a small glade, Lionel became aware of the growling of his belly and the weight of his sleeplessness. He dismounted, dug bread and cheese from the saddlebag, "By God's bones, this forest's as empty as my belly," he told Glaucus cheerfully and slapped the horse's sturdy grey neck. "Not a living thing in it save thee and me."

He ate standing, fearing to sit at ease lest he should sleep. Even if he had not been overwatched, the decaying warmth of the forest would have spoken of sleep to him. A weary Michaelmas summer lingered under Hartwick's leaves and shimmered in the still air. Late flowers and bright berries glowed in the shadows of the undergrowth, and, perched on a branch above his head, Lionel saw a small brown bird. A cony crouched by a tuft of grass; a badger peered around a tree root. The wood was silent.

When a hoof rang against stone, the noise echoed through the hush like a challenge. Lionel spun to the sound. At the edge of the glade, a yearling Hart stood proudly. It was white as milk and as tall as the King's grey steed, and its slender horns shone silver as the moon. For a moment, King and Hart stood at gaze, then the Hart huffed and bounded off into the thicket. Dropping his bread and cheese, Lionel scrambled onto the startled Glaucus and rode after the fleet white shadow, shouting for joy.

It was a chase like a dream, a hunt out of an old song. The Hart flew through the brambly undergrowth like a star, bright and near and untouchable. Sometimes it doubled, hare-quick, upon its own trail and flirted past its pursuer a bare spear-length away, whereupon Lionel would rear Glaucus up on his hindquarters and turn to follow after. Sometimes horse and rider would stand panting, sure their prey had eluded them. Lionel would catch the gleam of a ghostly flank or the twitch of one white ear, and then the Hart would break and run again, bounding tireless through the trees.

As the shadows lengthened, Glaucus' sides grew black with sweat and Lionel's face stung and bled from the whipping of a thousand branches. Perhaps this blood-letting damped his lust; perhaps hunger or weariness weakened his courage.

In any case, Lionel began to suspect that Hart, not King, was master of this hunt, and to fear that he followed a witch-beast to his doom. After all, no man could say precisely where the Sorceress' tower lay, or whether, following its mistress's evil whims, it might not move from place to place.

Lionel sawed back on the reins, but Glaucus only snorted, shook his head, and plunged on after the Hart. Next moment, he broke through a thorny hedge into a wide glade, splayed his forelegs, and halted, throwing Lionel forward onto his neck.

The King hauled himself upright and looked about him. In the middle of the glade, at bay against an outcropping of grey stone, he saw the Hart standing moveless, and all his misgivings drowned in a surge of triumph. Lionel leaped from his saddle and advanced upon the Hart, his spear forgotten, his sword drawn as if he faced a human knight. The Hart lifted its head to accept the challenge, belling high and wild into the air. Then it vanished.

Lionel strode to where the Hart had stood, peering sharply here and there as though to see where it might hide. Upon examination, the outcropping proved to be a small stone manorhouse, its door hacked and broken, its windows gaping shutterless: it was clear the place had been sacked, and that some time since.

Sheathing his sword, Lionel studied the scene. That no member of the household had survived was to be read in the bones and dented armor scattered in the tall grass and across the doorstep. He was about to enter the hall when his eye was caught by a sword-hilt showing above a clump of grass by the mounting-block. Curious, Lionel approached and saw that the sword was thrust above a long mound of dirt, guarding it as a cross guards a grave. Rust like old blood coated both hilts and blade.

Lionel's knees gave a little. He sat on the mounting-block, and with his fingers shut out grave and manor and sword and wood. Without doubt he had been led to this place, and from what old tales said of such things, he suspected that some great deed would now be required of him. He smiled grimly into his palms. Having ridden out blindly in search of he hardly knew what, he could hardly complain that his search had brought him adventure rather than venison. He must

abide the chance, or call himself no more a man. So thinking, the young King of Albia straightened his back, loosened his sword in its sheath, and awaited further wonders.

For a space, a great silence hung over glade and violated manor, smothering the beating of the King's heart and the soft rustle of Glaucus' grazing. Then from far off in the wood, a tormented cry began to echo and to moan. The hair prickled upright at the back of the King's neck. A listening pause, and then the cry again, closer and more mournful, and closer still, until the glade overflowed with wordless grieving. Awe-struck, Lionel stared into the trees and discerned a flicker of white in the depths of their shadows. The flicker steadied and grew and resolved into a Dove, a Dove as moon-white as the Hart, a Dove that lamented in a human voice. It circled the manor, then lighted, fluttering, on the hilt of the rusty sword.

"Alas," it mourned. "Alas, alas the day my love became the famous Flower of Serving-men."

Lionel's hand clenched upon the hilt of his sword, but he did not rise. The Dove fixed him with a blood-red eye and shifted its scarlet feet on the thickly encrusted hilt. Lifting its beak, it began to weep crimson tears which trickled down its throat and breast and bathed the sword in a stream of dark blood.

The King licked dry lips. "O Dove," he said, his voice grating hoarsely in his ears. "Pray tell to me thy grief."

Suddenly birdlike, the Dove preened itself, smearing its snowy wings with blood. Lionel nerved himself to question it further, but before he could speak, the Dove drew itself up on its grisly perch and began to sing.

Oh, it was her mother's deadly spite,
For she sent thieves in the dark of the night,
They come to rob, they come to slay,
They made their sport, they went their way.

And don't you think that her heart was sore
As she laid the mold on his yellow hair,
And don't you think her heart was woe
She turned her back away to go?

> And how she wept as she changed her name
> From Fair Elinor to Sweet William
> Went to court to serve her King
> As the Famous Flower of Serving-Men.''

As suddenly as it had given tongue, the Dove fell silent.

Lionel, who had felt no fear when the Dove began its song, shivered now with a strange dread. Seeling his eyes with finger and thumb, he prayed that Hart, Dove, sword, manor, all the mysteries ranged before him might prove to be the phantasms of an exhausted brain. But when he withdrew his hand from his eyes, the scene held in all its unearthly beauty. Some last crimson sparks of sunset flickered through the trees, burnishing the Dove's feathers and firing its bloody tears to ruby. The wood was dark around them; the glade was unnaturally still. The very fall of night seemed to wait upon Lionel's response.

But the King's wits were shocked by revelations and bewildered by riddles. Sweet William, the Famous Flower of Serving-Men. Fair Elinor, whose mother had sent thieves to rob her of her home and heart. In the space of a few lines of jigging verse, one was transformed into the other, handy-dandy, like a travelling magician's trick. Lionel had feared himself the unwilling slave of an unnatural love. That he loved was beyond doubt: William's name alone was enough to constrict his heart. Had his heart then proved wiser than his eyes?

Lionel shook his head to clear it. The waiting tension eased, and evening, cool and blue-grey, crept into the glade. The Dove shimmered in the dusk like a pearl.

That there were laws regulating such adventures, Lionel knew, but the lays that recounted them did not record what the poor wight might have thought when first he found himself surrounded by marvels. As the minstrels sang the tales, even untutored wood-cutters were unamazed when questioned by spectral beasts or raging wizards, and invariably returned the right response, pat upon their cue. Lionel was seized by a sudden envy for those long dead heroes. Whatever weaknesses or confusions they might have owned were buried deep in the splendor of their deeds, and they themselves protected from

judgment, invincibly armored in legend. So would he one day be, he reflected sourly, providing he did not fail the test.

With the recklessness of desperation, Lionel rose, drew his sword, and held it crosswise before him. Words sprang to his lips, inevitable and formal as a prayer. "I grieve for thee, good Dove," he said. "And to give thee ease, I cry vengeance upon the cruel mother of thy love. Upon this sword, I swear to thee that I will hunt down the unnatural hag and slay her without pity, as I would slay a wild beast."

In answer, the Dove spread wide its wings and glowed for a moment cruciform and blindingly bright. Then it vanished as the Hart had vanished, without warning or trace.

Trembling, Lionel lowered his sword and stood blinking until Glaucus nosed his shoulder, which brought him a little to himself. By clear moonlight, the King mounted his tall grey steed and rode from the haunted glade, too bewildered with what he had heard and seen to reck which path he took or how to find his way home again.

Chapter Three

FOR MARGARET, AUTUMN had always been a season of anticipation whose lengthening nights presaged the long, still, comforting darkness of winter. Autumn promised study and sleep and the most cordial pleasure of hearing the bitter demon winds screaming around her tower while she sat snug within.

This autumn, however, Margaret could find no comfort in the dying of the year. Her mirror was still turned to the wall and her breezes, sullen and dispirited, had slunk back to hide in the chamber of whispers. It seemed that her daughter's beneficent influence had soaked through the atmosphere like oil through a bandage to smother the haunted winds and soothe the wounded land. By October, only the duke of Hell remained abroad, restlessly prowling outside Cyngesbury's walls, where he sniffed at her gates and howled maledictions upon witch and sorceress alike.

Even as the stilling of her winds forced her to admit defeat, Margaret knew a kind of relief at their failure. Driven though she was by hatred and cankerous fear, Margaret had never truly imagined her daughter's death, and in one well-hidden corner of her soul, she dreaded a final victory. Half-gratefully, she recalled the arch-demon and abandoned her siege. Her campaign had not been fruitless, she thought. Her enemy's strength had been sorely tried. Now was the time to retreat and plan anew. Perhaps alchemy—of all arcane arts the least dependent upon the practicer's indwelling power—would yield her a weapon more apt to her will than her traitorous mirror.

So Margaret returned to the long, quiet hours of study she had forsaken for war. Although it was more complete than

any she had known before, her solitude was welcome, almost comforting. Her winds were exhausted, moodish, sour; her vixen was growing drowsy. Without the mirror to instruct her, Margaret was forced entirely upon her own wit and judgment in the matter of interpreting the texts she read, and she found the exercise pleasant. The properties of marcasite and antimony, the applications of amalgams and citrinations flared brightly in her mind, blinding the shadows that dwelt there, the shadows of Lentus and her daughter and the golden-haired executioner.

At the very moment that King Lionel was promising the Dove revenge, Margaret sat poring over a grimoire with her vixen dreaming and twitching at her feet. The air was chill and quiet. In the wash of candlelight over the grimoire's creamy pages, Margaret's blackest fears paled; their clamor was stilled by the small crackle of parchment when she turned over a leaf. Somewhere in her soul's still spaces, Margaret knew she was content.

She was puzzling over the alchemical theory of the mystical unity of all created matter when the vixen began to growl. Annoyed, she nudged her familiar with her toe. The growling did not cease, but settled into a low, tuneless note that Margaret eventually traced to her brazen horn. Curiously, she rose, went to where it hung, laid her hand upon it. The horn was warm, and it vibrated gently, as though some ghost blew insubstantial breath through its brazen length.

Margaret spoke a simple exorcism. The note persisted, swelled. Out of the tail of her eye, she saw the mirror's shroud twitch and billow. From curiosity, from habit, for the moment without fear, she went to it, turned its face into the chamber, cast aside its shroud, and looked.

For the first time in many months, the mirror was utterly blank, showing neither woman nor man, neither fox nor fire. Hopefully, Margaret searched its brazen depths and found a spark, a yellow glow that gradually sharpened into the flame of a pottery lamp set upon a table. She made out the form of a young man crouched over a thick volume, following the words of what he read with the forefinger of one hand. The light grew stronger, burnished the wheat-gold hair that hid the young man's face, glittered within the links of the heavy

chain that lay upon his breast. Margaret stroked the mirror's cold surface and whimpered.

Beneath her fingers, the young man rubbed his hands as if to warm them, then leaned back, yawning and stretching. The oil lamp flickered and cast deep shadows over eyes and mouth, hollowing the mirrored countenance like a skull. Nonetheless, Margaret recognized it. Her death. Her fate. Her daughter.

Margaret shook the mirror as though it were the woman's reflected shoulders she held between her hands. "Slut," she shouted at the unconscious image. "Hussy. Hedge-witch. Dost defy thy mother? I should have strangled thee with thy birth-cord!"

The reflection started and took on a listening look.

"Canst hear me, minx?" In her impotent fury Margaret was fairly screaming now. "My demons will rip thee, my winds will toss thee from the topmost turret of thy paramour's castle. I will destroy thee, thou hen in a cock's comb, though it mean my own destruction. Thou horror, thou worse than fiend, thou daughter of Lentus!"

On these words, the woman looked up, and through the mirror's window, her eyes met her mother's gaze and held it.

As in a mirror of steel, Margaret saw a triangular, bony face and narrow, brilliant eyes, a wide, snarling mouth, and a flow of hair like flame. Reflected in those steady grey eyes, Margaret saw a soul deluded by desire and blind to its own weakness, a soul that had bound up its power in unclean bronze and put its faith in the wind.

Margaret tore her eyes from that ghastly vision and snatched up her brazen horn. Without stopping to draw a pentagram, she summoned all her fourscore restive, vengeful devils: imps and sprites, demons and fiends. Upon the instant, her windy host swept into her chamber to find themselves constrained only by the twisted horn and their mistress's will. For a moment, her anger alone held them, and they writhed between her and the wondering face in the mirror, painfully, inexorably bound. Then the duke of Hell came whistling joyously through her tower windows, and with one frigid breath, froze all Margaret's fiery chains and snapped them asunder. Another breath blinded the mirror's brazen eye with frost and sent a profound chill into Margaret's heart. Yet even

as he marshalled her own army against her, she blew on and
on.

Caught in the gleeful maelstrom, arcane books flapped
noisily around Margaret's head. Crucibles and retorts clanged
against stone walls and tore great splinters from the wooden
shelves. Glass vials and delicate crystal vessels shattered in
the gale, and their shards spun in a glittering cloud through
the room. Cushions, tapestry, chairs, tables, lecterns, all were
sucked into the demonic whirlwind, and finally Margaret's
vixen was snatched from under her mistress's skirts and swept
yipping into the air.

Hopelessly, doggedly, Margaret winded her horn, her gaunt
cheeks distended with the effort to drown out the demon
army's roar. She fed her breath with all her sorcerer's power,
on and on in an unbroken, raucous, brazen cry, until her horn
exploded into a shower of ragged bronze slivers. Then, in a
silent rush of frozen air, the demons departed to their own
realm, and Margaret fell senseless beside the broken body of
the vixen.

Chapter Four

SURELY A BENIGN enchantment lay upon Hartwick Wood that night, for Glaucus never stumbled or lost his way among its tangled paths. With the reins slack upon his neck and his rider lumpen upon his back, the great horse went perforce where the enchantment led him, but his ears lay back upon his skull and his hide fluttered nervously.

As for Lionel, he was riding in a rainbowed haze, enrapt by mingled emotions. Waking dreams hunted one another through his mind: of unkind slaughter and unearthly beasts, of unnatural mothers and unending grief. Amid this haze of conjecture and wonder, one truth alone shone clear. The Chamberlain was a woman; William was Elinor. Heaven smiled upon his love.

"Elinor Flower." Lionel spoke her name aloud as if the sound alone could make her true shape more real. "Fair Elinor, wiser than the Seven Sages, more dear to me than life. How could I ever have thought thee a man?" Hands tight upon the pommel of his saddle and eyes closed, he tried to envision his beloved dressed as a queen, with her wheat-gold hair netted in jewels and her slender figure at once concealed and displayed by a close-laced, low-bosomed gown.

But the face that rose before his mind's eye persisted in looking too strong for its delicate frame and the body too hard for its clinging draperies; trapping William in Elinor's garments could not change Lionel's most lively image of his love. In imagination, Lionel unlaced the gown and drew it from his beloved's body. But the only female nakedness his

mind could conjure was the girl whore's narrow-hipped and hairless frame.

Lionel started and swayed on Glaucus' back; the great horse blew down his nose and tossed his head. The riddle of his heart, Lionel thought ruefully, was darker than the riddle of the Dove's song. He looked to Elinor to answer it.

With an effort of will, Lionel sat straighter in his saddle. The Dove's song: what could it mean? It teemed with riddles, and not an answer among them. "They came to slay." Who had been slain? The Dove, for one. He must have been her lover or, more likely, her husband—a father or brother would not name her "love," and William, no, Elinor, was too chaste of manner to have been any man's mistress. From the manor, Lionel guessed that this husband had been a knight, endowed with a forest holding. He could also venture to put a name to him: what name would she adopt if not her husband's?

But was the Dove that "he" upon whose yellow hair Elinor had laid the mold? The grave was too small to be a grown man's. And what about the Hart, the yearling Hart, that had led him to the glade? Had Elinor lost a son, then, as well as a husband?

Lionel considered the tale he had constructed and his heart dissolved in pity. Poor unfortunate, to be so violently deprived of husband, child, home, all in an instant and through no chance of war or plague, but through a cruel mother's spite. Such a mother, Lionel thought, was unnatural, cursed, inhuman. He would hunt her down and butcher her like a wild swine, wherever she might lair. He had sworn to do no less.

But who was Elinor's mother and where did she dwell? The Dove had given him little enough to go on. Staring blindly into the darkness, Lionel marshalled the few facts he knew, point by point. The woman had sent thieves to rob her daughter of all she had: she therefore must be powerful, to own or buy the services of ruffians. Of course she was most evil, to torment her child against the use of kin and kind. But though the brigands had murdered the household down to its least member, they had left Elinor alive to bury her dead and find her way to Cyngesbury. Having ordered the death of all around her, why stop short?

A branch caught at his hair, nearly sweeping him from

Glaucus' back. Startled, Lionel roused himself to find that the moon had set and the wood stretched pathless and dark around him. Lionel drew back on the reins, intending to halt and sleep until daylight brought clearer counsel, but Glaucus could not be halted. Such a midnight ride, spell-led, was of a piece, Lionel thought, with the Hart and the Dove and William, who was Elinor, who then must be his own true love. So Lionel's mind circled and circled like a bird on a string.

For all enchantment and Glaucus could do, it was mid-afternoon before Lionel rode through Cyngesbury's western gate and through its winding, crowded streets to the gate of Cyngesbury Castle. By this, both King and horse were weary almost past knowing where they were. Slowly Glaucus plodded under the portcullis into the castle yard. The startled guards ran to help their king dismount, but Lionel urged his steed forward and up the wide steps, on through the doors into the great hall.

Although the midday meal was done and the trestles cleared from the floor, the great hall teemed with knights and lords who clustered around the Master Chamberlain and noisily argued whether a party be sent in search of their wandering monarch or no. When Lionel appeared amongst them—pale, staring, mounted on his tall grey horse—they fell silent, and then with one voice, they exclaimed aloud and crowded against Glaucus' sweating sides.

At the center of the noise and pother, Lionel sat stone-like, oblivious to all but William, who was pushing through the press of lords and guards and pages and court ladies. When he reached his sovereign's side, William grasped his stirrup and anxiously searched his face. Lionel gazed down into the beloved grey eyes, heard the beloved voice exclaim, "My liege!" And without thought or plan, he seized his true love's arm, heaved him up to his pommel, and kissed him fiercely on his parted lips.

If Lionel had imagined that his beloved would return the embrace, would twine loving arms like ivy around his neck, he was disillusioned. The mouth he kissed so warmly was cold against his lips; the body in his arms was stiff and unyielding. Wounded, amazed, Lionel opened his eyes upon his love's pale countenance, and was for the first time aware of the gaping, grimacing faces beyond.

They were not, as he had imagined, alone, but perched on Glaucus as on a high rock, surrounded by a whispering sea of courtiers. Lionel looked about him, and, as his mind pricked awake, his belly sank with dismay. His nobles stared transfixed, some agape, some with their lips primmed in disgust; here and there a lady smiled slyly behind her hand. At the edge of the crowd, the little Countess of Pascourt sobbed loudly in her aunt's embrace.

With the hot blood beating in his ears, the King cleared his throat. If he had been dreaming, now he was awake. He knew, of course, that he held a woman in his arms, but his court did not; he must make haste to tell them.

"This lady," he began, his voice hoarse and dry. A tide of murmuring rose around him, floating him in sudden anger. "This lady," he roared, "has been cruelly wronged." The murmuring subsided.

Lionel continued more moderately. "It has been revealed to me that this lady is Elinor, Lady Flower, wife to Sir William Flower, who was foully murdered with her household and her little son. She took his name and the habit of a man, and came to court to serve her king." He glared out over the throng as if daring comment. The hall was utterly still.

"My liege," said a low voice in his ear. "Your horse trembles with weariness, and you are in no better case. Dismount, and let the grooms see to Glaucus."

Lionel brought his grainy eyes to the figure he held close to his breast. "What's that? Oh. Yes, Glaucus has borne me nobly," he said; but he made no move to dismount. Around him, noise and light sank and swelled in soothing, rhythmic waves. He swayed a little as he sat.

Something was tugging at his boot. Lionel looked down to see William standing by his stirrup, clearly waiting for him to dismount and follow him. Her. Well, whether William or Elinor, man or woman, his beloved stood with arms outstretched, offering him peace and rest. What could he do but accept? Lionel swung from the saddle into his true love's arms. His knees gave under him, and, belatedly, men-at-arms ran to him, but he waved them away, laying his arm instead around the Chamberlain's shoulders. The crowd surged aside to let them pass, watching while Elinor paced stony-faced

down the length of the hall with Lionel hanging upon her shoulder like a wounded man.

In this manner, Elinor half-carried her king to the royal apartment. She led him to a cushioned chair and shrugged free of his embrace. "You are weary, my liege," she said, retreating across the room to William's chair. "Let me call your gentlemen to attend you, and we will talk when you have slept."

Lionel yawned hugely. "In truth, I am entirely foredone, but there are two things I must say before I rest. I have seen thy husband's ruined manor and have prayed by thy son's grave, and I know it is thy mother who has done thee this harm. I have sworn vengeance upon her." He smiled then at his fair chamberlain who was, beyond all belief, a woman. "I would tell thee also that I love thee."

Elinor clung to her chair with white-knuckled hands. "My mother? My mother is Bet Martindale of Nagshead Farm, and a kinder woman or a more loving has never breathed." Her low voice trembled and cracked like a boy's. "I beg you, my liege, to say how you come to know these things."

An image of the blood-boltered Dove sketched itself upon Lionel's inner eye, and he chuckled helplessly. "A little bird told me, as the saying goes."

There was a small, shocked silence. Then Elinor spoke, her voice glass-hard. "I take not the jest, my liege."

"Thy pardon." Lionel pulled himself upright and rubbed his head hard, leaving his hair in a tangled aureole around his face, which made him look younger far than his two-and-twenty years. "I speak nothing but the truth. Thy husband's soul came to me as a Dove. He sang of thy loss and grief, and named thy mother the cause. I have sworn upon my sword that I will slay her. I know no more."

"So," said Elinor, and her voice was very sad.

Lionel leaned back in the chair and smiled at her sleepily. "Come and kiss me, love."

For a moment Elinor stared at him blankly; childlike, he stretched out his hands to her. Her countenance softened then, and, moving across the hearth, she smoothed back Lionel's tangled hair and kissed his brow. Briefly, the King thought of catching her in his arms, of forcing that shapely mouth to yield him a lover's kiss, but he sighed instead and fell asleep.

* * *

After King and Chamberlain had departed the great hall, the court erupted. Each man turned to his neighbor to wonder and exclaim aloud. Among them all crept Thomas Frith, collecting scraps of talk: "A fine, bold piece, to gull us so thoroughly"; "At first I thought . . . well, I could not choose but think"; "The King must be bewitched, or mad"; and, most often, "But what of la Haulte Princesse Lissaude?"

Presently, his mind soaked with news as a trencher is with juice, Thomas tore down to the kitchen.

"Master Flower is *what*? The King has sworn *what*?" Master Hardy glared down at the page, who in his excitement was jigging wildly from foot to foot. "In the name of St. Saltus, ninny, cease this babbling and hopping about, and tell thy tale like a sober Christian." He dealt Thomas a smart rap on the skull with his horn spoon. "Now, calmly: what ails the King and Master Chamberlain Flower?"

Thomas rubbed his head and grinned. "Well, sir, King Lionel rode his horse straight into the hall amidst all the lords and ladies, and he kissed Master Flower, and then said his name was really Elinor, and that her husband was killed. And all the court is set a-boiling, sir, and says the King's run mad and will marry Master Flower instead of the Gallimand princess, and there will be war."

This news created as great a stir as Thomas could have wished. Scullions and undercooks left their spits and their bowls to crowd around him, and Master Hardy bludgeoned him with questions until the boy was as sulky as he had been excited.

When at last Master Hardy was satisfied he knew all that Thomas had to tell him, he swore softly and stroked his chin. Young Flower must have had a rare laugh over that scene in the stillery, he thought. But who would have guessed the lad was a lass, such a bony stick as he was?

The stink of burning meat intruded upon his musings. Master Hardy looked up to find the spits still and the tables deserted. "Idle fools," he shouted and charged among them, ladle at the ready. Cooks and knaves scattered to their proper places like sheep before a dog. In the midst of their bleating, a female voice shrilled. "False! Devil! Viper! *Woman!*"

Into the kitchen stormed Bess, her bosom heaving and her

eyes sparking black fire. She was attended by Mistress Rudyard and a blanching of wide-eyed laundry-maids.

"There, there, poppet." Mistress Rudyard patted Bess's back with a motherly tenderness. "I never liked yon coxcomb, for all his airs and his learning."

"His?" Bess balled red fists and raised them to the heavens. "*His?* No coxcomb he, but a flaunting jade, a rantypole, a horned ewe, a roaring, lying, damned *woman!*"

Joan sidled up to Bess, her face piously crumpled with suppressed laughter. "Poor wench," she said, smugly sympathetic, "to find thou'st lusted after a maid all this long while. It be no wonder thou'rt fashed."

"Oh!" Bess rounded on Joan, set violent hands upon her linen cap and, tearing it from her head, sent it sailing into a cauldron of soup. "Oh," she cried again, and began noisily to wail and moan.

While all the rest stood helpless by, Hal Clemin pushed forward, seized Bess by her plump wrists and shook her soundly, whereupon she stopped her wailing with a gulp and looked indignantly, as if minded to turn her wrath upon him.

"Whist, now," he told her firmly. "Thou'lt find a proper man to love thee soon enough." And, turning his back on the amazed kitchen, Hal Clemin, slight, neat, and proper, put his arm around Bess's waist and led her tenderly away.

In the great hall, Lady Brackton stood at the edge of the milling crowd, clasping Alyson to her bosom and trembling. "I always said William Flower stank of shameful secrets," she said indignantly. "I misliked him from the first. 'This lady!' By the purity of my bride-bed, no true lady would dissemble so!"

"O Aunt!" Alyson burrowed her face deep into the folds of Lady Brackton's wimple, imagining the court's looks and pitying whispers: "There's the foolish girl who pursued the handsome Chamberlain. See how she weeps! She'd have wept harder if she'd caught him."

Nose a-flare with excitement, Lord Brackton worked his way through the press to his wife's side. Alyson heard him barking nearby: "No, no, my lord. The man's a maid. Did you not hear His Majesty say so?" Then a low mutter into Lady Brackton's ear: "What can the boy be thinking of,

Elizabeth? King Geoffrey would never have played his court such a scene.''

"Hist, Alfred," said Lady Brackton.

"Oh," he said uncertainly. "Yes, yes, love, I see her. Poor lass." He gave Alyson's shoulder three small pats. "Young Flower has much to answer for, one way and another." Distracted, he paused, and: "The King will be needing a new chamberlain," he said thoughtfully.

Like a quail in a field, Alyson stood shivering in her aunt's arms, small and hunted and unable to stir for shame. Oh, why could not the floor of the hall gape and swallow her up, sparing her the torture of living thus humiliated, thus dishonored? The excited conversations around her began to run together in Alyson's ears like babbling water. Perhaps, she thought hopefully, she would faint. Then out of the stream, a single voice rose: "My lady Alyson," said Sir Lawrence Ostervant. "Do you allow me. . . ."

In a flurry of skirts, Alyson tore from her aunt's embrace and fled the hall.

When Lady Brackton sought her niece a little time later, she found her in the solar, flung sobbing across a windowseat, her lark's-wing hair ruffled over her face. Murmuring "There, now," and "Gently, gently, dear heart," Lady Brackton eased onto the seat beside her, took Alyson's head onto her lap, stroked her hair and her heaving shoulders. For a minute or more, Alyson yielded gratefully to her aunt's motherly care.

"Indeed, sweeting, it could never have been, were the Chamberlain never so much a man," began Lady Brackton unwisely.

Alyson bolted upright, declaring she would not be petted like a baby that had lost its rattle. Then she ran from the apartment to her own bedchamber, where she slammed and barred the door.

All that evening and into the night, Alyson swept a path through the rushes, weeping and raging like a diminutive Herod. In vain did her maid-servant Margery beat upon the door, imploring her to unbar. In vain did Lady Brackton seek to lure her out with promises of a soothing posset, a time away from court, a jennet mare of her own. Humiliation deafened her to their pleas.

How could she have been such a fool as to mistake a woman in a doublet for a proper man? But who would ever have thought that a woman would so disguise herself? The King had called her "Lady Flower." Lady Flower! What manner of lady would stoop to hauling water and chopping onions? What manner of lady showed her legs to the world, consorted with kitchen boys, shared a stillery with a fat laundress, and sat for hours together lecturing a green girl on the properties of sage and verbena?

With a shamed wonder, Alyson recalled those tedious lectures and the breathless attention she had accorded them. Surely William, no, Lady Flower, had known all along that an interest in herb lore could never keep a countess in a kitchen-garden day after stifling day? How Lady Flower—that counterfeit man, that brazen, bare-legged jade—must have laughed in her embroidered sleeve at Alyson's foolish doting. Well, Alyson may have been a fool once, but now she was wiser. Never again would she lose her heart to a pretty outside. Love was an illusion and beauty, a dream. So Alyson told herself, and weeping, slept at last.

When Alyson did not appear to accompany her aunt and uncle to Mass next morning, Lady Brackton forbore to send Margery to wake her. There were white faces and shadowed eyes enough haunting the halls and chambers of the court: nobles fearing a war with Gallimand, servants fearing a new chamberlain. Better to let the maid sleep.

As she entered the royal chapel on her husband's arm, Lady Brackton sought in vain to empty her mind of worldly concerns. She felt so weary, so overstretched, so old. When we are fourteen, she thought, sleep is a sovereign physic. Would that physic were so efficacious at threescore. She knelt down, signed herself, took her beads into her hands. Beside her, Lord Brackton's eyes were red-rimmed and his brow deeply furrowed: worry and ambition between them had allowed him little rest. Lady Brackton folded her hands and bowed her head. *"Cum invocarem exaudivit me,"* she prayed. *"Miserere nobis."*

Alone of all his court, King Lionel had slept deeply and dreamlessly, waking at cock-crow refreshed and fired with

the prospect of action. He burned to see his chamberlain again, to put to this Elinor Flower the questions that he must ask her to unravel the Dove's riddles. Although it was barely light, he called for Thomas Frith to rouse Elinor if need be and summon her to attend him.

Wound taut as a cross-bow with nerves, Lionel paced, and as soon as the door opened to admit Elinor Flower, let loose his rattling flight of questions.

What was the name of her husband's demesne, and of whom did he hold it? Where was Nagshead Farm and how had she come to be fostered there? Could she recall some noble lady who might have made much of her when she was young, or who had helped or hindered her parents to their amaze or pain? Could she explain why she had cut her hair and come disguised to court when she might have come as a suppliant and demanded revenge upon the thieves as her right?

Elinor endured this barrage with set lips and lowered gaze. Every now and again she would clench her folded hands and look up as though to reply, but Lionel babbled on. Time and again he called her "Will," halted, laughed, and begged her pardon for the slip. The sleep-blurred memory of the scene in the hall unnerved him. Elinor had not exchanged her man's cote for a woman's kirtle, and there grew in Lionel's mind an unsettling sense that he spoke to one who, not being William, yet wore William's face; one who was neither man nor woman, but some third sex yet unknown and unnamed.

At length, having exhausted his store of questions, "Here is the knowledge I must have," Lionel said. "Is there anything you know may lead us nearer?"

Elinor fixed her eyes upon her hands and bit at her lip. Lionel thought that he had never seen William look so ill, not during the plague or the worst of the summer's miseries. "I know the name of my husband's murderer," she said finally, "and the place where she dwells."

Astonished, Lionel gaped at her. "Who is she?"

"The Sorceress."

"The Sorceress." For a moment the word hovered between them like a new-conjured demon. "The Sorceress of the Stone Tower?" Lionel asked.

"Even so, sire."

Lionel raked unhappily at his hair. "She is doubly culpable, then. First for the murder of your family and second for the tormenting of my kingdom. And still we dare not approach her."

"We can, sire." Elinor's words were clipped, her tone contemptuous. "The Sorceress has been stripped of her demons. She is now powerless as a farm-girl whose menses are not yet upon her."

Suddenly, Lionel had had his fill of mystery and of sibylline discourse. A pox upon the woman! Would she force him to pry her knowledge from her word by word? Surely William had been more forward, more open in his manner and speech than this hard-faced stranger who sat before him in William's gown and chain. Lionel found that he was shouting. "How do you know this? By God's bleeding wounds, woman, you will answer me!"

Elinor complied, her voice as cold and heavy as grief. "Two nights since, as I sat working in the stillery, I was visited by a sending. It seemed to me that I heard a voice, ranting but muffled as if it came from a great way off. I listened, and the voice grew until it rang in my ears. Horror, it called me, and worse than fiend, and daughter of Lentus." She paused. "There was a sorcerer lived in the stone tower once; it is said that he brought this sorceress there as his leman. He often walked abroad among men, attended by the shadows that served him. My father . . . Tom Martindale, saw him not long before I was born. Once his name was known and feared from Seave to Barthon: Lentus, master of shadows, Sorcerer of the Stone Tower."

Lionel searched Elinor's stony face for some sign of her parentage, for some mark of Cain, some devil's shadow upon eye or brow. This woman to whom he had declared his love, this chamberlain to whom he had entrusted his kingdom, was a sorcerer's child, heir to abomination, blood-kin to the kingdom's greatest enemy. Rage clenched him. "We understand," he said harshly. "But this does not answer us how you come to know the Sorceress' power is broken."

He half-expected her to temporize, to hesitate or blind him with conundrums, but she answered readily enough. "The Sorceress appeared before me as though she looked through a window in the air. There was a room behind her. Her eyes

met mine; and in that moment, although I did not know her face, I knew the inmost secrets of her heart. It was very like the shock of love, and yet unlike." Elinor paused, and her tight voice tightened further. "Her name is Margaret."

Lionel opened his mouth to ask her once again how she knew, but Elinor rushed on. "Almost at once she broke away, yet I could see her still, small and far away. She blew a twisted horn, and a whirlwind answered her blowing. The horn shattered and the scene was extinguished."

"She is dead, then." Lionel wavered between relief and a righteous anger that his oath had been forestalled. "My kingdom is safe and Hell itself has avenged your husband and child."

Elinor shook her head blindly. "The Sorceress Margaret is not dead," she said. "She must be seized and burned and her ashes buried, each flake apart from every other so that her soul may find no resting-place." Like her words, her voice was flat, unequivocal, colorless. "She must be slain. I will have justice."

Lionel stared at her. Fear, grief, rage, even misplaced love, were humors Lionel had heard were proper to women. But never had he seen or heard tell of any woman thus enstoned by passion, annealed and tempered by hatred as a man might be. Where any ordinary woman would have wept or raged, Elinor sat with her eyes sand dry and her body held in quivering check.

At a loss, Lionel took refuge in formality. "Then in God's name we will seek the Sorceress to burn her," he said stiffly. "We have promised your husband no less."

Elinor made a reverence and left him standing by the window with his hand half-reaching to stay her.

How dared the woman depart without hearing all he had intended to say to her? Yet, with so much anger between them, how could he have spoken to her of love? Indeed, at that moment, Lionel hardly knew whether he desired her or loathed her.

But as he recalled the interview, his heart softened. He had been too sudden with her, both in word and deed. Whatever blood ran in her veins, she had always served him faithfully. And how could he expect the woman to embrace a new love

when the old lay unavenged? Time enough to woo her when her mother was dead.

An image flashed across his mind of a harpy, fair-faced and bare-breasted, feasting upon a woman's charred body. Such imaginings, he told himself sternly, were the fetid breath of thwarted desire. Why, it was only lately that he had thought himself enamored of a man, whose body was denied him by God and Nature. Now he knew he loved a widow. Widows are estranged from love by grief. Elinor's husband was a full year dead; but she was shocked now, overwhelmed by too many revelations: in time she would soften. Lionel called Thomas Frith from his post outside the royal apartment.

"Summon the lords to council," he told him. "And that without delay. We will quest after a sorceress."

Chapter Five

MARGARET SAT ALONE in the uppermost chamber of her stone tower. Her hands clutched the arms of her great carved chair. A day and a night had passed since she had dragged herself there, a day and a night which she had endured in a waking trance of despair. Not a single sprite remained of her windy army, not so much as an impish draft to sweep away the dust of failed rituals. Her power had fled with her demons, and she had left to her only her wits that were clouded with loss. For the first time in thirty years Margaret regretted that she could not weep.

On the morning of the second day, she roused herself and mechanically began to set her chamber to rights, so that when doom overtook her it would not find her disordered. She swept the room clean of the shards of her horn and her sorcerous vessels, clasped the useless grimoires and codices and ranged them on their proper shelves in their proper order. The broken body of the vixen she shrouded tenderly in the mirror's iridescent veil and laid on a cushion. That accomplished, she stripped off the rags of her grey kirtle and clad herself in a fine green gown, cut low above her breasts and edged in fox-fur. Her flame-gold hair she plaited under a wide jeweled head-dress; her white fingers she weighted with rings of opal and serpentine. When she was thus robed and crowned, she pulled her mirror to its accustomed place beside her chair, and, settling herself against the torn cushions, began to search its depths.

Margaret had need of all the patience her despair could teach her; though the mirror's surface rippled, for day after

day it showed her nothing but a gleaming mist, opalescent as the bloom over a blind man's eyes. Moveless as stone or her vixen's cold body, Margaret bent her gaze steadily upon her mirror, with only the liquid glittering of her eyes to betray that she still lived.

Nor did she stir on the third day when the mist rolled away from the bright image of a sunny woodland glade. A yellow-haired man, bearded and splendidly dressed, rode a tall grey horse at the head of a dozen armed nobles. The mirror and Margaret followed the warlike company through the wood's mazy paths, through thorn and bramble and tangled briar to the very foot of her stone tower.

The yellow-haired man dismounted, gestured to his nobles to await him, thrust aside the hanging ivy, and strode through the tower door. Across the ruined guard-room he came, climbing without a pause up through her bedchamber and the now-quiet room of whispers. A clatter of booted feet sounded in the stairwell, and, just as his reflection disappeared from her mirror, King Lionel of Albia stepped into Margaret's topmost chamber.

Slowly, Margaret lifted her pale eyes to his ruddy, determined countenance. "What do you want of me?"

"Your life." Lionel had not expected to fear her, this broken sorceress, but when he met her clear grey eyes, he felt a cold sweat prickle on his brow. She was very fair and queenly, and a shadow of William informed her face and her long, calm hands. Lionel, looking on her jeweled head-dress and her green gown and the swelling curve of her white breasts against the rusty fur, wondered how much her daughter would resemble her, dressed at last in a queen's array.

Margaret's thin lips curved in weary amusement. "Take it, then. My daughter has stripped me of the power to summon the feeblest imp to protect me." Then she returned her eyes to the unreflecting bronze mirror beside her chair.

How could the mother be as indifferent to his wrath as the daughter to his love? Here, at least, he had the power to enforce attention. Lionel hurled the mirror's carved stand across the room and planted himself, legs astraddle, in its place. "Mistress, you *will* look at me, who am your victim and your judge. In the past six-month, you have brought death and suffering to my innocent subjects, and before that,

slain your daughter's husband and her blameless child. You may jest as you will; my heart is hardened against you.''

Margaret recoiled from Lionel's shouting as though he had struck her. Her mirror had fallen a little distance away, and lay tilted against a lectern. A ray of sunlight glared blindingly across its bent surface; but it seemed to Margaret that she could still see within it the shadows of a woman and a man and a struggling vixen.

When once again she turned uncaring from him, Lionel seized Margaret's unresisting hands and dragged her to her feet and hallooed loudly for his nobles.

Fairly baying in their eagerness, twelve lords coursed up the stairs at their master's call. They burst into the chamber like a pack of hounds, or devils, swept Margaret out of the King's hands and down the narrow stairs, where they bound her hand and foot and slung her ungently across a horse's withers. Their rough hands dishevelled her green gown and the brambles along the woodland paths tore her skirts and ripped the jewels from her head.

When the sorry procession rode next morning through Cyngesbury and into the castle courtyard, Elinor, had she been watching, would have seen her mother trussed up like a wounded doe, her molten hair quenched in the mud cast up by the horse's hooves.

Chapter Six

As soon as he had seen Margaret safely bestowed in the deepest and dankest of Cyngesbury's dungeons, King Lionel commanded Lady Flower to be brought before him in his private apartment. He thought she must be dressed as a woman by now, and his heart beat feverishly when he imagined her metamorphosis. Would she outshine Queen Constance his mother, the fairest woman he had known? Would she be as fair as Linette the Moonwhite, great queen of the courtly lays? Or would she resemble her sorcerous mother?

A familiar boyish figure slipped into the chamber and bowed. Lionel's heart beat more feverishly still.

"William!" The name burst from him like a cry of pain. He bit it short.

"My lady Flower." His cheeks afire, Lionel leaned his hip on the table and folded his arms in an assumption of ease. "Why have you not yet clad yourself in garments more suitable to your sex?"

Elinor clasped her hands before her, very composed, *point-device* the serving-man. "Your Majesty's household is still in need of a chamberlain to guide it, my liege. And, although the members of that household are accustomed to obeying my commands, they are not accustomed to obeying a woman. By now they know my true sex, but of habit, they obey my trappings of office, and so I have chosen to retain them."

"I cannot fault your reasons," said Lionel shortly. "Yet your dress is unseemly for one who will be Queen of Albia. I would have you in women's clothes as soon as may be."

Elinor frowned, her hands tightening hard upon each other.

"What of the treaties with Gallimand, my liege? You are already betrothed to la Haulte Princesse Lissaude."

"By God's bloody wounds," Lionel groaned. "I had clean forgot her."

He turned away from his ambiguous love and leaned his fists upon his worktable among the parchments and pens and crumbling bits of sealing-wax. From the corner of his eye he could see Lissaude's portrait, restored to its tall easel and pushed back against the wall. Plague take the peevy wench; he wanted none of her. Perhaps he would send word to King Arnaud that he had the pox; perhaps he would cast off his crown and live with Elinor as a simple knight in her husband's manor; perhaps he would beg Elinor to remain in court as his mistress and trust Lissaude to turn a blind eye to his adultery.

"My liege," said Elinor behind him, "I cannot be your queen; your honor and your kingdom's welfare forbid it. 'Tis true the sorceress Margaret can do no more harm, but Albia's weakness must be redressed, and for that the Princess's dowry is necessary, and the help of Magister Venificus."

"Then should I marry Magister Venificus," said Lionel pettishly. "I have no love for the girl, that I should spend my life bound to her. Only look at her: a sheltered child who has lost her heart to a painted image, recking nothing of the man it pictures. Is this, this poppet to be Queen of Albia and sit beside me on Albia's throne?"

Elinor returned no answer. Lionel imagined her stony-faced and disapproving at his back, a nurse biting her lip over a troublesome child. The image stung him, and he wheeled to blast the woman for her presumption. But the figure that confronted him was not, after all, a self-righteous scold, but a slender young man who leaned earnestly against a chair-back in an attitude as dear as it was familiar.

Disarmed and defeated, Lionel threw up his hands. "Kings cannot please themselves in their loves. I will marry Lissaude. There is no more to be said."

There was a pause, then: "Has Your Majesty considered whom he will appoint as the next Chamberlain?" Her voice was briskly impersonal: William's voice. "Lord Brackton is a sensible man, as is his eldest son Walter. And with his younger son Peter being Your Majesty's saucier, he has a

certain knowledge of the workings of with Your Majesty's household.''

''Granted,'' said King Lionel, heartily wishing the interview done. ''Let Lord Brackton be Chamberlain. It is as my father would have wished it.'' But the thought of Lord Brackton, with his restless manner and his worried brown eyes, caused the King more annoyance than ease. For a moment, Lionel imagined the scene in the great hall unplayed, the Dove unheard, the Hart unhunted. He saw William by his side, beloved and yet remote, friend and counsellor, playing chess on winter evenings, walking in the herbary, perhaps standing godfather to Lionel's heir.

The dream vanished, as ghostly, for all its homeliness, as the Hart. Such a distant, bloodless companionship was not what he had wanted from William. Soon or late, his passion would have declared itself, Elinor would have been unmasked, and all this pain and shame inevitably suffered. Lionel took his seat by the hearth and looked at the eerily familiar figure opposite. ''Will you stay at court, Lady Flower? Or will you return to your husband's hall?'' He felt suddenly older and infinitely sad. ''Come, sit and talk with me as you did when you were William.''

Elinor released her grip on the chairback, but did not sit. ''I am no longer William, my liege,'' she said shortly. ''I cannot remain in your court. And there is nothing at Hartwick Manor that I may return to.''

An uneasy sense of guilt stirred Lionel in his seat. He had loved this woman; whether she bared her legs or concealed them in long skirts, she was his subject, had been his faithful servant and his friend. He must provide for her. A title? No, she was no old soldier. A manor? A farm? What reward was proper for a woman? An idea came to him. ''I will give you a dowry from the royal coffers and your choice of my lords for a husband,'' he said. ''Any man would be glad to call you his wife.''

Elinor's face hardened. ''I am not a horse or a cow to be bestowed upon a friend when it is no longer useful. Nor is a husband a reward for good service, like a manor house or a plow of land. My liege, only a year past, my peaceful and accustomed way of life was most bloodily torn from me. In your service I have found peace; in pursuing my vocation of

healing, I have myself found ease. Now these things, too, are taken from me.''

Lionel took breath to protest, but, lifting her hand, she forestalled him. "I give you no blame, sire, for you were weary past caution. No man being thus weary, and . . . loving, could have done otherwise.''

Her pardon cut Lionel deeper than her anger; for it revealed not only her indifference, but his own unkingly weakness. A knight in a minstrel's tale might sweep his beloved to his saddle-brim and carry her off into happily-ever-after. But King Lionel of Albia was no simple knight to act thus on impulse, thoughtlessly. Nor was his life a minstrel's tale, to end so neatly. There were no songs about happily-ever-after, Lionel remembered.

"What will you do?" he asked.

She waited long before she answered. "I made my way once in the world, my liege. I will do well enough as cook or understeward in some lordling's hall.''

"As William?"

"As William."

Suddenly, blindingly, Lionel was furious. "And will you beguile another poor wight into believing that his heart treads the primrose path to damnation?" he shouted. "Even now you play the boy, thinking that the shape most pleasing to my eye. For God's sake, woman, if in good sooth you are a woman, attire yourself more seemly; I'll have no damned hermaphrodites in my court." Lionel swung into his bed-chamber and cracked the door shut behind him, leaving her shocked and still behind the protecting chair.

The last week of October brought hail and lowering skies, and a damp, heavy chill that hardly yielded to the warmth of a smoky fire. Lady Brackton and her niece sat in her bower, busying themselves with her eternal embroidery. Now and again a frown rumpled Lady Brackton's plump face as she glanced up from her tapestry to study Alyson's pale cheeks. Her tiring-woman, Dolly Whitlow, was huddled by the fire, laboring with rheumatic fingers to sew a jeweled band onto a kirtle and relating the news that she had had of Bess when she went to the laundry to fetch clean linen.

"They rode in early, my lady, just after dawn, a full dozen

lords and earls all guarding the one foul Sorceress, and a tricksy quean must she be and all, to cause such a flurry and flap.'' Dolly turned the worsted heaped upon her lap and smoothed the band consideringly. ''Bess were folding sheets with Joan at the laundry door, and the Sorceress passed within arm's length, tied belly-down on her horse. Bess do say she looked most fierce and fair, for all her dirt and fetters. They'll burn her within the fortnight, they say.''

Alyson threaded her needle with white silk and grimly attacked a lily. How the old goose did chatter. Why should Dolly think that anyone might be interested in how the Sorceress looked or when the Sorceress was to burn?

There was a sharp rap on the door. Alyson started and pricked her finger.

''Dolly, see who knocks,'' said Lady Brackton placidly. Grumbling a little, Dolly heaved herself to her feet and hobbled to the heavy oak door. Alyson watched the old woman fumble with the latch and laid down her needle, suddenly fearful.

Lady Brackton's voice rose on a note of unbelief. ''Lady Flower?'' Open-mouthed, Alyson stared at the slender figure, dressed in cotehardie and furred gown, hesitating upon the threshold. Elinor bowed, somewhat awkwardly. Alyson turned toward the window and made a great show of examining her embroidery. With chilly courtesy, Lady Brackton bade the visitor enter and be seated, and inquired if she would take wine.

Elinor declined the wine, then paused as if at a loss how to begin. ''You wonder what brings me to you, Lady Brackton.'' Her voice was soft, almost shy, her head a little bowed. ''I would ask a boon of you. Now that I am a woman again, I have need of women's clothing.''

''I do not understand what you require of me, Lady Flower,'' said Lady Brackton stiffly. ''You have been known to be a woman this week and more; had you wanted a smock and kirtle, surely you could have procured them in that time.''

Elinor's hands clung together as though for comfort. ''Lady Brackton, in kitchen and hall alike, you are spoken of as a kind and Christian woman. To you I will confess that, although I grow weary of this bootless mummery, I shrink from asking help of those who might take pleasure in refusing.''

She fell briefly silent, then continued. "In Cyngesbury Castle, there is not a man, gentle or simple, who is not affronted by me. There is not a woman who is not shocked and offended. My steps are dogged by whispers and my simplest orders are executed awry. Even when I was cast out of my home, I was not so helpless as I am now, for I could depend on my own wits to gain my food and clothing.

"When I was a girl, I hated to sew and spin, and for that I was more than commonly clever in garden and kitchen, my mother did indulge my whimsy. When I was a wife, my husband likewise humored me, giving me women to make and mend that I might be freed of a task I loathed. Now I am a widow, I have not the skill to clothe myself." Elinor's voice faltered. "I am well paid for my stubbornness, for I yearn to dress my body in the mourning I have long worn in my heart."

Lady Brackton rose, and, crossing to Elinor, drew her out of her chair and examined her critically. "You are something too tall to wear any gown of Alyson's, and something too slender for mine, but with a little contriving, my underlinen should fit you well enough. Dolly, take Lady Flower to my chamber and look out a smock for her. Then help her shift her clothes, and bring her back to me when she looks like a Christian woman again."

Alyson had listened to this exchange with fluttering uncertainty. She hated this woman for a brazen deceiver. Of course she hated her—she had determined to hate her. And yet. How could anyone hate a shamefaced widow, unable to procure so much as a smock to cover her nakedness?

Raising her eyes from her silks, Alyson saw Elinor move towards the inner chamber with Dolly hissing mournfully behind. Impulsively, she rose and darted to her side, but could not bring herself to look into Elinor's face.

"Lady Flower," she whispered. "May I attend you?" Awaiting no response, she ran into the bedchamber and flung open the great carved chest that held her aunt's clothing, began to rummage through drifts of linen and fine wool. In her flurry, she made a fine muddle in the chest and found nothing to serve her purpose.

Dolly, waddling close behind, wrung her hands and wheezed. "Why, my lady, here you have mousled and pawed your

good aunt's clothing as though they were a pile of rags, and found nor smock nor kirtle to cover this lady's body withal.'' Creaking and hissing, the tiring-woman lowered herself beside the chest and buried her arms in it. ''You must help untie the lady's points, child, while I set this in order again.''

Cheeks burning, eyes lowered, Alyson approached Elinor. ''It seems I must be your body-servant, Lady Flower.'' Her hands fluttered before Elinor's breast, helpless before the unfamiliar fastenings. ''Where should I begin?''

''There is no need for this, my lady. I have been putting these garments on and off for nigh on a year, and have had no one to wait upon me.''

Elinor's voice was sharp with embarrassment, and, looking up into her face, Alyson saw that the clear grey eyes were blurred with strain and that hard lines had come to dwell in the corners of the shapely mouth. It was the face of a woman filled with shame and sorrow, not with pride at all. Pity overcame Alyson, and an unaccustomed motherliness.

''It would please me to serve you, if you will allow it,'' she said gently. ''You are a lady, the widow of a knight, and a lady is served by the daughters of her friends. My aunt stands as a mother to me, and as she has befriended you, so it is my duty to serve you and to learn what you are pleased to teach.''

Elinor stared at her for a moment, then spread wide her arms and laughed. ''Well argued, little scholar. Very well, I shall teach you how to uncase a man, although I counsel you to save the practice until you are wed. Unbutton my cote and untie the points behind. The rest I can reach myself.'' She shrugged her chamberlain's gown to the floor and began to unlace her clothes.

Soon a fine woollen cotehardie, a padded pourpoint, and long cod-pieced hose with leather soles to them joined the gown upon the rushes, and Elinor stood shivering and barefoot, clad only in a linen shirt. Having at last found a suitable undergarment, Dolly heaved herself to her feet and gathered a furred bed-gown from its peg. ''It's cold to strip yourself bare, my lady,'' she said. ''That shirt will serve as well as a smock, and my lady's nightgown will see to your modesty.''

''No,'' said Elinor, and pulled the shirt over her head.

Alyson closed her eyes and backed up against Dolly's

buxom solidity. Then, curiosity mastering her shyness, she peeped at Elinor through her lashes. Elinor's body was tightly wrapped from hip to armpit in a long band of white linen, and she winced a little as she began slowly to unwind it. First her belly was revealed, scored by the marks of childbearing; then her sides, welted by the linen, and finally her breasts, bruised and flattened from long binding. Pressed into the darkened flesh over her left breast was a large jewel, which came loose as she bent, leaving its imprint upon her skin. On the same chain gleamed a slender golden ring.

Elinor looked ruefully down her body. "These breasts could now scarce give the lie to my late manly attire."

Finding this unequivocal nakedness unbearable, Alyson snatched up a smock and cast it over her head while Dolly wheezed sympathy and advice. "What you want for they bruises, my lady, is a tub and an embrocation."

"A tub, yes, Mistress Whitlow, and rose-leaves and myrtle to steep in the water. But, of your mercy, no packings or bandages." Elinor sighed as Alyson swathed her in the voluminous bed-gown. "At this moment, I do confess that this small bodily freedom is more to me than power or honor or coffers of gold." She smoothed the skirts of the gown and folded her hands piously at her waist. "Do I look like a Christian woman again?"

"Your head is bare, my lady," said Dolly severely, and tucked Elinor's cropped hair into a linen cap over which she pinned a wimple and a veil. With her face framed in white linen, Elinor looked older, paler, harder; Alyson briefly wondered how she could ever have thought her fair. Finally, Elinor drew the jewel from her bosom and laid it outside the heavy wool of the bedgown.

"Is this your husband?" asked Alyson, taking it in her hand. The painted face was lantern-jawed, with a wide, humorous mouth, and straw-colored hair curling incongruously around high, broad cheeks. "He looks . . . very kind."

"Indeed," said Elinor, "my William was no beauty. But he was very kind. He gave me this bauble after our son Henry was born. I complained that we could ill afford such toys, and he replied that as I had labored in childbed to give him a living image of himself, so had he labored in the field to give me a painted one."

Elinor smiled down at the portrait, then dropped it gently on her chest and held out her hand to Alyson. "Come, Lady, let us be friends. If William Flower has offended you, then Elinor Flower must humbly beg your forgiveness. Once I had a daughter called Alys, though she did not live for me to teach her herb lore or aught else, poor chick. While I sat beside you in that garden, be assured that I loved you well enough, though not as William might have loved you, had he been able."

Chapter Seven

THAT VERY DAY, King Lionel named the Earl of Brackton Lord Chamberlain and during the week that followed, the court set about retuning its dissonant loyalties. Belowstairs, Master Hardy a little lowered the unnatural pitch of cleanliness. In the great hall, the nobles whispered of new taxes and levies to pay for the rebuilding of Albia, and in the solar, the ladies discussed the mushroom friendship between Lady Flower and the countesses of Brackton and Pascourt.

"They've grown so close, Grisel, that my lady Brackton must eat when my lady Flower is hungered, and my lady Pascourt must drink when she is athirst," said Lady Dumbletan to the Baronness Carstey, who was newly returned to court. "And they keep to themselves, like nuns, although Alyson and Elizabeth have not gone so far as to swathe themselves in black as my lady Flower has done. They say"—Lady Dumbletan's voice dropped to a confidential murmur—"that the King is beside himself with rage for that the lady is gone into mourning for her dead husband and will not speak to him except in company. It is said that they have quarrelled."

"So la Haulte Princesse will be Queen of Albia after all," said Grisel, whose ambition was to be first Lady-in-Waiting, or perhaps the young Queen's Mistress of Robes. "I shall have to con over my Gallimandais, for by all accounts, she speaks very little Albian. I wonder if she is truly as fair as report paints her."

"If youth is beauty, then she'll be fair enough," said Lady Tilney dryly. "The Princess Lissaude is but seventeen years of age. Furthermore, Rosamond du Frise writes me that

Lissaude is innocent, sweet-natured, and much enamored. She will without doubt make our king a good wife: he has been too long companionless."

"Our late chamberlain was companion enough as long as the King thought her a man," said Lady Dumbletan. The other ladies turned shocked stares upon her and she blushed hotly. "But all the court *knows* that His Majesty loved Master Flower dearer than a brother. Ay, me," she said, bowing her scarlet face over her frame. "Our Lady knows I mean no harm, but my words pop out all awry."

Lady Tilney shook her head over her tapestry. "You are a fool, Isabel, but your tongue and not you is the traitor. We all know what you mean to say. But there are those in the court who would hear in your words an echo to their thoughts. We can only pray that our little queen will not find herself wed to a king who would liefer wield a barren sword than plough a fertile field."

Lady Tilney's prayers, if indeed she uttered them, were fated to go unanswered. For when Lady Flower came to court, she robbed the King not only of William, but of his simplicity as well. No longer could Lionel equivocate his need or his heart. The lover he longed for was William: not Elinor Flower as wife or even leman, but William, wise and steady and manly fair.

More disturbing still, Lionel recognized that it was not William Flower alone who sparked this flame in him. Suddenly, Lionel found himself uncomfortably aware of the warm deftness of his chamberer's hands, dressing and undressing him morning and night. He took more active pleasure than ever he had before in the fierce, concentrated beauty of esquires on the practice-field, the plastic strength of a guard's muscled arm, the unexpected softness of a bared throat. He had wanted to touch such things before, had felt the yearning for them in his secret heart, but never before had desire emerged into his waking mind, there to be recognized and named by its proper name.

Where he once had been self-deceived, now Lionel would not trust himself to tell himself the truth. Repeatedly he examined each action, each friendship for the taint of unnatural lust. Would he dare to wrestle again, play quarterstaves

with Lord Molyneux, drink with Sir Edmund Sewale, clap
this man on the shoulder or clasp that one by the hand,
without betraying himself? Never had Lionel known so well
the workings of his own heart, and never had he been so
afraid. What kind of health could Albia regain, ruled by a
man who lusted after men?

During the long night watches, Lionel brooded over the list
of the Kings of Albia, his legendary and honored forebears.
First of his line was King Aquin the Capnite, then King Peter
the Good, Hugh Longarm, and Edgar the Dragon who founded
Cyngesbury; King Edmund the Wise, and his son Nicholas
Giant-Killer who died issueless and left the throne to his
nephew, John the Mage. Following the Magician King was
John II, called the Holy, Stephen Lackwit, and King Geoffrey
the Honest, who was his own father. Ten kings, each with his
title and designation to define him for posterity. To be named
"Lackwit" was thought shame enough. Was Lionel destined
to figure in the chronicles of Albia as King Lionel the Sodomite?

So the King trembled for his soul and his kingdom, and
there was none he trusted to counsel him. What his confessor
would say, Lionel well knew, and William Flower was no
more. Lady Flower had swallowed him up, translated the
serving-man into a widow with downcast eyes, draped in a
black robe like a nun's habit. No, Lionel could never confide
in Lady Flower, who seemed to have shed William's sympa-
thy and wisdom with William's cote and gown. Comfortless,
alone, Lionel could only clutch his arms and weep.

The morning of the Sorceress' trial, the undercooks were in
such a dither that every sauce tasted strongly of vinegar and
the meat pies were served up soggy and raw. Pages dropped
trenchers and slopped ale over the tankards like pot-boys at a
common inn, and the turnspits kept the roasts spinning so
briskly that the meat could not cook. When Master Hardy's
eye was not upon them, cooks and scullions shed their aprons
and crept mousy away from half-done tasks, so that midmorn-
ing found the kitchen nearly empty and the great hall packed
and seething like a starling pie.

Just before noon, Master Hardy processed majestically from
the kitchen with Mistress Rudyard on his arm to take his
place at the front of the gallery. As if they had waited on his

entrance, horns sounded a tucket. The great doors to the courtyard flew open and Thomas Frith, flanked by heralds in scarlet tabards, paced down the hall to a solemn fanfare. Behind him followed the jury, which in acknowledgement of Margaret's crime, was a noble company. The new Lord Chamberlain and the Lord Chief Justice, nine earls of Albia and the Duke of Trinley marched in scarlet pairs, all robed and coronetted and decked with golden honors. Lord Brackton was seen to finger his new chain nervously as he walked.

When these luminaries had disposed themselves to either side of the throne, the trumpets sounded a second time for the Archbishop of Albia. A third flourish, and King Lionel came in at last, with his scarlet robes billowing behind him and his face stern under the high golden crown of Albia. Briskly, the King strode from door to dais, ascended the steps, and turned to the company. In the young King's face and mien the full majesty of his royal father shown clearly.

The King sat down; a fussy little man like a bantam cock strutted to the center of the hall and cleared his throat. Albia having been for so many years a contented land, Lord Higham was not often called upon to fulfill his post of Lord High Justice of Albia, and he made a great business of preening his scarlet feathers, eying his parchment scroll, taking a great breath, and crowing:

"Oyez, oyez! His Most Puissant Highness King Lionel, Duke of Albia the Less, Earl of Bucklesford, Protector of Capno, Knight of the Most Sacred Cross, and Sovereign Lord of the Kingdom of Albia, doth call and convene this court to try Margaret, hight the Sorceress of the Stone Tower, for treason against her country and her king. Let the accused be brought forth to stand her trial."

Around Master Hardy, the household began to push and crane so that he was forced to cuff an ear or two before he could get a clear view of the floor. When the stir finally subsided, the Sorceress had come before the court.

Master Hardy gawped at her like a hobbledehoy. Margaret of the Stone Tower had been dragged before that august company dressed in a muddied green gown that hung in tatters around her legs and revealed an unseemly expanse of her bosom. Her uncovered hair hung in coppery elf-locks around her shoulders, and her face was smeared and filthy.

But though she was fettered with iron, she held herself up-right and proud as a queen while Lord Higham read out his accusations of murder and theft, of treason, and of consorting with demons.

"Margaret, hight Sorceress of the Stone Tower," he concluded at length. "How plead you to these charges?"

Margaret lifted her pointed chin and gave him such a look of disdain that he fairly blanched. "How should I plead, sirrah? This is no trial, but an innyard entertainment, a morality play whose end is well known to all. You are already determined that I am guilty, so it matters little what I plead." Turning from Lord Higham, she addressed King Lionel directly. "I have the right to confront my accuser. Who is it calls me sorceress and traitor?"

Lord Higham glanced up at King Lionel, who nodded. "The King himself, speaking for the restless soul of one Sir William Flower, accuses you of murder. Your daughter, Lady Elinor Flower, bears witness to your sorcery." Lord Higham gestured to the herald, who blew again. "Stand forth, Lady Flower, widow of Sir William Flower, knight and lord of Hartwick Manor." A ringing silence followed his words. Then a figure in deep mourning glided into the hall, a figure wrapped in solemnity as in her inky mantle.

Her fetters clanking from her lifted wrists, Margaret took an involuntary step towards Elinor, then froze as her guards moved to restrain her. Her lips were folded tightly, but unuttered curses rang in her clawed fingers and staring diamond eyes. At Master Hardy's side, Mistress Rudyard made a pair of horns with her thumb and little finger, and spat between them.

Master Hardy laid a reassuring arm about her plump shoulders. "By St. Nefandus, Molly, yon's a wild piece. But I'll back Mistress Chamberlain Flower against her nonetheless."

"Hush thee, Piers," whispered Mistress Rudyard. "The Sorceress speaks."

"So, daughter. Thou comest like a bird of ill omen eager to peck betimes at my dying body. Say if that panoply of mourning be for thy husband and his puling brat, or be it for thy mother, who is to be burnt tomorrow?"

Her face pale and set, Elinor moved nearer and looked steadily into Margaret's eyes. At first, it seemed that Elinor,

with her face pinched by a wimple and pleated barbet, was the elder of the two. Margaret, dishevelled and defiant in her whore's green gown, could have been taken for her daughter's daughter. But under Elinor's calm gaze the Sorceress' proud stance faltered and she shrank in upon herself until she huddled like a crone at her daughter's feet.

"Ask her," Margaret screeched. "Ask her how my power was taken from me. If I am a sorceress, then she is a greater, who could turn my own servants against me. Beware," she cried, pointing at the King with one shaking hand. "Beware, thou besotted boy, how thou givest thy love to a witch who hath no heart, who betrayeth and destroyeth her own mother, who denieth her own sex."

Lord Higham, who had been standing by all this while with his mouth ajar, hastily called for the prisoner to be silenced, but at the King's imperious gesture his excited cackling stilled.

"Your daughter does not stand trial here, Mistress, nor yet do we," said King Lionel. "You are our prisoner, seized with our own hands, in mortal jeopardy of your life, and it were best that you bear yourself more seemly before this court."

"This court," sneered Margaret. "This just court wherein one accuser is my own daughter and the other my judge. If the court were seemly, then would I bear myself so."

At this, King Lionel laid aside his sceptre and descended the steps to stand on the floor of the great hall next to the kneeling Sorceress. He turned to Lord Higham, who had gone as crimson as his robe. "We yield the authority of this court to you, Lord Higham, as Lord Chief Justice of this our realm of Albia, and enjoin you to question us straitly, as you would any witness."

Choking a little, Lord Higham climbed to the step just below the throne and visibly gathered his scattered wits. Then haltingly he questioned Lady Flower and King Lionel as to what they knew of the prisoner, her character, and her deeds.

Clear and low, Elinor recounted the scene in the stillery, how she had heard a voice railing from the thin air, and had looked up from her work to see the face of a strange woman who glared and cursed at her like a demon of Hell. No, she had not known at that time that the woman was her mother. No, she had not commanded the woman's demons to turn

against their mistress. Yes, she had guessed from her words and actions that the woman must be the Sorceress of the Stone Tower. Then Elinor set forth all the reasons she had given King Lionel for believing that this same sorceress was the cause of Albia's late plagues and famines. She read from the scroll of Magister Lebbaeus, in which he had written of his unsuccessful trial of King John the Mage's mighty ritual of prohibition. When Lord Higham asked Margaret if she had aught to say to her daughter's accusations, the Sorceress only crouched lower and snarled.

"These crimes were in themselves enough to burn you, Mistress," said Lord Higham, "for you have been an hundred times a murderess by the setting-on of your demons. But our lord the king does accuse you of two murders in especial, of Sir William Flower of Hartwick Manor and his son Henry Flower, a child of one year. My liege, how came you to hear of this crime?"

Then King Lionel told the court of his adventure, beginning with the white Hart, "whom we verily believe to be the speechless soul of this lady's son, Henry," and ending with the ruined manor house and the pitiful grave and the white Dove that wept tears of blood as he sang his woe. When the King was done, an awed hush fell over the hall as each man stared at the huddled, tattered form of the Sorceress and the two stern figures that flanked her.

In the midst of the hush, Margaret rose upon her knees and cried aloud. "She was born to be my bane and he was born to slay me. Wherefore should I not seek to revenge my own death upon them who were fated to be the cause of it? Wherefore should I not attempt to save my own life?"

"With her own lips she condemns herself," shouted Lord Higham. "Each word she speaks is a blasphemy." He appealed to the nobles. "How say you, my lords? Is the woman Margaret innocent or guilty?"

"Guilty, my lord," said Lord Brackton, and, "Guilty," said Lord Heanor, who sat by him, and each of the lords of Albia in turn echoed their judgment: "Guilty."

"So be it," said King Lionel, and mounted the steps to the throne. "Lord Chief Justice, pronounce the verdict."

"Margaret, Sorceress of the Stone Tower, this court finds thee guilty of treason, of sorcery, and of murder. Thou shalt

be taken at sunrise to be burnt alive, and may God have mercy on thy soul.''

Margaret raised her face from her hands where she had hidden it, and looked upon the King and upon her daughter with wild despair, as though she might howl aloud. But she uttered no word or cry as her guards bore her from the hall and cast her roughly into her cell.

Presently, a barefoot friar came there to her in case she should repent and wish to be shriven. But Margaret only snarled at him and curled herself in the farthest corner of the cell to wait out the night alone.

While Margaret awaited dawn in the castle dungeon, Elinor sat in Lady Brackton's apartment and prepared for her own departure from court. A leathern budget was propped to one side of the hearth, and around it were spread linen shirts and woolen blankets, a wooden cup and a paper of salt and a clasp-knife and some small packets of dried herbs which Alyson picked over with listless hands. In the bedchamber, Lord Brackton sighed and muttered over inventories and daily accounts.

Lady Brackton was pleading with Elinor to stay. ''Can you not at least be put off until spring?'' she asked. ''Under my protection and the dignity of your mourning, you need fear neither gossip nor the King's importuning. If you go, I will lack you sorely, and so will the little maid.'' At this description of herself, Alyson gave an indignant and tearful sniff. ''If friendship cannot move you, consider what will become of Cyngesbury Castle without you. Brackton is but a poor hand at lists and figures, and could very well use your advice in these matters until he becomes more accustomed to dealing with them.''

Elinor shook her head. ''It is your kindness that seeks to detain me, I know, and that is more pressing than all your other persuasions. I care not for gossip, nor is the King minded to press his suit, for I have, I think, much wounded his pride. What takes me hence is my own pride: I do not care to remain at court on sufferance. As for advising Lord Brackton—Lady, you know well your husband loves me not, either as Chamberlain or widow or as his wife's gossip. He will take no advice from me. Better he should look to you.''

Lady Brackton smiled. " 'Tis true that the arrangement of a king's household is not so different from the arrangement of an earl's, and I've overseen that for two score years and more." She sighed then, and looked fondly at the door that hid her husband. "Yes, Alfred is a proud and stubborn man and not easily counselled, but he will hear from me what he will hear from no other soul. You have routed me, foot and horse, and I have no single argument left to send against your going." Folding the shirt she held, she rose and kissed Elinor's brow. "I wish thee God-speed, my dear," she said and went in to her husband.

Long after the rush-lights had burnt low, and long after Lord and Lady Brackton had retired, Alyson sat with Elinor by the dying fire, staring idly into the embers while Elinor stowed the packets of herbs into her leathern budget.

"Let me go with you," Alyson said. Without lifting her eyes from her work, Elinor shook her head. "What will become of me, then?"

Elinor laughed. "You are no towered princess in a troubadour's song, little bird," she said. "Nor, unless you refuse all food and drink and starve yourself, are you like to die of love."

Indignant, Alyson gaped at her and spluttered. Elinor put the budget aside, and, coming to kneel by the young girl's chair, gathered the delicate fingers into her strong peasant's hands.

"Listen to me, my lady Alyson, Countess of Pascourt, and listen well. Although you were once betrothed, your body is hardly a woman's and your heart is yet a child's. In grief, in experience, in hardship and care, I am old enough to be twice your mother.

"You have said that you would not be parted from me, that you love me. But this loving of yours is an infant's wail, a need and a demand for love. As for myself, I have all but forgot what loving is. I feel no more than if my heart were swaddled in linen bands, flattened and bruised as my breasts have been. I cannot give what you would have of me.

"Beyond even this, you do not in truth know what you ask. Troubadours have sung of knights errant, of tall white steeds and clear June days and silken pavilions at journey's end. Dear birdling, my errantry is no such thing as this. I am

neither knight nor alderman, and so I go on foot, with all my wealth upon my back. I go in autumn, through the dying of the year, into a countryside where famine dwells and the ghosts of children my own mother slew. I will heal where I can and earn my bread. Perhaps I will live out my years upon the roads; perhaps I will cook or scour pots in some lordling's kitchen; perhaps I will be slain by outlaws; perhaps I will find my mother's tower and plant a garden there. But what I do, I will do alone.''

Throughout this speech, Alyson sobbed aloud, as though her tears would drown the words that burned her. "You will take Ned with you, who is only a scullion, and could not love or serve you half as well as I," she wept.

"Ned is as stubborn as you. He will follow whether I will or no. But I allow it only because he is a scullion; life on the King's highway is little harder than life in the King's kitchen."

"But what will I do, while you and Ned go adventuring?" Alyson wailed. "Must I sit in this castle or in Brackton Hall, embroidering smocks and hangings and cushions and frontlets for my dowery until King Lionel pleases to sell me and my fortune to some hideous, drooling dotard, and then sit in my husband's castle, embroidering the same for his children until the day I die? Must I become like Lady Carstey or Lady Dumbletan, too foolish to know that they are bored?" She tore her hands from Elinor's and beat them upon her knees. "What must I become if I do not go with you?"

"Hush thy crying, infant," snapped Elinor. Stubbornly, Alyson shook her head and hid her raddled countenance in her hands. She felt a chill as Elinor rose and moved across the fire, a draft as she stooped for the budget. Alyson listened for the rustle of skirts that would proclaim her seated once more, but she heard instead the soft crackle of dry rushes spurned underfoot and the muted creaking of damp hinges.

"Wait!" Alyson sprang to her feet. In the doorway, Elinor turned, her mouth and eyes stern shadows in her white face. "I will give over, if my grief displeases you," Alyson told her sulkily. Elinor showed her her back.

"No, wait!" Alyson called her pleadingly. She could not let her leave in anger, despising her. "I am like Lady Dumbletan already," she said, very small. "My study must

be to differ from her. Please come back and set me my lesson.''

Sighing, Elinor returned to the fire and sat for a while in silence. ''To a child,'' she said at last, ''nothing exists unless he holds it in his hand. A dropped trinket is lost forever; the sun dies each night when he seeks his bed. The moon and stars circle his small globe, and nothing is until his eyes fall upon it and give it meaning.''

''That is to say that I am too much concerned with myself.'' Alyson felt chastened, a child indeed.

Elinor smiled. ''In spring, there will come another child to the court. Men will bow when she passes, Lady Carstey and Lady Dumbletan and Lady Tilney and even your worthy aunt will hang upon her every word and leap to obey her, and each night she will bear the weight of royalty upon her breast. This child is two years your senior, but she has spent much of her life in a nunnery—she knows little of the world, and less of Albia. She will be frightened and far from home.''

''La Haulte Princesse Lissaude,'' Alyson said softly. '' 'Tis true, I had not thought she might be afraid.''

''If you earn her trust with discretion and her love with true service, then will you have a task to keep you from boredom and a friend to solace your heart. As for the rest of your complaint,'' Elinor shrugged practically. ''The world goes as it will, and not always to a woman's liking. But the Queen of Albia's gossip need never marry a hideous, drooling dotard.''

Pondering these words, Alyson watched the fire, then gave a nod and scrubbed her face on her long sleeve to rid it of the lingering traces of storm. ''When will you leave?''

Now Elinor's voice was troubled. ''Tomorrow, after dawn. When they have burned the Sorceress. Margaret. My mother.''

At the sight of Elinor's widowed countenance, Alyson came near tears again, and then she remembered her gift, conceived and made in secret preparation for two warrior maids to go a questing on the roads of Albia. She had made one for herself, too, but that must be put by. ''Must you bind your breasts again?'' she asked.

Elinor raised her head, surprised. ''Yes. My body's too much a woman's, else.''

''I have a gift for you.'' Alyson went to a chest and brought forth a curious garment like a corselet, which she laid

on Elinor's lap. "This should take the place of binding. I laid a stuffing of caprace between two pieces of linen, sewed it through so that it would not shift, and made a sleeveless smock of it. It will do to hide the swell of your breasts and hips. See, it laces up the front, thus." Alyson demonstrated on her own slender body, then found herself enfolded awkwardly in Elinor's arms, and her own cheek wet with Elinor's tears. "It is but a little thing," Alyson said, feeling the blood rising to her face. "Because the binding hurt you so."

Elinor released her and took the corselet from her body. "I have nothing to give thee, little bird, but only one more thing to ask of thee." She lifted her husband's jewel over her head and unclasped the chain, slipped the gold ring from the chain, clasped it again, and settled it back around her neck, where it glowed against her black gown. "Is there paper here?" she asked.

Alyson brought parchment, ink, and quill and sat silently by as Elinor indited a message and folded the ring within it. "Thou hast sworn to be thy queen's true friend," she said to Alyson. "Wilt thou now yield her thy first service? When I have gone, give thou this into the King's own hands."

With a solemn consciousness of portents and omens, Alyson took the packet. Then Elinor kissed her cheek and chin, and left her to seek her bed and what sleep she could find before Lauds called them both to Margaret's burning.

Chapter Eight

THE MORNING OF the execution was dank and chill. Although it was past time for the kitchen-knaves and undercooks to be astir, the cook-fires still smouldered under their banking ashes, and the long tables gleamed pale and bare. In the pantry, a rat feasted undisturbed upon cold capon. The great hall stood empty, its carpeting rushes drifted into the corners and under the benches without a man-servant to sweep them even again. The ladies were all arisen, but the solar was deserted; in King Lionel's apartment, grey light fell upon an empty, tumbled bed. Every member of the royal household, both high-born and low, stood shivering in the courtyard and awaited the sunrise.

Around the pyre walked the King's executioner, checking that the faggots were truly laid to burn hot and long. A hugger-mugger business, he thought sourly. Pity the King couldn't have waited another day. A burning's not a be-heading—just a dais, a block and an axe, a morning's building and a minute's work. A burning takes two days to prepare: one to build the scaffold and erect the iron stake; one to gather a cartload of brush and twigs, bind it into faggots, lay it under and around the scaffold so that the fire would draw well. Two days; and he'd had barely one. King Lionel may have told off a dozen men-at-arms to help him build and gather and bind and stack, but even with the extra hands, the executioner had been hard-pressed to finish by dawn.

A thin drizzle began to fall on the company gathered in the courtyard, chilling them marrow-deep. The torches spit sullenly and the executioner had a new worry. What if the rain

225

kept the fire from catching, or from burning cleanly if it did catch? It would be a great shame if the Sorceress were to smother before ever she felt the flame.

Master Hardy, wise in the ways of fires, said as much to Mistress Rudyard, who harrumphed and pulled her mantle more tightly around her.

"Smothered or burned, she'll be none the less dead, and all this hurly-burly over and done," she said. "It seems that we've not had one quiet day since Master Flower swooned upon the kitchen floor. I'll be glad to see the back of him, though my Ned do follow after." She shivered, and Master Hardy was moved to steal his arm around her waist.

On the steps of the great hall, King Lionel sat enthroned. He had lain awake late into the night and when he had slept at last, it was to dream of hunting a fox with pale, cold eyes, a vixen that nipped and struggled as he flung her into a fire where she was transformed into a slender figure whose wheat-gold hair rippled over a naked, sexless, unburning body. There had been doves in his dream, and a tall, homely man holding a fair-haired child in his arms. Both child and man were clothed in flowing streams of blood.

Lionel glanced aside at Elinor, standing near the foot of the pyre in her raven's garb, shivered, and buried his cold hands in his furred mantle. Behind its pall of clouds, the sun was beginning to rise.

A drum sounded from the bailey and Margaret walked into the forecourt. She was chained and surrounded by guards, filthy and in rags, but she stepped towards the pyre calmly, even proudly, as though she had come to be crowned. There was no hatred left in her, no false hope or fear. She had been a dead woman since the moment her horn had burst. Her defiance at her trial had been nothing but the impotent snarling of a fox brought to bay. All she could do now was bare her throat to the hounds and submit.

Thus thinking, Margaret did not shrink from mounting the pyre, but leaned against the stake as if it comforted her, and stretched back her arms with passive dignity so that the executioner might chain her hands behind it. But when the man bowed his head to ask her pardon, she saw that his hair below the obscuring black hood was yellow as corn. Only then did Margaret begin to whimper with fear and struggle against her fetters.

With a final tug on the chains, the executioner slid down the pyre and took a flaring brand from his apprentice. First he thrust it here and there deep within the pyre, then lit the brambly brush at the edge and signed for his apprentice to encourage the reluctant flames with a small hand bellows. Damp, grey smoke rose around Margaret, so that her eyes smarted, though no tears came. Margaret blinked. Below her she saw her daughter staring up at her, grey eyes wide and blank. The pushing of the throng unsettled the hood of her black mantle, and it slipped back from Elinor's head to reveal a smooth cap of wheat-gold hair.

Margaret laughed, an hysterical barking cry. "Behold him," she cried. "The famous Flower of serving-men! Alas the day that she was born."

A billow of smoke set her coughing and a familiar face leered at her through the choking pall. "Margaret, my dearest dear," Magister Lentus whispered in her ear. "See, I have brought some ancient friends to speed thee on thy way. Since that thou didst slay thy grandson and mine, I have looked forward with joy to attending thee in thy dying agony, but I am but a damned soul and even this joy is denied me. Thy pet, thy arch-demon, thy duke of Hell, grows most impatient for thy soul."

Her grandson. Her blood. In her fear and foolishness, Margaret had wrought her own doom. For the first time in thirty years she wept, but her tears dried upon her lashes before they could fall. She felt a breath of hot air upon her cheek and flames crackling below her, licking through the twigs heaped at her feet. A spark singed her cheek, and her eyes flew open reflexively. Neither smoke or flame met her horrified gaze, but the vast cloudy face of the arch-demon whom her arrogance had once sent scudding about the countryside, spreading petty mischief. His smile told her how his pride would be assuaged.

The demon breathed on her, and the agony of his glacial breath burned deeper within her than the agony of the fire. Behind him roiled thick, tainted shadows, darkness made visible. Margaret screamed once, voicelessly. Then the arch-demon gathered her into his coldly burning arms and bore her headlong hurtling into Hell.

* * *

Of the demon's triumph, the court knew only that a dry wind had sprung up in the courtyard, sourceless and unnatural, and blew the Sorceress' smouldering pyre into a red-gold flagration. The executioner fell cursing back from the blaze, and the King sprang to his feet. Elinor had been standing at the pyre's foot with the Countess of Pascourt.

"You, guards," he shouted above the fire's roaring. "Douse the stables and the smithy. And let the castle gates be swung wide. We must clear the forecourt." He turned to Lord Brackton, who stood gaping at his elbow. "See you to your niece, my lord, and to the safety of Lady Flower. I saw them standing together, hard by the pyre."

Lord Brackton blanched and swallowed and moved uncertainly towards the steps. A roaring tongue of flame licked the castle steps, and he fell onto his knees, crossing his breast with a trembling hand. Behind him, he heard his wife cry out upon God.

It took some little while for the crowd to realize that Margaret's bonfire burned without spark and without spreading. And when they did, their bodily fear yielded to a more spiritual dread. With a hectic mirth, King Lionel appealed to the white-faced Archbishop of Albia, who stood clutching his rosary. "Hell has joyfully taken our offering, Archbishop, and now would take our castle as its antechamber. Can you not rid us of this infernal visitation?"

Shakily, the Archbishop raised his crozier against the conflagration and the fire died, winking out as if it had never been lit. The air was cool and sweet, with no lingering stink of flesh or hair. Stake and scaffold and wood were gone, and the flagstones were clean of ash. Of Margaret of the Stone Tower nothing remained, not so much as a tooth or a smoking bone.

Crossing himself perfunctorily, the King ran down into the teeming courtyard to where he had seen Elinor standing. Behind him, he heard his nobles mumbling heart-felt prayers and a woman screaming. The members of the crowd knelt where they had stood and rendered up their thanks to God, and in their midst the King stood staring wildly around him as if he were again in the haunted glade with the Hart just vanished from his sight.

A dark-mantled woman moved away from the arch of the

castle gate and began to pick her slow way through the kneeling crowd. Relief washed over Lionel, followed by a sick weariness. It was all to do again, the regrets and the empty protestations; why could not Elinor, like her husband and her son, simply vanish away? The woman drew nearer and Lionel saw that she was not Elinor, was far too small to be Elinor. She was gone, then, with her false face and her false body and the false love they had promised him. Perversely, he felt a pang of loss.

The woman pushed back her hood to reveal Alyson Pascourt's pale and tear-slick face. Gravely she curtsied low, handed him a tightly folded parchment. Gravely King Lionel thanked her and slipped the parchment into his breast. Then he called his nobles to him and returned into Cyngesbury Castle. Behind them, the doors of the great hall were shut fast and barred.

The burning and its aftermath had taken but a watch, and now the hours of the Feast of All Hallow's spread before Lionel like desert sands. He felt as he had when his mother had died, and Robin: bereft, alone, deprived of comfort, deserted by love and haunted by memory. Elinor was gone, trailing the ghost of William like a shadow behind her. Margaret was gone, but she had left a legacy of want and suspicion behind her. How many more sorcerers and necromants lurked within Albia's pale? Could even the Wizard Venificus ferret them all out? What Lionel most desired was to sit by the fire and brood or to sweat out his melancholy in quarter-staves or swordplay. But he had denied himself such exercise, for his soul's sake.

Petitions still piled his worktable, and a treaty for the purchase of seed-grain from Galentia, and a letter from King Arnaud which had accompanied a portion of Lissaude's dowry, sent in token of his fatherly regard. Doggedly, Lionel began to sift the parchments into some semblance of orderliness.

After dinner, his patience deserted him, and a vague restlessness drove him back and forth before the fire, then down the stairs and through the courtyard to the gardens. It was no weather for an idle stroll. The long drought had given way to a rainy autumn that chilled and soaked the earth. Most of the country's stores of grain had been spoiled by the past sum-

mer's heat or eaten; there would be famine and hardship in the winter ahead. Through the thin drizzle, Lionel strode down the Rose Walk and past the wall of the Queen's Garden, through the herbary's fragrant paths and out again into the North Garden. At the end of the gravelled walk before him he saw the entrance to the infant maze.

Although he knew the maze well and took some pride in being able to pass from gate to heart between *Pater Noster* and *Amen,* Lionel was lost before he had taken twenty steps. It should be simple enough, he told himself, to find his way again, for the hedges were as yet only knee-high, and he should be able to trace the path to the gate at least, and there begin again. He climbed upon a new-hewn seat and peered through the murk for some familiar statue or turning by which he could orient himself, but all he saw was a random jumble of hedges and, dimly, the maze's inmost circle, brown among the green. Mist overlay the pattern with the bony carcasses of cows hummocked upon barren fields; the curses of starving peasants muttered ghostly above the rain.

Hastily, Lionel leapt down from his perch. It was bad enough to be lost in his own bride-gift without being haunted by visions as well. He could, he thought, trample through the close-planted junipers and by force come out of his predicament. Once he would have done so without taking further thought, tearing young branches heedlessly, denying the puzzle he had set himself to unravel. Robin would have done so. The image of his boyhood's friend rose up before him, laughing, plunging knee-deep through heather, sword in hand, his horse's blood shining crimson on his armor. Beneath his raised visor his face was young and vivid, his eyes at once blazing and curiously blank. In the midst of his dark beard, his mouth gaped wet and red. "For Lionel!" he shouted. "For St. George and Lionel of Albia!"

If Lionel of Albia had drawn his proffered love a step beyond the poetic abstractions of King Beaubrace and the knight Joyeau, what would Robin Wickham of Toulworth have said? Would he have returned that love again, kiss for kiss, touch for touch? Or would he have turned from his lover with loathing, as passionately his king's enemy as he had been his friend? Sitting in his bridal maze on this feast of All Hallow's, Lionel was as certain as if the dead had spoken that

Robin would have spurned him. The boys' love they had shared had been illusory, fragile, incorporeal as a dream. Robin's dying preserved it thus, as though it had been carved in stone like the beautiful effigy adorning his unfinished tomb. Let it, let Robin, rest in peace.

The King sighed. Well, he would not use force. Nor would precedent help him, since the learned directions meant nothing without a point of reference. Did courtly love extend to men? he wondered briefly. Did Beaubrace dream of taking Joyeau to his bed? Lionel shook his head, struggled to bring his wandering mind to heel. Now, what said William when he had drawn the maze? "This maze is like a woman's heart, for the center may only be achieved by one who seems not to seek it."

King Lionel wrapped his mantle closer about him and set off away from the maze's center. Whenever a path branched or he reached a blind end, he sought his goal and turned counter to it. With many false casts and much retracing of his steps, and a time of frustration when all paths seemed to lead him to a dry stone fountain he could not remember having seen before, Lionel made one last turn away from the herbary wall, and entered the maze's heart.

No flower or grass or herb had yet been planted in that small open plot, nor any decoration set there. The pattern of the central knot was lost in a forest of sticks and string. The damp mizzle had hardened into rain, the clouds hung sullenly over the towers and turrets of Cyngesbury, and the junipers and the grass looked sad and grey in the dull light. King Geoffrey stood before him, Queen Constance by his side, and the look they turned upon their son was a look of stern grief.

Anger rose in Lionel's breast, and a great weariness. "I have done my duty, Father," he cried bitterly. "I have bartered my happiness for Albia's good, and I swear I will keep my end of the bargain. My body is my country's, Father; but my heart is my own. It is not for you nor any human man to judge whether its yearnings will damn or bless me. That judgment is for God alone."

The ghosts wavered, dissolved into mist. As she faded, Queen Constance stretched out her hand to him. Lionel thought he felt a feather touch upon his cheek, and was shaken by a great trembling sigh that was close to weeping.

Over his heart, a pressure and the faint crackle of parchment. Lionel drew forth the packet Alyson had given him that morning and broke the wax that secured it. A plain gold ring dropped into his palm. On the parchment were a few words, written in William's firm, clerkly hand.

> *My Liege Lord & Sov'rign Kynge. I leeve you my rynge as a gifte to Lissaude, yr. betrothed wyfe. May yr. lyfe wit her bee as bleste as was myne with the manne who sette it on my fynger.*
>
> *If ye are minded to search for mee, thynke only thatt Elinor Floure is ded, burnt to clene asshe with her wiked moother, and thatt only the ghoste of William Floure wanders the roads of yr. kyngedom until it bee graunted reste.*

Anger came as a welcome release from pain. "A pox on the woman!" Lionel shouted to the listening mist. "Presumptuous wench!" Would she presume to instruct him to love Lissaude? And for her sake, too! Was the woman blind, deaf, insensible? Had not each word he spoke revealed that it was William he loved, not Elinor? And who was she to lesson others in the business of living? She, who would make herself into her dead husband's image and bury herself in her grief, shunning life and love together.

For a space Lionel stood glaring at ring and missive. He read it twice and thrice, and on the fourth reading, his anger began inexorably to drain from him. Grief. This, he thought, was a document of Elinor's grief, an anguish so black as to blind her to the inward hurts and needs of all other but herself. William had been nothing more than the servant of the King of Albia: Elinor had had no interest in the workings of Lionel's private heart.

Lionel folded the parchment and put it in his sleeve, then peered within the ring's worn circle. A posy was carved therein: "Mine hert dwel in thy brest." Might that not be the true meaning of the Hart and the Dove? Was it not revenge, but love that kept them bound to Hartwick, that kept Elinor bound to them?

Love or revenge, the life she had chosen to lead was not such an ill life. She had a servant to attend and company her, freedom to come and to go and to keep what moneys she

earned for her own use. Many men would choose such a life over the ties of family and land: he felt the call of it himself. Ruefully Lionel smiled and slid the ring onto his smallest finger. Elinor had had large hands for a woman, and it fit easily.

Lionel's heart was eased by this small defiance in spite of rain and ghosts. They were alike, Elinor and he, in that they both loved phantoms. Might not that be his salvation as well as hers? Sodom had been burned for lust; there was no biblical proscription against loving an idea. Surely nature's harmony would not be untuned if the King of Albia loved a ghost. As for his body—that would be Lissaude's, and he'd make a poor ruler indeed if he could not rule his body's desires.

Solemnly, Lionel kissed the ring and swore to keep it as William's love-gift to him. Another ring would do for Lissaude.

Through the scents of mud and wet grass, Lionel caught the sharp green savor of juniper. Bending, he picked a waxy bluish fruit from one of the bushes, held it to his nose, and wondered whether William had left behind him a receipt for the draught that kept the inhabitants of Galentia in such wonderful good health. No less than his ailing country, Lionel stood much in need of healing. Perhaps, he thought, he would pledge his bride on their wedding night in a distillate of juniper instead of wine. If she found it bitter, or complained it was too strong, he would say it was a potion that would bring increase to their bride-bed. These properties, after all, were the juniper's natural gift, and the receipt had been given him by Lady Elinor Flower, the renowned herb-mistress who had once been Royal Chamberlain of Albia.